Victorian

Paisley Shawls

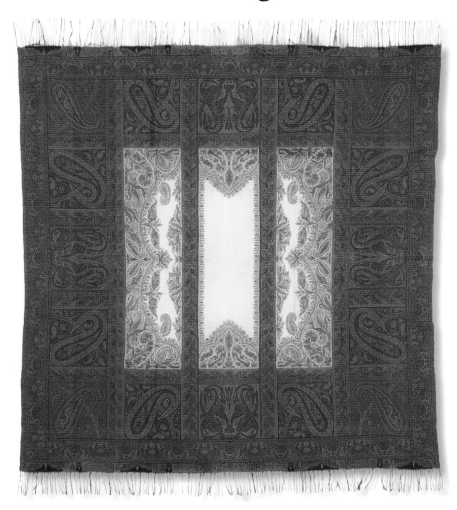

Chet Gadsby

4880 Lower Valley Road, Atglen, PA 19310 USA

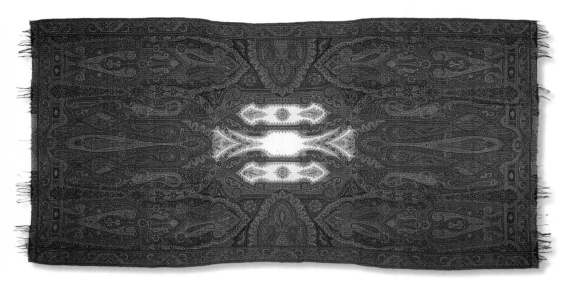

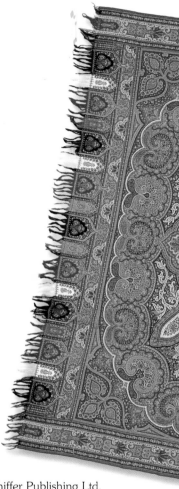

Published by Schiffer Publishing Ltd.
4880 Lower Valley Road
Atglen, PA 19310
Phone: (610) 593-1777; Fax: (610) 593-2002
E-mail: Schifferbk@aol.com
Please visit our web site catalog at **www.schifferbooks.com**
We are always looking for people to write books on new and
related subjects. If you have an idea for a book, please contact us
at the above address.

This book may be purchased from the publisher.
Include $3.95 for shipping.
Please try your bookstore first.
You may write for a free catalog.

In Europe, Schiffer books are distributed by
Bushwood Books
6 Marksbury Avenue
Kew Gardens
Surrey TW9 4JF England
Phone: 44 (0) 20 8392 8585
Fax: 44 (0) 20 8392 9876
E-mail: Bushwd@aol.com
Free postage in the UK. Europe: air mail at cost.

Designed by Bonnie M. Hensley
Cover design by Bruce M. Waters
Type set in BernhardMod BT/Souvenir Lt BT

ISBN: 0-7643-1570-6
Printed in China
1 2 3 4

Dedication

I dedicate this book to my family: Ruth, Hazel, and Frank

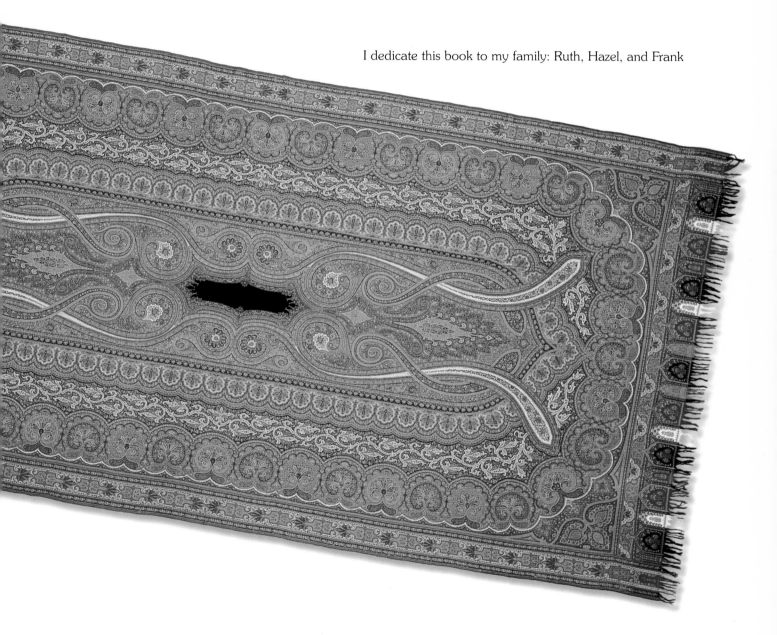

Acknowledgments

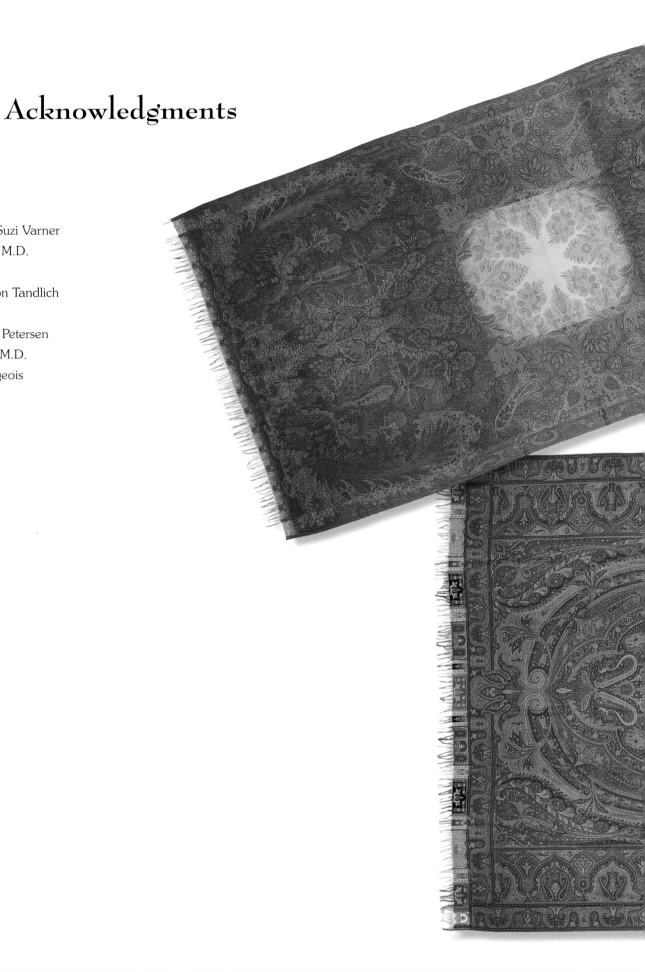

Suzanne and Suzi Varner
Suraj Bowery, M.D.
Barbara Dunn
Joyce and Leon Tandlich
Frank Ames
Lena and Earl Petersen
Martha Boyd, M.D.
Barbara Bourgeois

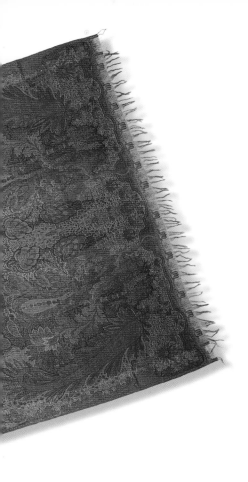

Contents

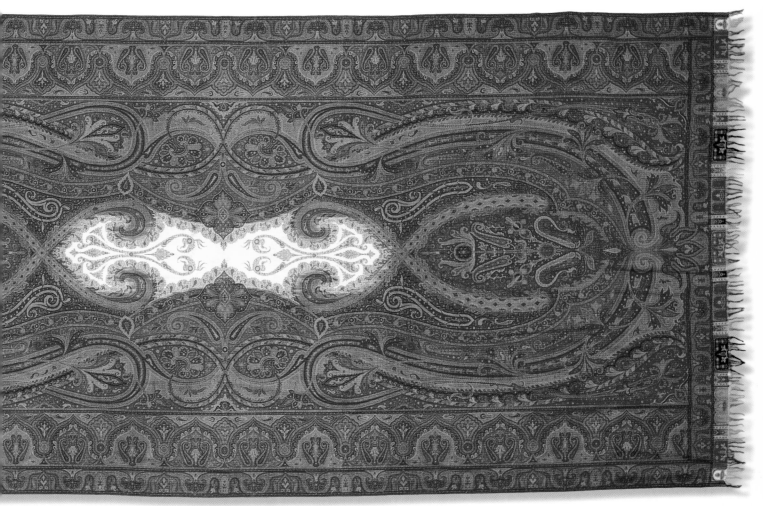

Introduction

Within these pages, I would like to share with you my private collection of paisley shawls (also called shoulder mantles) as well as how I started collecting these beautiful shawls nearly twelve years ago.

During my thirty-seven year career in radiology, I've always collected something. I presently have a collection of theme plates, liquor decanters, wild life Andrea porcelains, and finally, my paisley shawls.

One day at work, a radiologist I worked with came to my office and stated, "I hear you often go to many antique shows!" That started the dialogue. The radiologist was from India and asked if I saw paisleys in my travels. I stated that I was not familiar with textiles and I didn't believe I really knew exactly what a paisley was.

The next day, she brought one into work and showed me this very long "cloth" she had recently acquired at an auction. I told her that I may have seen these things, but didn't pay any attention to fabric items. She asked if I would keep an eye out and if I saw one, to purchase it. I was given carte blanche to purchase as many as I could—price was no option nor was the condition of the shawl a factor.

Over a span of five months, I acquired seven shawls, all over ten feet in length. This physician had family in India that could repair any damage and then each of these long shawls would be quartered into four separate shoulder shawls she could wear with her Indian attire outside of work. She had the pieces of each shawl glued onto a cheese cloth material to give body to each section and she would wear that piece over one shoulder and tuck it into the belt of her sari.

I learned a great deal about paisley shawls from my physician co-worker. She gave the sections of each shawl as gifts to family and friends. She paid for the shawl as well as for the repairs done in India and for the cutting up of a long shawl into four separate shoulder mantles. I was fascinated with the finished product when the item came back in separate pieces from India, as I knew the condition when I had bought it.

I received a call two months later from a New Hampshire antique dealer stating that she had just acquired a magnificent shawl and asking

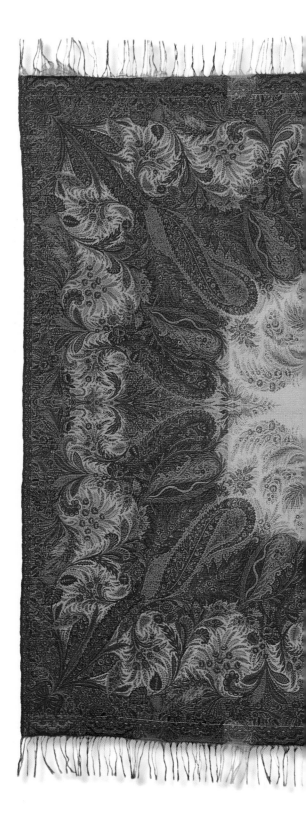

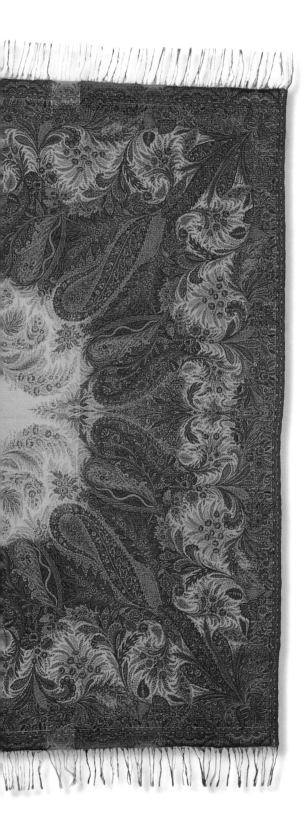

if I would be interested, as I had bought from her before. I drove up to the show and she had the shawl in a bag under the table for me to see. She wanted me to have first refusal on this item. When she opened and spread out the shawl, it was twelve feet long and had a small red center and I thought, "This one is for me!"

I brought this shawl into work and showed my co-worker and said I was going to keep this one for myself. The shawl was like new—not a hole, snag, or stain. The colors were brilliant. My co-worker examined it very thoroughly and stated that, "Once you study the intricacy of the pattern, you will learn to love these shawls, as each one has its own personality." She explained to me about the fringe ends of the shawl, that the different colored blocks are called "gates," and that from the design, you can tell from what part of India the shawl originated. She was very familiar with motifs used in the end blocks or gates of the shawl.

Over time, I started to acquire shawls at the rate of one every other month. I would bring in each shawl to work and my co-worker would study the pattern and tell me where in India the design was from. She named villages or towns I had never heard of. It was amazing to listen to her talk about all the various designs, weave methods, and colors. It is from her that my interest peaked and I then started to look for only paisley shawls at the shows and the shops.

From dealers and other knowledgeable people I've bought shawls from, I learned what books to buy and I found a wealth of information to assist me in deciding the quality and rarity of the product. I became hooked on collecting to the point that I saw nothing else in a shop or at a show. I was addicted!

This book illustrates a variety of shawls from several countries and provides an overview of shawl types, information on cleaning and storage, and tips for selecting a shawl. The history and origin of shawls has already been written by several foremost authorities—those interested in pursuing further historical detail will find several good resources in the Bibliography.

Types of Shawls

There are many different types of shawls. They were, and are today, part of a woman's wardrobe. Centuries ago, men also wore them as part of their attire in the seventeenth century.

From the mid-eighteenth up through the early nineteenth century, shawls were made in all types of material. There were lace, crocheted, block printed, roll printed, and woven shawls. Many countries manufactured shawls and they were mass produced in all forms of material and blends. Frank Ames's pattern book, *The Kashmir Shawl and its Indo-French Influence,* is a good resource for reading more on the background of shawls.

The paisley design (boteh) has always intrigued me. As will be seen in the next chapter, this design dates back to the Mogul art period of India. India was the largest producer of loomed shawls, also known as machine made. France was also a large manufacturer of loomed shawls, utilizing the designs from India. Hand made paisley shawls were from a part of India known as Kashmir, thus identified as Kashmiri shawls. The finest goat's wool was used in both the loomed and hand made type of paisley shawl. Many were made with a silk blend and have a distinct "feel" to the shawl. Scotland manufactured paisley shawls utilizing a different type of weave called a Jacquard weave. These are "double" shawls, in which the pattern and color are reversed on the opposite side. I have in my collection several of these types of beautiful shawls.

The Kashmiri (Indian) hand made shawls often have mis-matching seams of all the individual pieces sewn together. This can be seen on the back side of the shawl and these seams cause a "lumpiness" when laid out flat on a table. This is a sign of poor quality workmanship. A shawl with matched seams that lies flat on a table is a shawl of the highest quality. Most of these shawls were signed by the artists who designed and made them. They were not mass produced and it took years to make only one; consequently, these types of shawls run extremely high in price for perfect or near mint condition examples.

Another type of paisley shawl is called a "Faux." These shawls are made to simulate a Kashmiri shawl. They are loomed utilizing a heavier

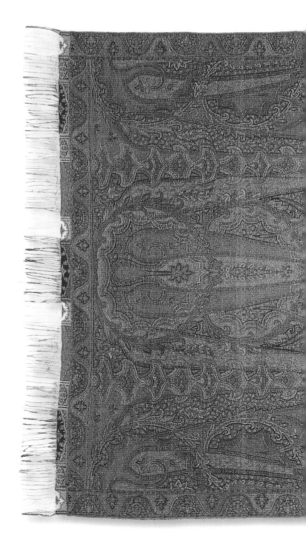

gauge wool and have beautiful intricate designs. Most of these type of shawls came from Ireland and are again, very beautiful, utilizing the Indian motifs. Some have an embroidered signature, generally within the center field; I have found that the signature is not always the designer of the shawl, but rather the emblem/logo of the loom factory that manufactured it. Some of these shawls have a hand made Kashmiri border around the four sides. The border was added to the shawl after the completion of the loomed shawl.

Rolled or block print shawls, usually on silk, are another type of paisley shawl. These shawls are made using a block design inked onto silk or a very fine wool and silk blend material. They are made in various lengths and the designs are as intriguing as those of the woven shawls. These shawls have a gorgeous array of vibrant colors in the overall design. Today, modern shawls are made using a material called pashmina, which is even softer than cashmere and comes in a variety of colors.

Dutch shawls are more recent, from about the early 1920s. They are smaller in size, are of a jacquard weave, and usually have fringe on all four sides. The colors are both vivid and muted on these shawls and the colors are reversed on the opposite side. I am fortunate to have a very rare round shawl of this type in my collection.

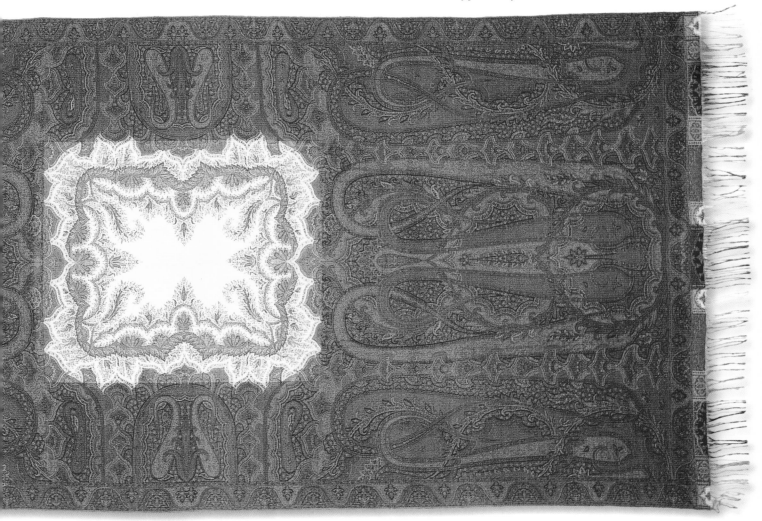

A Brief History of Paisley Shawls

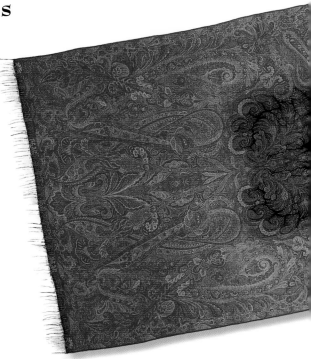

Blanche Beal Lowe, in a 1956 article published in *The Spinning Wheel* magazine, traced the history of paisley shawls in a capsule; the colorful story she describes forms the basis for this chapter. According to Lowe, the story began in the Vale of Kashmir, a province located in the northwest corner of India. Lowe views the history of these wonderful shawls as a fascinating mystery tale:

> Woven into your grandmother's Paisley shawl is a "who-dunit" story as rich in color and complex in design as the shawl itself. Who did it? How? When? Where? and Why? Answers to those questions tell a story that increases appreciation whether it be sentimental or esthetic, pecuniary or technical.

The term "paisley" suggests Scotland, but the story did not begin in Scotland as many people believe. Rather, as Lowe notes in her article, it began in Kashmir India. There, the Brahman Code of Manu was set into place centuries before Christ for the people of Kashmir and all of India. According to this code, sons must follow fathers in all aspects of art, including weaving—learning the long-practiced skills and secrets of generations long past.

Art-loving Moslems ruled India for over three hundred years (1526-1857), and during this time they encouraged all forms of artistic expression. Lowe writes:

> Like the ruling nobles of Florence, the great Mogul Emperor Akbar (1556-1605) kept a "stable" of craftsmen, and required his minister to record their accomplishments in the "Institutes of Akbar." Here, for example, is classified by date, value, color and weight, every shawl made in the palace. For Akbar delighted in shawls.
>
> But the best of the Emperor's weavers couldn't match the shawls from the, as yet, unconquered province Kashmir. The Kashmiris, explained Akbar's overseers, had a monopoly on the

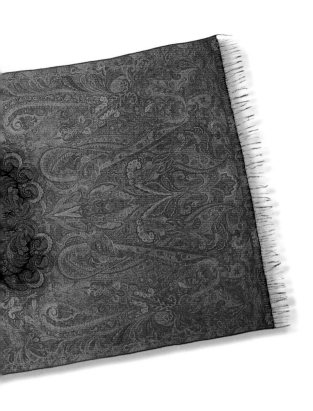

imported fleece of the Tibetan shawl goat which made a fabric softer than sheep. And their unique needle-and-weaving process permitted richer decoration. The water in Kashmir, people said, explained the more vibrant colors their dyers achieved. And who could match Kashmiri skill with hand loom and needle?

In 1586, Akbar took over the trade of loomed shawls in Kashmir, where reportedly 200,000 shawls a year were being produced. In the sixteenth and seventeenth centuries, the Eastern and Western empires met during the European expansion of political domination and trade—caught up in this mix, notes Lowe, were paisley shawls … and Grandmother.

Once western women were exposed to the beauty of these shawls, the demand for them grew. In 1774, Warren Hastings, from Britain, admired Kashmiri shawls and encouraged the demand by ordering several for his wife. Soon, other officials from Britain were doing the same. The ladies displayed their colorful wraps, which "dazzled the eyes of envious home folks." At this time, the East India Co. began importing them, and by 1777 shawls imported from Kashmir had become the fashion rage in England. Later, France discovered the soft woolen shawls for their elegant French ladies. As Lowe describes it,

> Madame, who had abandoned her cloak, wished not to be described as "well-dressed"; she must now be "well-draped." Many eager French ladies were thus "draped" in gifts of Indian and Persian shawls sent home by officers of Napoleon's army in Egypt (1798-1801).

In 1810, Napoleon gave the empress Marie Louise a very rich allowance for her shawls. Clipper ships returning from the Orient carried costly gifts of Kashmiri or Indian shawls and this vogue of indispensable shawls soon spread across Europe—and to the New World as well.

Driven by the forces of fashion, the luxury trade of Eastern shawls headed west around the turn of the nineteenth century. The price of a Kashmir shawl was prohibitive, however, for all but the ladies of wealth. None of these ladies could own only one.

To satisfy the millions of women who were thus deprived of a Kashmir shawl, the demand on textile manufacturers was to develop affordable facsimiles, so these women too, could be "shawled." This, as Lowe described, was not so easily accomplished:

> [S]uccessful imitation of Kashmir shawls, even by experienced textile manufactures, was more easily called for then

done. For example, a single kashmir might embody several techniques. Some were a combination of weaving and embroidery. Others were patchwork of loom-woven patterned or plain pieces sewn together, with flourishes of embroidery to hide the tiny seams and frequent irregularities … Still others, the rarest and finest, were made in one piece on the hand loom.

Imitation of the hand loomed Kashmir was studied. The weaving of a handmade Kashmir did not carry the cross-wise thread, or weft, to the full width of the cloth. Rather, the technique used was "twill-tapestry," which involved weaving the weft back and forth around the warp threads only where each color was needed to form the pattern. Each turn of the weft was interlocked with a different colored thread of the adjacent motif, or of the background color. The interlocking wefts created a ridge around each design.

A quicker process was developed called "shuttle" weaving. In this method, the weft thread was carried across the full width of the cloth, allowing the weft to appear only on the side of the pattern. The long floating threads on the underside of the cloth were usually shorn off

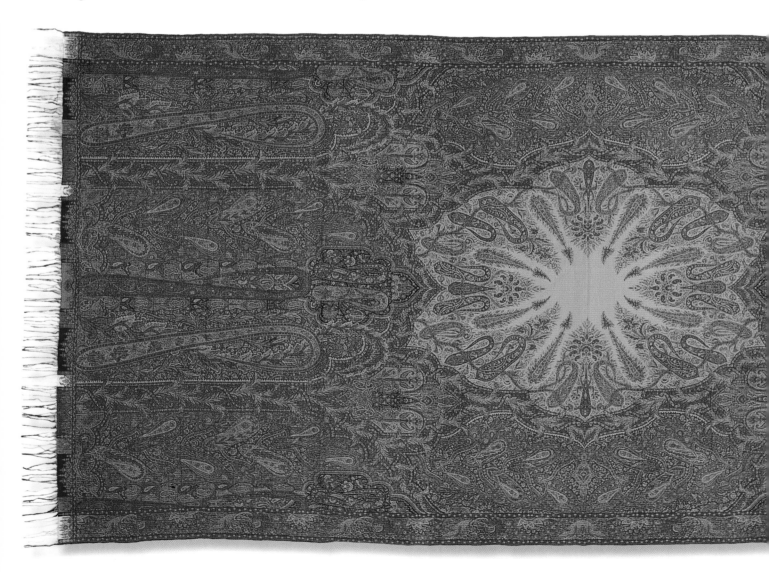

during the final process. The design side of a shuttle-woven imitation very closely resembled the Kashmir shawl. The reverse side of each shawl, however, revealed the origin.

Another consideration was that in order to mass produce these Kashmir imitations, a material compatible to the Tibetan goat fleece had to be available. The Kashmirs had over sixty-five colors and their designs were extremely complex. The typical Kashmir designs were called "cone" or "pine" by the West. Lowe states that some feel this oval design with a curled-over head was an art form derived from Persian floral ornament. Others, however,

> …insist that the design, common to the ancient religions of Persia, Egypt, and Palestine, had mystic significance. The Oriental was a mystic, they say, who gave symbolic expression to the Ideas that governed his life. Because the palm tree was his chief Source of Life, he logically chose the fruit or "cone" of the male date palm to symbolize fertility, or the communication of life.

> Whatever its origin or ancient significance, some form of the design was for centuries familiar decoration for book-illumination, tiles, carpet, household goods—and the ubiquitous shawl.

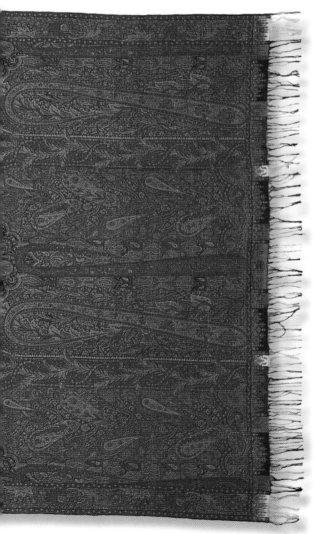

In 1808, the East India Co. sent William Moorcroft to India to assess the trade in shawl goods. He devoted most of his time in Kashmir to obtaining as much information on manufacturing these goods as possible, as well as to acquiring the necessary materials. The Tibetan fleece, however, was clearly monopolized and to that end, he failed in securing a supply.

Around this same time, weavers from Paisley, Scotland traveled to Edinburgh to learn new techniques in shawl weaving. The new techniques spread quickly, as the Paisley people were already well experienced in weaving skills. Around 1812, the Paisley weavers began using a new mechanical device, called a "ten-box lay," in order to copy the intricate patterns and create exact reproductions of the Kashmir shawl. Soon, agents in London were sending tracings of shawl designs to Paisley and in return, imitation Kashmirs were quickly making their way back to London. While the original Kashmir cost approximately one hundred pounds, the newly created copies sold for a mere twelve pounds. The success of the shawl market in London created competition.

By 1818, the town of Paisley, after twelve years in the business, began competing with the true Kashmir in far-off Persia and Turkey. By 1820, the new copies or simulated shawls made it onto the Indian

market. There, the British Moorcroft noted that merchants were unaware at first that the shawls were not Kashmir fabric; when they discovered the shawls were simulated, they credited British designers for their close copies. Lowe states:

> British artists, thus praised, were rarely from Paisley, however. For call it resourcefulness or sharp practice, the Scots pirated the (as yet) unprotected designs of the dominant Norwich (and later French) manufacturers…
>
> Alert to each effort to improve methods of shawl production, Paisley characteristically sized up the superiority of the Jacquard loom on which French weavers were producing their "improved designs." By 1840 the Scots' mastery of this remarkable machine enabled them to reproduce rapidly the most elaborate design of their current models: kashmir imitations made by the French, which even the Kashmiris were copying!
>
> And elaborate those patterns were, for designers of "French kashmirs" had let themselves go with the old-time Kashmir "cone" motif. In skillful combination of (principally) red, blue, green, white, yellow, scarlet, and black, they stretched out that oval form into dream-like curlicues, beautifully proportioned and interlaced.

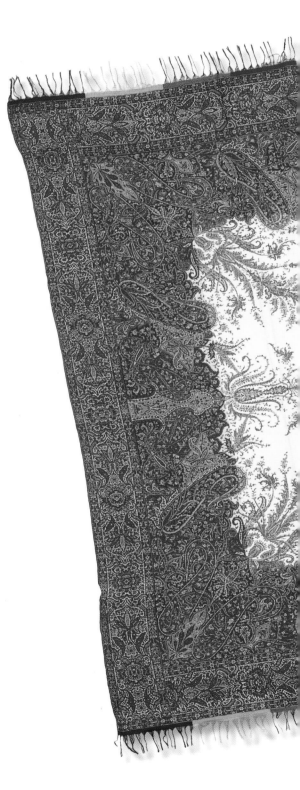

The "Paisley Pattern," which ultimately came to signify the pattern's design rather than its town of origin, was very much prized in the western Victorian world. The shawls were produced with large and small designs, in long and short square shapes, as well as with poorly, or well made, reversible and block printing on silk-cotton.

Some shawl wearers were clearly not happy to see that the design of their expensive Kashmir had been copied and printed on cotton or silk at prices affordable to all in Europe and America. Indeed, concludes Lowe:

> When the Franco-Prussian War (1870-71) choked off the kashmir trade, the long-time garment of the élite was already disappearing from the wardrobes of the wealthy. And not long afterward, the less fashionable "Paisley" slipped from Grandmother's shoulders when she stepped out of her crinolines.
>
> The Paisley shawl is gone, but its pattern persists. In many materials, for varied uses, at prices agreeable to all, manufacturers are still making those colorful curlicues which the eyes lovingly follow in Grandmother's Paisley shawl.

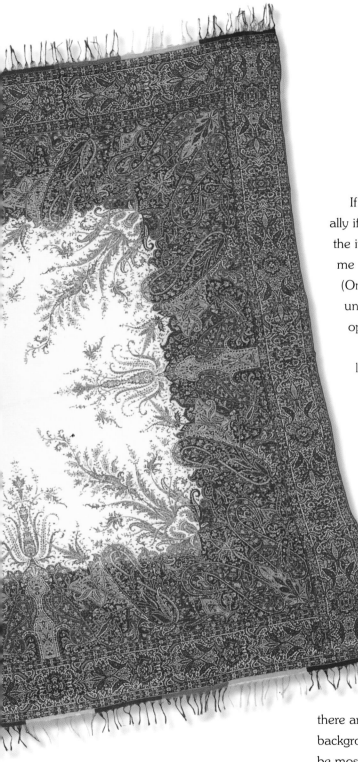

Selecting the Shawl

If I like it, I buy it! The actual ticket price will reflect to me personally if the condition, color, and feel are all within the asking price of the item. Condition is the most important factor to me. This will tell me how well the item has been taken care of throughout the years. (On some shawls, I have seen excellent repairs that were virtually unnoticeable and very hard to find. I would not pass up the opportunity to acquire a shawl I like with an excellent repair.)

In my experience, all woven shawls have what I call small little "nibs," seen when the shawl is held up to the light. This is due to the very tiny breakdown of the wool fiber brought on by age, regardless of how well the shawl has been stored. Certain dyes used cause oxidation and slight discoloration over the years. The reaction of some aniline and vegetable dyes used long ago has, over time, caused a small breakdown of the wool fiber. Moth holes and vermin attacks are part of life relative to wool and wool silk blends, if they are not properly stored over the years.

Next to condition, the second most important factor is color. Black is the color most commonly used in the center field of loomed shawls, while tomato or turkey red is the second most commonly used color. These two center field colors, red and black, are those most frequently seen on shawls found at antique shows and shops. The next three colors most commonly used in the center field are cream, green, and blue. I have found that there are different shades within this grouping of colors—the cream background can be cream or off white, and the green background can be moss green or apple green. The blue background has three distinct shades: dark blue is the rarest shade, while turquoise and light sky blue are the two more commonly used center field shades.

I have seen very rare colors that I am still searching for: lilac, rose, burgundy, mustard/saffron yellow, pumpkin, and brown background center fields. These loomed shawls are magnificent and very rare. In my early

years of collecting, I was, at first, not attracted to the soft, muted color European shawls, mostly from France. I concentrated on black, white, and red center fields with sharp contrasting colors in the overall design. As I expanded my collection, I started to appreciate the soft muted colors of the European shawls, as there were a variety of different color central fields and dramatic designs to search for.

In my assessment of a shawl, the third factor after condition and color is "feel"—including the actual weight of the shawl. A shawl that has been placed into a washing machine and dryer will have undergone a total transformation. The "patina" will be gone and the background color will have bled all over the shawl. It is, in my view, a total loss. Woven shawls *can* be cleaned, if done correctly (see Cleaning and Storage).

The weight of the shawl, referred to above, tells me if the shawl has been cared for and protected over the years, as well as whether silk was used in the wool blend. There are some "loose weave" loomed shawls, which are lighter in weight as they were worn in warm weather. The weave is not a tight weave and these shawls are equally as beautiful as tight weave and silk wool blends. Loose weave type shawls often had very rare center field colors used. Another feature of these shawls is that the horizontal warp threads (width) and the longitudinal weft threads (length) are easily seen. It is the weft threads that result in the finishing ends of the shawl, producing the fringe at both ends of loose weave and tight weave shawls.

In my collecting experience over twelve years, condition, color, and weight, along with complexity of the overall design, are the criteria I use in selecting a shawl; these ultimately start a dialogue as well over the purchase price of the item. Many sellers are, of course, trying to get as much as they can for the item. Often, I will bring to their attention certain facts about the shawl and often, within seconds, will know how well informed the seller actually is. Too often, a seller is trying to get a price as if the shawl were a hand made cashmere shawl rather than a machine made loomed shawl. Ninety percent of the time, I will get the price lowered to a more realistic price. When a seller is firmly headstrong in obtaining too high a price, then there is no sale transaction and one needs to move on! I have, on occasion, left my name and number should the seller reconsider my offer and I have sometimes received a response that generated a purchase of the shawl. I have also been in situations where, knowing that I am looking at something rare enough to be part of my collection, I have spent more than I wish to in order to have this particular shawl or may have had to accept a few apologies, such as an unnoticeable repair, some fringe loss, a small stain, or a small, inconspicuous faded area.

Dating the Shawl

There are many factors that are used to determine an approximate date of shawl manufacture. These include the overall design, type of weave, whether ready made fringe has been added, and whether the shawl has been pieced together in sections. Collectively, it still can be difficult to date the shawl with precision, as many countries copied the techniques throughout the years.

There are two methods I use for dating the shawl, as described in Monique Levi-Strauss's book, *The Cashmere Shawl.* These are the width of the shawl and the height of the harlequin fringe ends called "gates" or blocks. The designs within the blocks complement the overall shawl design and both designs of the shawl and blocks help pinpoint the origin, as does the underside weaving technique. The various color shades of the blocks also signify that the shawl was manufactured using each of those block colors as an individual central color field, while keeping the same overall design pattern.

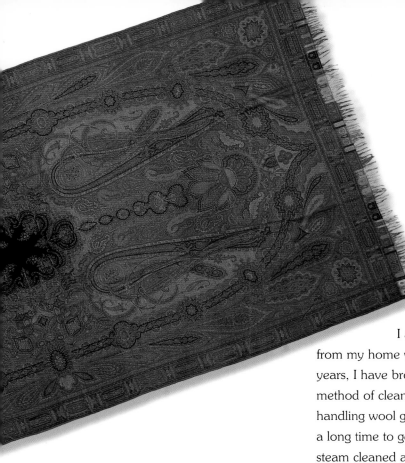

Cleaning and Storage

Cleaning

I am fortunate to know of a dry cleaner two towns away from my home who specializes in cleaning only vintage textiles; over the years, I have brought several shawls to this place for cleaning. Their method of cleaning is totally different from that of a regular dry cleaners handling wool garments. The cleaning is done by hand and it does take a long time to get the item back (about five to six weeks). The shawl is steam cleaned and pressed. The colors are vibrant and the steam pressing leaves a nice sheen on the shawl. The cost averages forty dollars.

Because of the frequency of my visits to the cleaners, the owner told me how to clean a shawl myself.

My method for cleaning a shawl now involves a one hour soak in cold water only. I do not use warm or hot water, as this will cause the colors to run out of the fabric. I use a very mild detergent—Wisk™, yellow top. Wisk is made in several strengths; the yellow cap top is the mildest. I fill up the washing machine tub with cold water, mixing in one capful of the Wisk. I place the shawl into the washing machine and let it soak. After an hour, I gently give the shawl a little agitation by hand, then turn the knob to only spin out the dirty water. Next, I let the tub fill up with more cold rinse water, gently agitate the shawl a second time, and again turn the knob of the machine to spin out the rinse water. I repeat this step again to make sure I get rid of all the soap. It is important not to let the machine go into a wash cycle of any kind, as the blades will do damage to the fragile textile.

After three rinses, I take out the shawl and hang it on an indoor clothes dryer rack to dry out slowly. It takes about four to five hours. Never use a tumble drying machine, as doing so will alter the entire texture of the wool: the shawl undergoes such a transformation, it looks like a fluffy blanket and is a loss!

When the shawl is completely dry, I steam press it. The shawl now

has a nice sheen and the colors are more vivid than when I purchased it.

Not every shawl needs cleaning. A shawl that has a strong odor of naphtha (mothballs) and a "feel" of dirt needs cleaning. This could be a shawl full of eggs that could easily infest other shawls. Naphtha is a very caustic chemical used in mothballs and restrooms. Naphtha left in mothballs over many years in a trunk will cause fiber breakdown at the folds of material, regardless of the blend mix in the material. The naphtha emits a gas and will do damage to fragile textiles during long term storage. To store winter clothing away till the next season, mothballs are fine. This is short term storage. However, I prefer and highly recommend natural cedar for long term storage.

On two occasions, I've brought home a shawl to find a small unwanted moth larva. Yes, it can be picked off, but you have no idea how many more are hiding under the threads on the back of the shawl. A textile dealer friend recommended placing the shawl in a plastic bag, leaving it in the freezer for a couple of days, and then steam pressing the shawl. This will guarantee disposing of any other moth larvae that may be present. I do this routinely now when I purchase a shawl, even before it gets washed, should it need washing and then steam pressing.

Storage

There are many ways to store delicate textiles correctly. My method is to use a trunk in mint condition. I don't use re-done or re-papered trunks. I find very old, clean trunks with the original paper all intact inside and in mint condition. You will generally find such mint trunks in high end antique shops. I then buy tongue and groove cedar wood planks at a home improvements store and cut to size to line the inside bottom of the trunk and the four sides. I cover the bottom cedar planks with acid free paper and lay the first two shawls on top of the paper, with another piece of acid free paper on top of those shawls. I do this for each layer of shawls until the trunk is filled to capacity, allowing for space at the top for the wool fiber to breathe. Each of my trunks hold about forty shawls.

Plastic material from the cleaners should never be used for long term storage. This type of thin plastic emits a gas that will cause breakdown of wool and silk especially. Atmospheric changes will cause the fiber to "sweat" inside the plastic and cause dry rot to set in during long term storage. Plastic blanket storage bags are fine for short term storage or transporting shawls. Blanket bags now come with a mesh to give the stored item some air, but it is still plastic material and I am very reluctant to use any form of plastic to store aged fabric for long term.

My collection today consists of nine trunks with acid free paper in

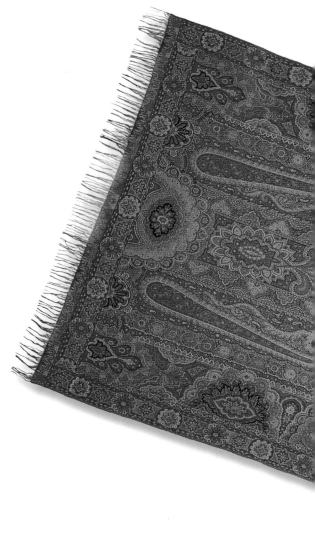

between the layers of shawls. Once a year or so, I take each shawl from the trunk and refold it. Each trunk is numbered so that I can refer to it. All of my shawls are photographed, and on the back of the picture notations are made about the shawl, including the trunk number it is stored in.

Another method of storage I've tried is to roll the shawls in acid free paper and place them side by side in the trunk, then add additional rows until the trunk is filled to capacity. However, I experienced difficulty trying to find a particular shawl to display using this method. With the previous method, I can very quickly find the shawl I am looking for.

I know of two individuals with very large paisley shawl collections who pay the expense of storing them at a climate controlled facility, all hanging in wooden garment closets. Personally, I do not like the inaccessibility or monthly expense involved with this method of storage. Unlike me, neither of these individuals displays a shawl as I do, from time to time, on my dining room table.

Another alternative to a trunk would be a large, heavy, cardboard container, such as those used by moving and storage facilities. Seal the flaps with masking tape on the underside of the container, lay the tongue and groove cedar wood on the inside bottom of the container, and lay a sheet of acid free paper over the wood. Then lay the first shawl onto the paper, place another sheet of acid free paper over the shawl, and continue on till the container is filled to capacity. Seal the top flaps with masking tape in order to maintain tightness and keep un-wanted "crawlies" from entering the container.

Paisley Shawl Illustrations

The following illustrations consist of shawls from Europe, primarily France, England, and Scotland, and shawls from India. All places mass produced these machine made shawls.

The measurements provided for each shawl are from selvage to selvage and from gate end to opposite gate end. Fringe is excluded from the measurements.

The weight of the shawl is consistent with the type of twill weave, tight or loose, as well as the blend mix of the threads. Heavier shawls are made with a tight weave, in which no weft or warp threads can be seen. The loose weave shawls are lighter in weight and the weft and warp threads are easily seen. The wool/silk blends are the heaviest of shawls. Some of the light weight shawls are not only a loose weave, they were woven with the softest cashmere wool—making this type of shawl exceptionally soft as well as light in weight.

The prices listed have a market range, with several factors determining the actual price one would consider paying—outside of "getting a good deal" from an individualized transaction. The three main factors influencing price are:

1. *Condition.* Value will be reduced for shawls that have stains or fading, are dirty (easily detected by smell), or if small tiny holes are seen when held up to the light. Fringe loss, weak or missing selvage, and repairs are also to be considered. The weight of the shawl may also influence price; in general, the heavier wool/silk blend shawls will have a higher value, though this is not always the case.

2. *Design.* Intricate, complex designs of pine cones, botehs, floral, and sprigs throughout the entire shawl will increase the value. Pictorial designs are the rarest and most expensive of any shawl. Shawls having a huge solid center field with very little woven design work are a bit less valuable. Such shawls were more appropriately worn as shoulder mantles, as only the woven edge and border ends of the shawl are seen. The large solid color center fields are earlier (c. 1830); over the years, the central color field became smaller in size, giving way to the more desirable, intricately woven loomed shawls.

3. *Color.* Any bleeding of colors running into each other is a sure sign the shawl has seen hot water, which alters the shawl greatly and significantly decreases the value. The colors themselves, whether softly muted or vibrant, do not affect the price. Both types have their own characteristics and are worthy of the asking price.

Long Shawls

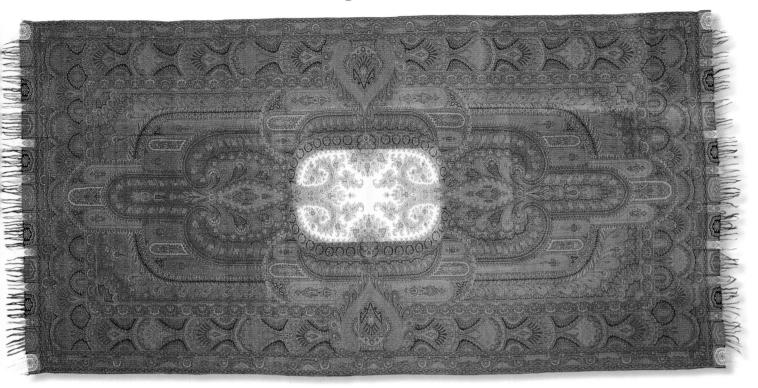

1. 60.5" x 116". Tight weave...wool. Very intricate design. See long shawl #202 for the identical design with a black color center field. France, c. 1860. $600-900

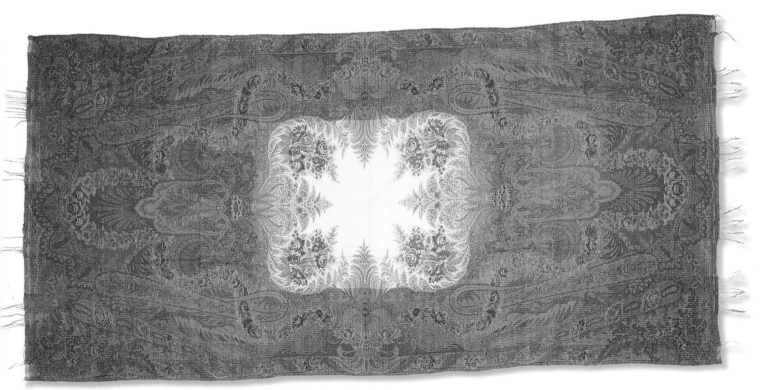

2. 60" x 120". Loose weave...wool. Rare floral, garland, and paisley design. This was my first acquisition of this rare shawl. A larger one with different weave is shown as long shawl #32. France, c. 1850. $1000-1200

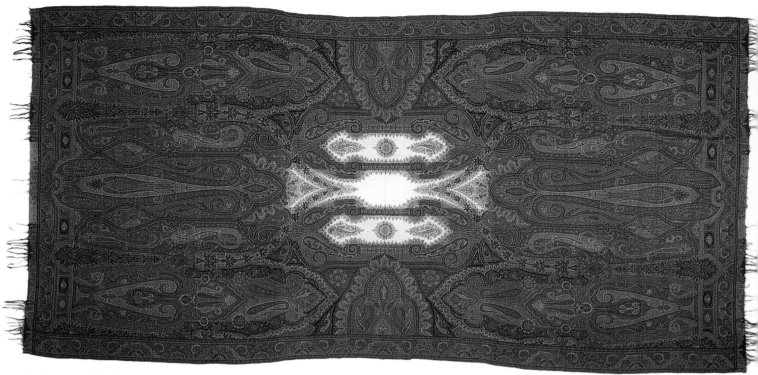

3. 62.5" x 124". Tight weave...wool. Rare tri-field center. France, c. 1850. $900-1200

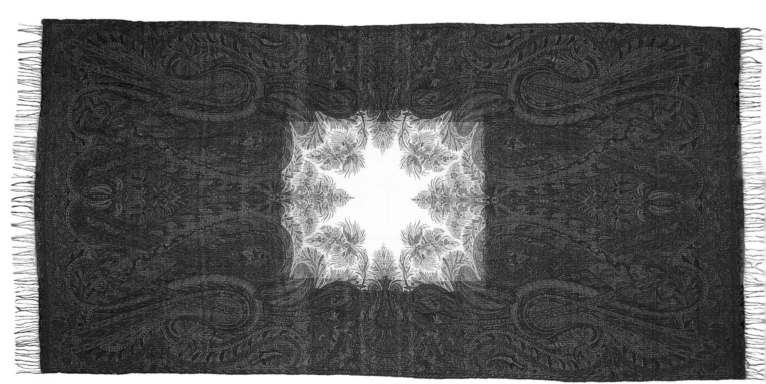

4. 64" x 123". Loose weave...wool. France, c. 1850. $700-1000

5. 62" x 126". Tight weave...wool/silk blend. Norwich design. England, c. 1850. $500-750

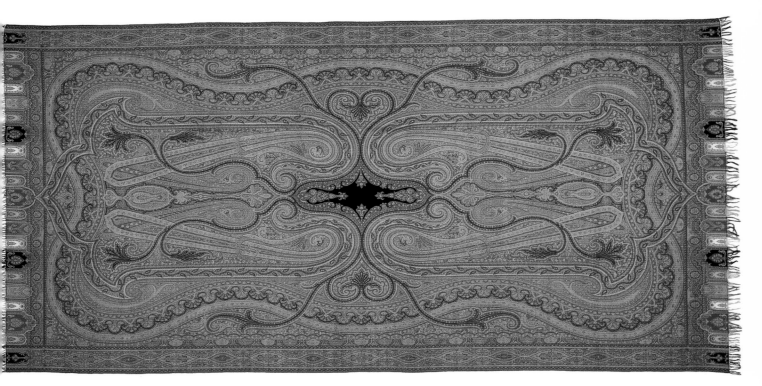

6. 63" x 130". Tight weave...wool/silk blend. India, c. 1870. $600-900

23

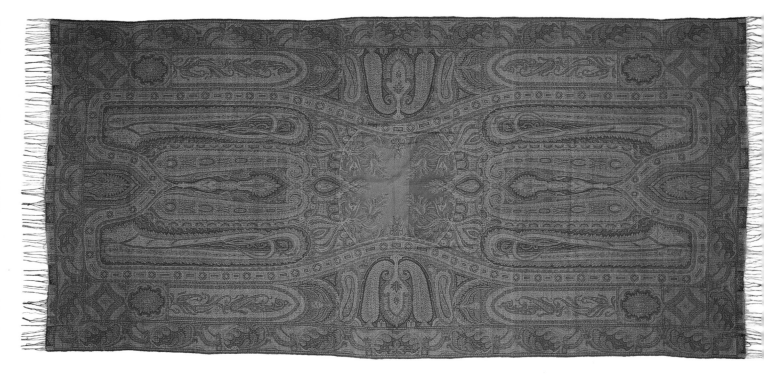

7. 60.5" x 124". Loose weave...wool. France, c. 1855. $500-800

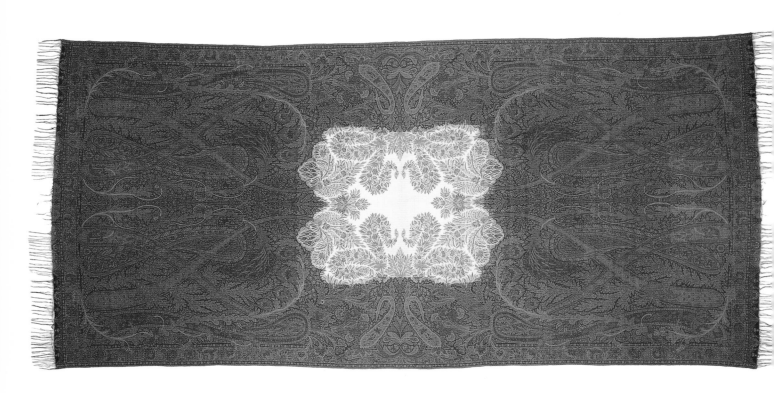

8. 59" x 128". Tight weave...wool. France, c. 1850. $500-800

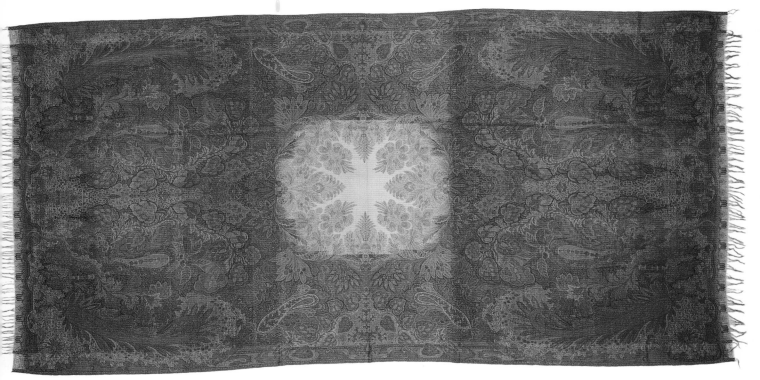

9. 65.5" x 125". Tight weave...wool. Very muted colors. England, c. 1850. $700-1000

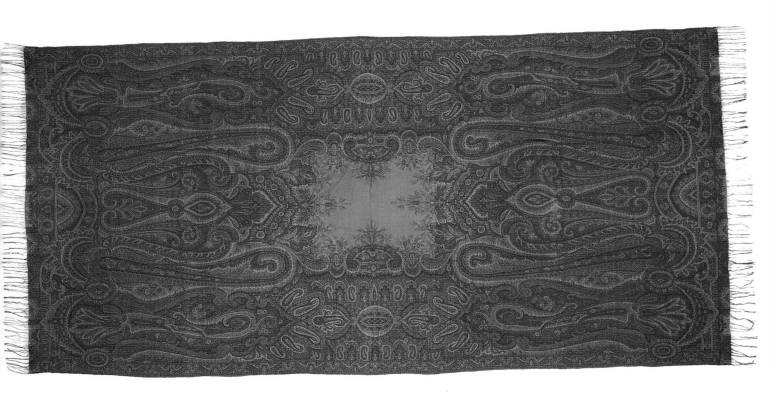

10. 60.5" x 124". Loose weave...wool. Blue accents around green center field. England, c. 1855. $500-800

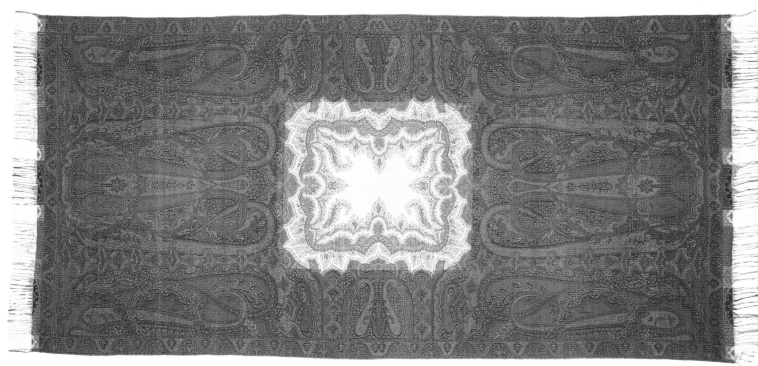

11. 62" x 124". Loose weave...wool. France, c. 1855. $500-800

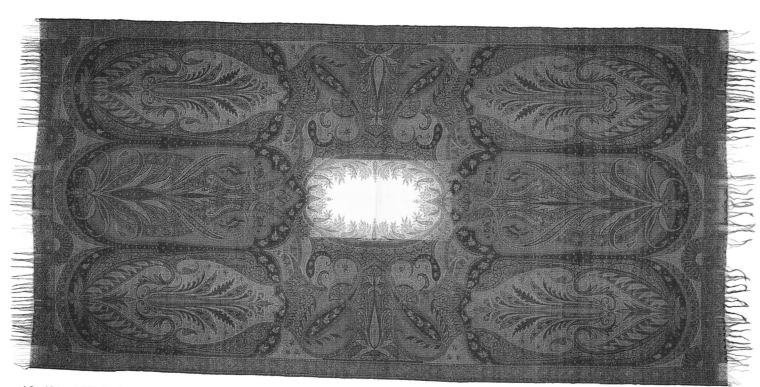

12. 63" x 120". Tight weave...wool. Unusual design overall. France, c. 1850. $500-800

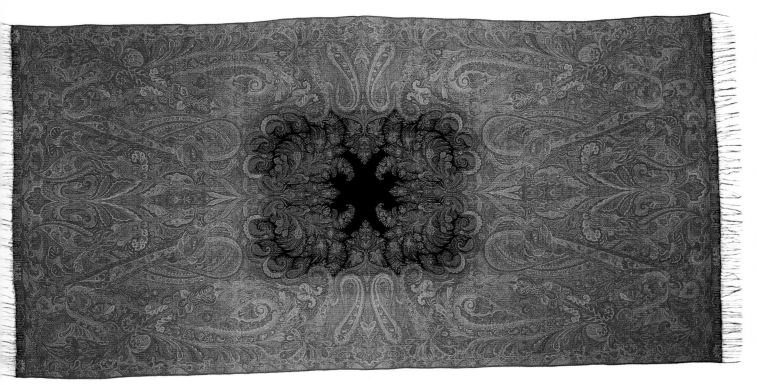

13. 62" x 126". Tight weave...wool. England, c. 1835. $900-1200

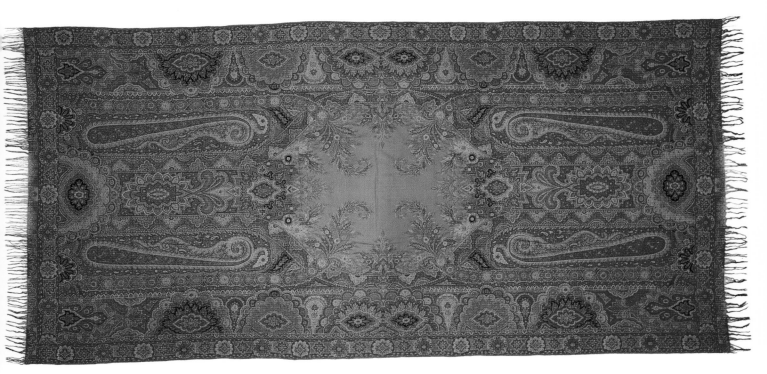

14. 59" x 124". Tight weave...wool. France, c. 1855. $900-1200

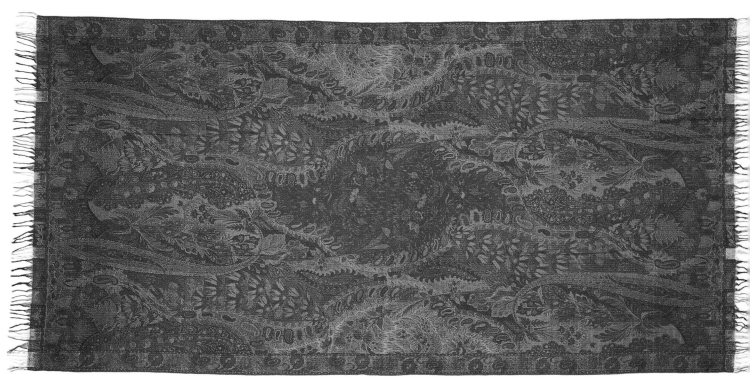

15. 66" x 126". Tight weave...wool. Tri-color, red, blue, and green
fields. France, c. 1860. $1200-1500

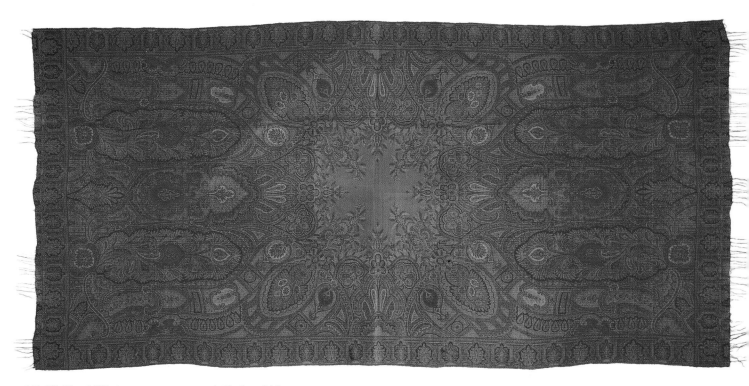

16. 58.5" x 122". Loose weave...wool. Red and blue accents
around green center field. France, c. 1865. $500-750

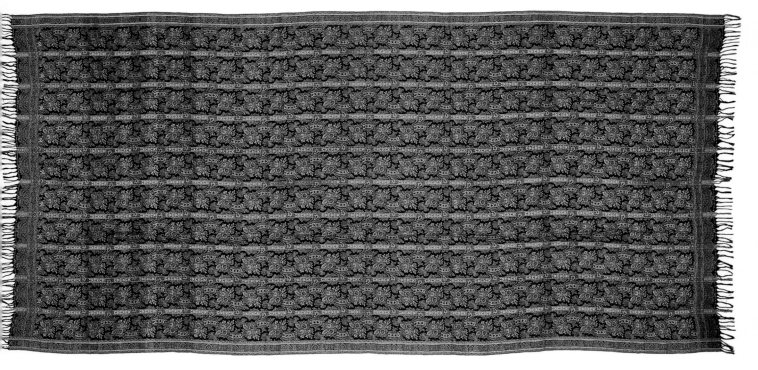

17. 61.5" x 122". Tight weave of heavy silk and wool blend. Roman stripe of floral and paisley embroidery on black background. England, c. 1870. $800-1000

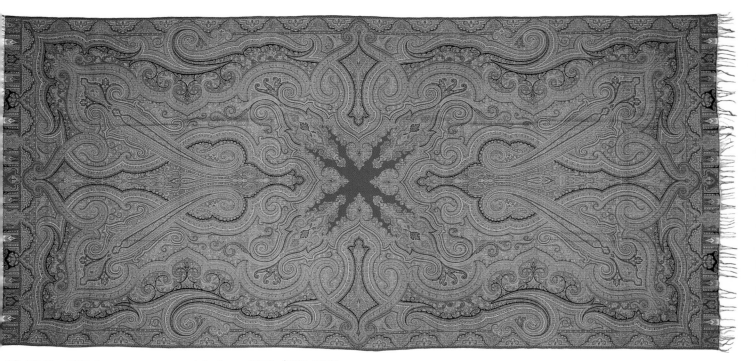

18. 59.5" x 128". Loose weave...wool. India, c. 1865. $800-1000

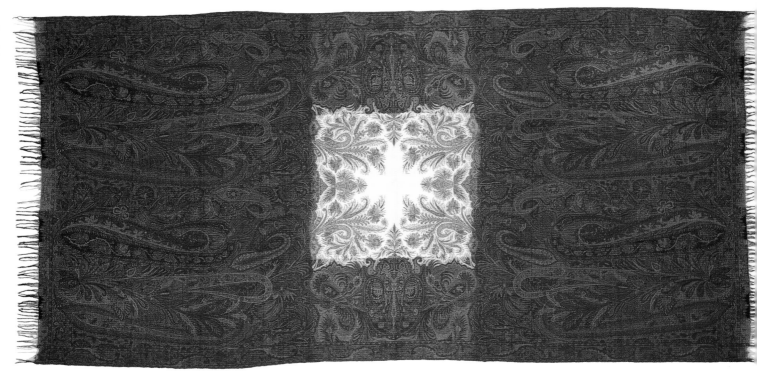

19. 63.5" x 126". Tight weave...wool. France, c. 1850. $900-1200

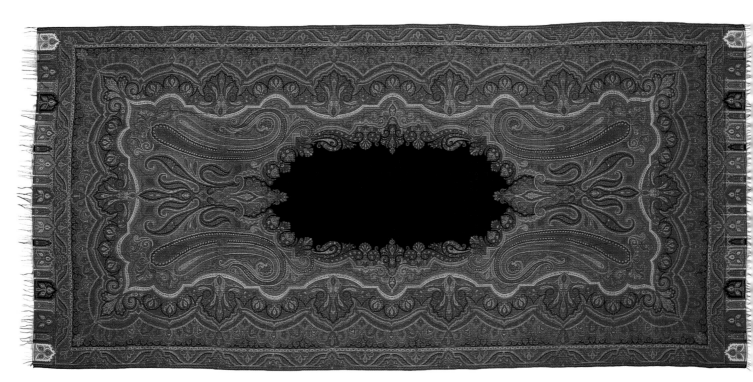

20. 61.5" x 127". Loose weave...wool with white accent. India, c. 1870. $800-1000

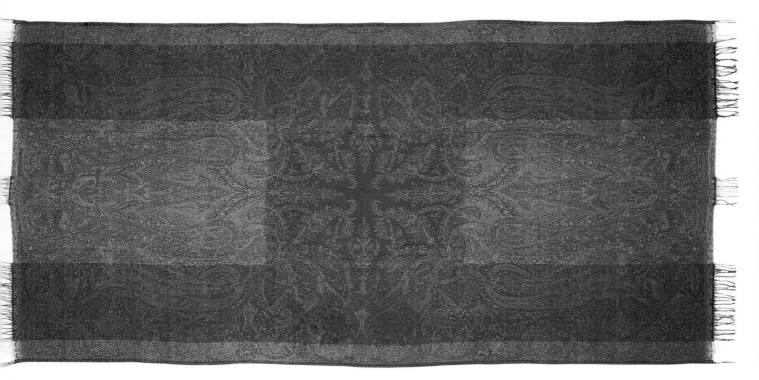

21. 60.5" x 124". Loose weave...wool. France, c. 1835. $700-1000

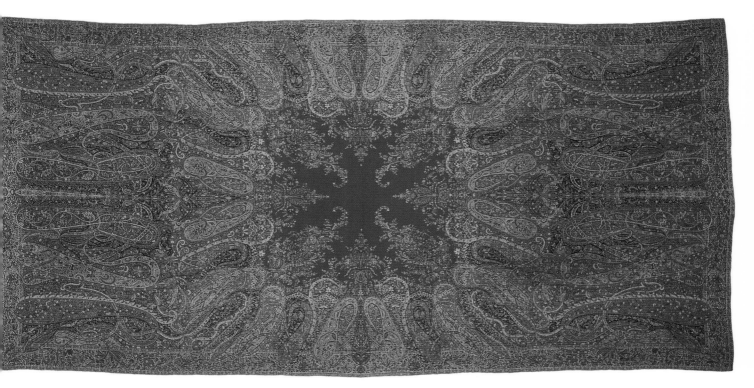

22. 62" x 126". Loose weave...wool. Fringe removed, harlequin
ends in place. France, c. 1835. $700-1000

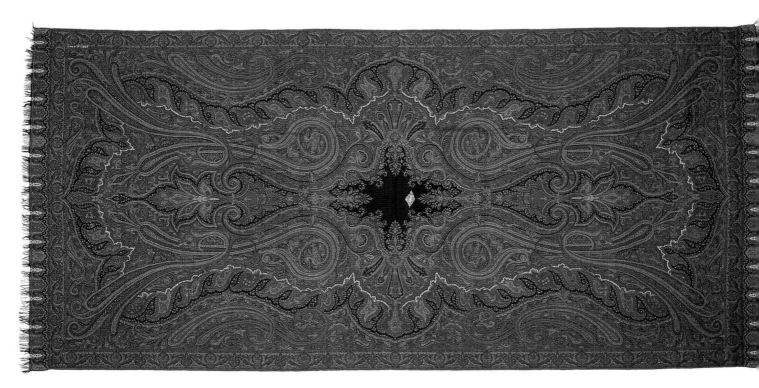

23. 60.5" x 127". Tight weave...wool/silk blend with white accents. Signed and numbered on side border. Embroidered emblem in center field. Attached 5" vertical border gate with fringe. India, c. 1860. $1200-1500

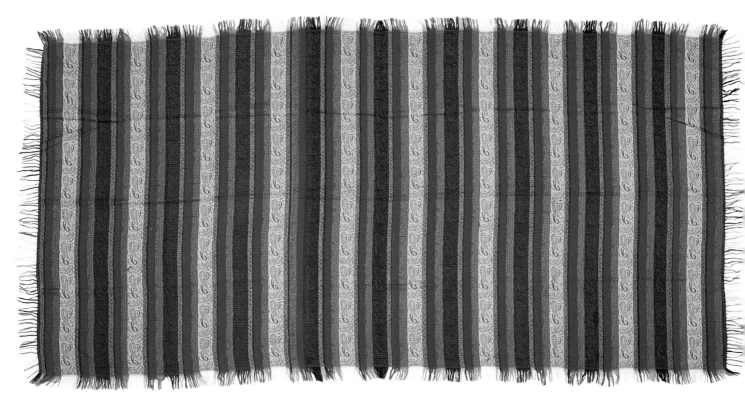

24. 62" x 116". Tight weave...silk and wool blend. Horizontal Roman stripe. Added knotted fringe on vertical ends. Scotland, c. 1890. $300-500

25. 62" x 114". Loose weave...wool. France, c. 1850. $500-800

26. 63.5" x 129". Loose weave...wool. France, c. 1855. $700-1000

27. 66" x 126". Tight weave...wool. France, c. 1835. $700-1000

28. 61" x 128". Tight weave...silk and wool blend. Roman stripe.
France, c. 1870. $800-1000

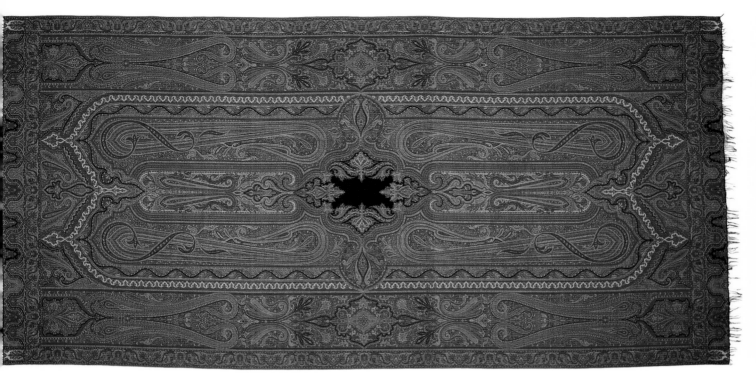

29. 62" x 133". Tight weave...wool with white accents. England, c. 1870. $800-1000

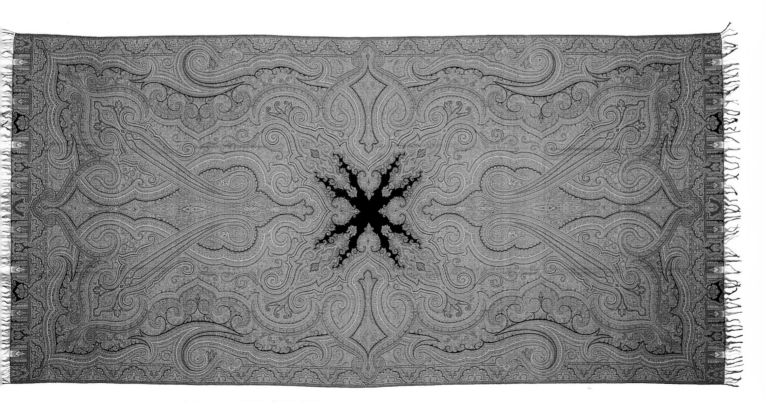

30. 62" x 127". Tight weave...wool. India, c. 1870. $700-900

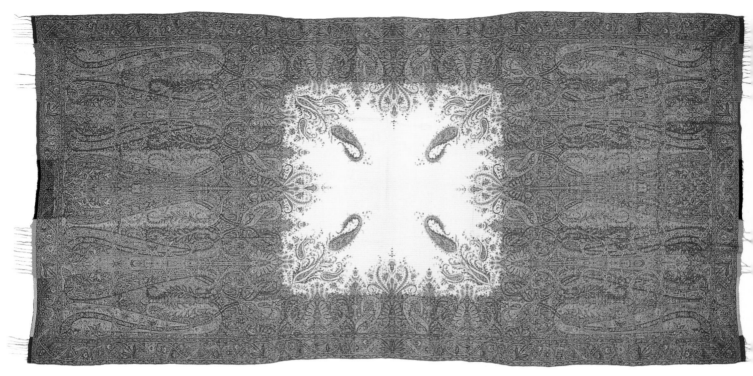

31. 60.5" x 123". Loose weave...wool. France, c. 1830. $800-1000

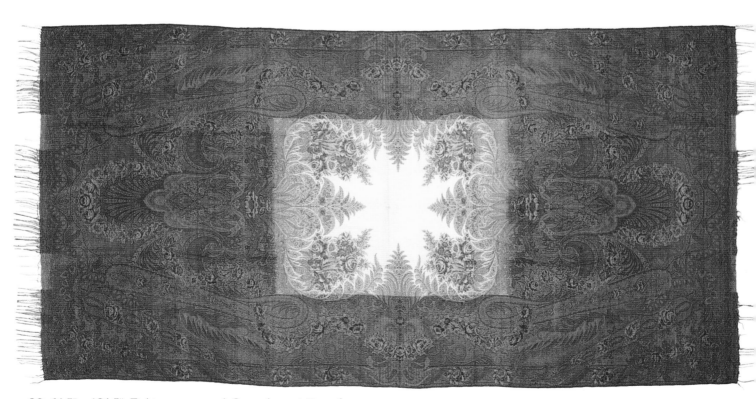

32. 64.5" x 124.5". Tight weave...wool. Second acquisition of a rare roses, garland, and paisley design. It has larger dimensions and different weave than long shawl #2. France, c. 1850. $1000-1200

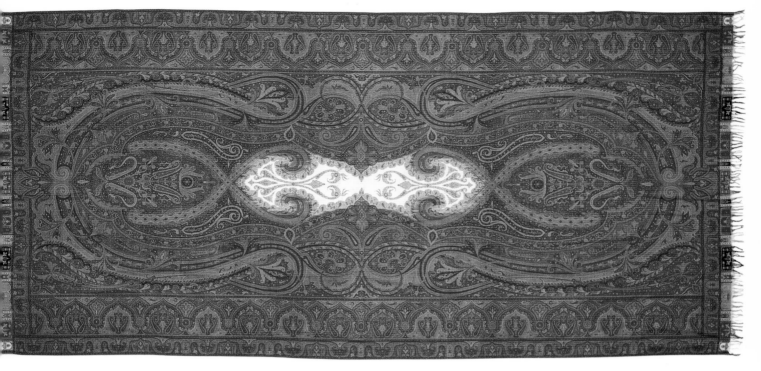

33. 63.5" x 134". Tight weave...wool/silk blend. Unusual center field with complex design. France, c. 1865. $900-1200

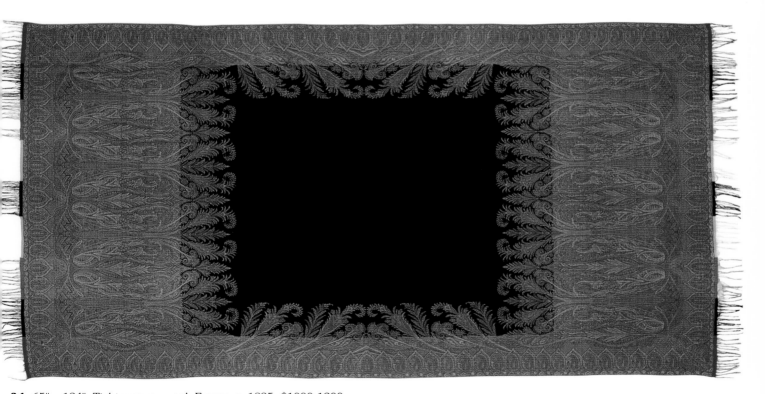

34. 65" x 124". Tight weave...wool. France, c. 1835. $1000-1200

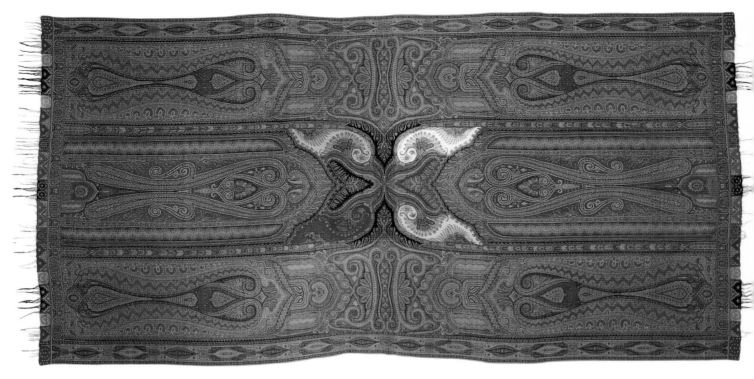

35. 60" x 122". Tight weave...wool. Unusual center, Four season shawl. France, c. 1870. $1200-1500

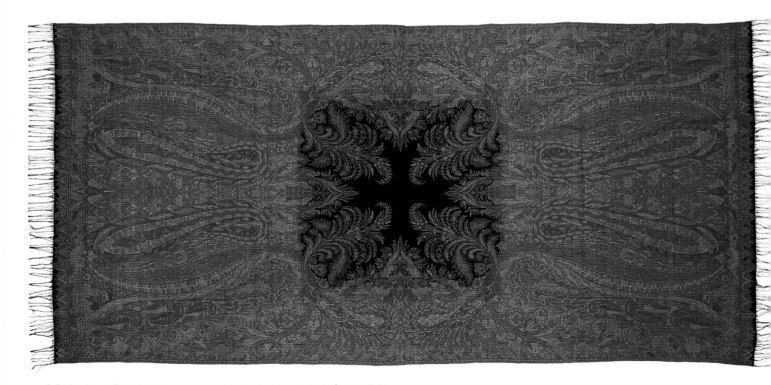

36. 61.5" x 131". Tight weave...wool. England, c. 1855. $700-1000

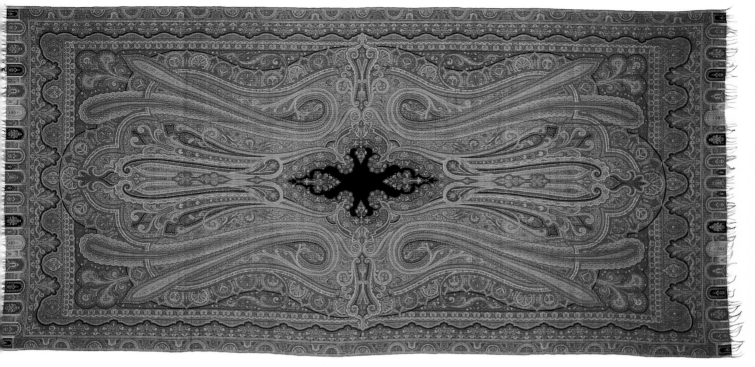

37. 62" x 130". Tight weave...wool. India, c. 1865. $600-900

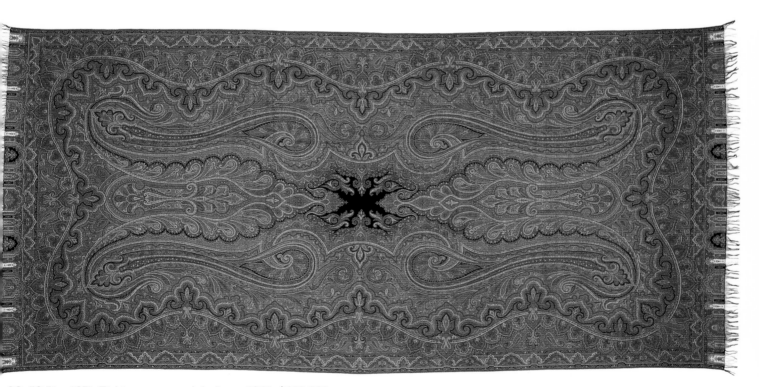

38. 59.5" x 127". Tight weave...wool. India, c. 1865. $600-900

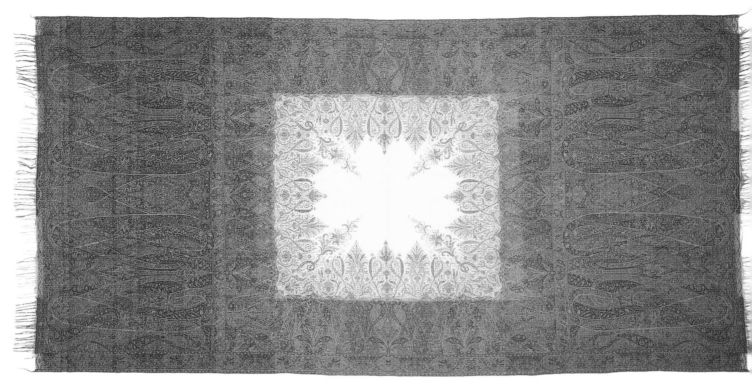

39. 65" x 134". Tight weave...wool. France. Rare brown color with cream center. Museum quality piece, c. 1850. $1200-1500

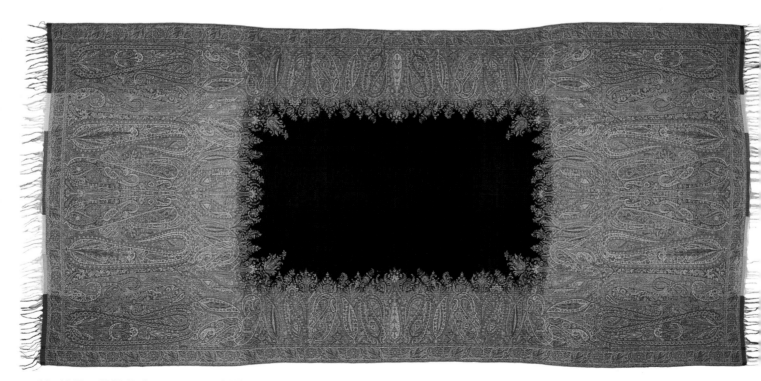

40. 62.5" x 132". Tight weave...wool. Vibrant colors. France, c. 1845. $500-800

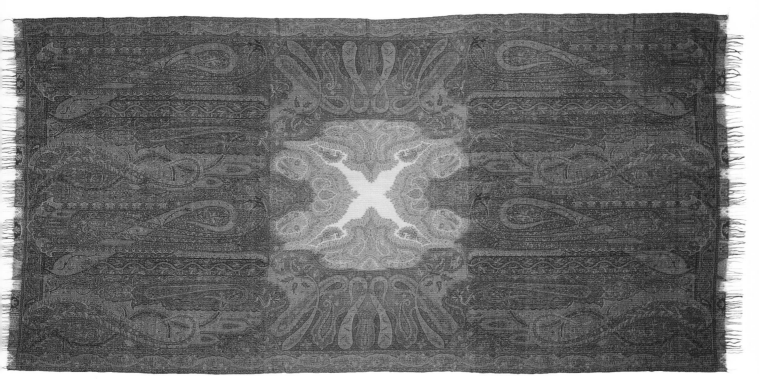

41. 65.5" x 125". Loose weave...wool. France, c. 1860. $500-800

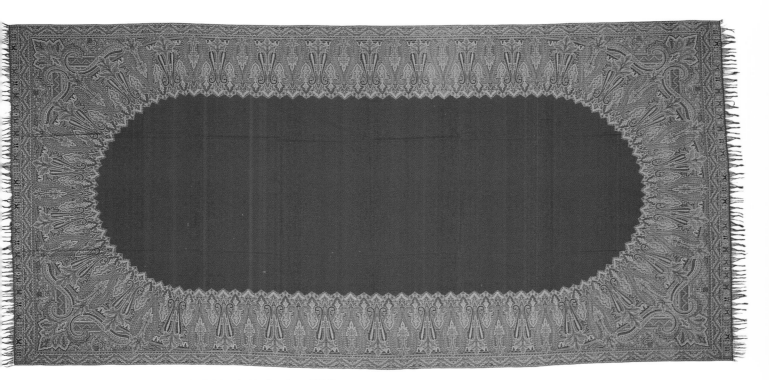

42. 61" x 126". Tight weave...wool/silk blend. England, c. 1870.
$500-800

41

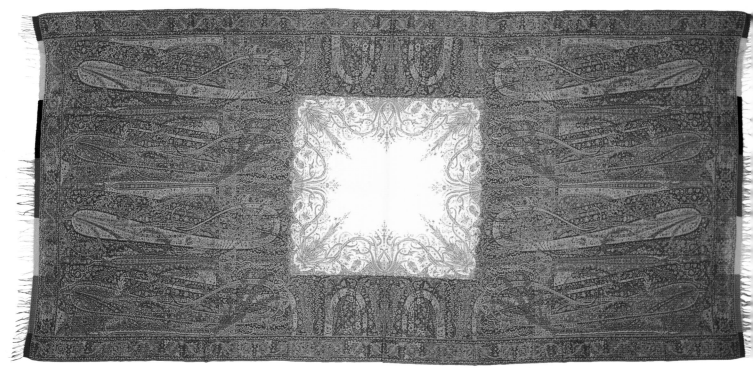

43. 64.5" x 128". Tight weave...wool. Vibrant colors. France, c. 1850. $700-1000

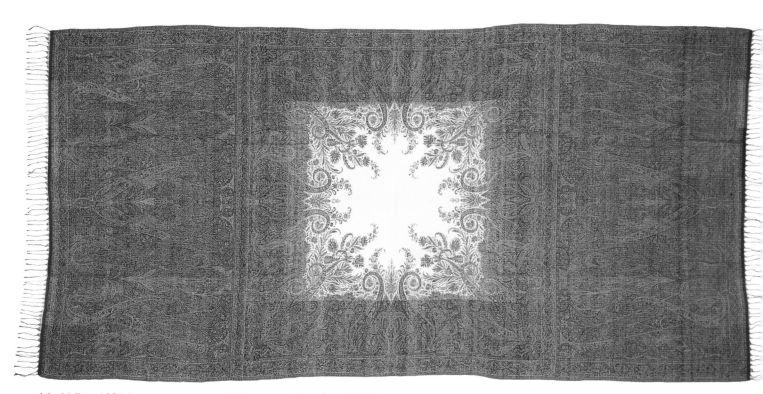

44. 64.5" x 133". Loose weave...wool. France, c. 1845. $700-1000

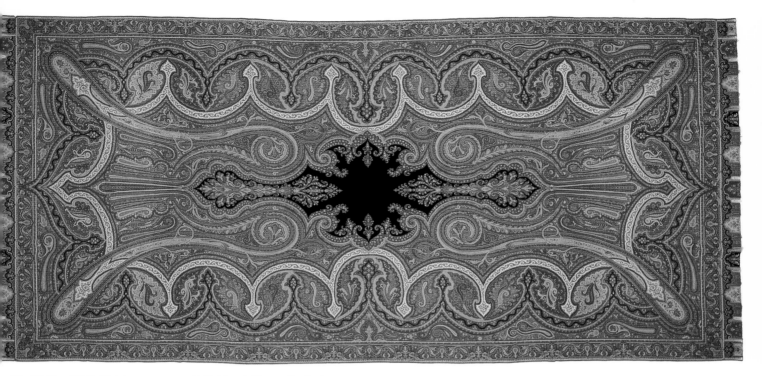

45. 62.5" x 132". Tight weave...wool/silk blend. Dramatic design, white accents. Museum quality piece. Fringe removed. India, c. 1845. $900-1200

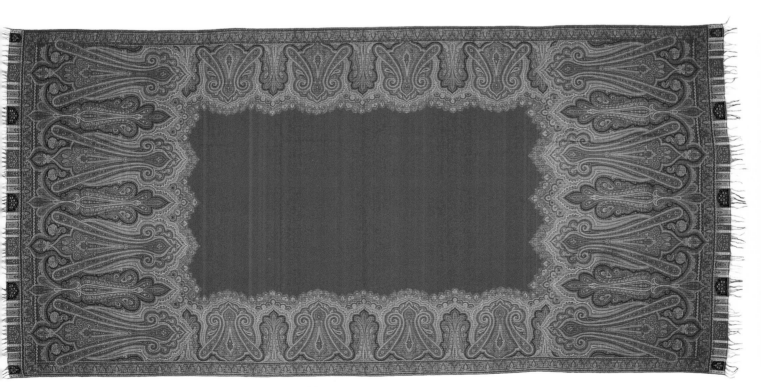

46. 62.5" x 128". Tight weave...wool/silk blend. India, c. 1865. $500-800

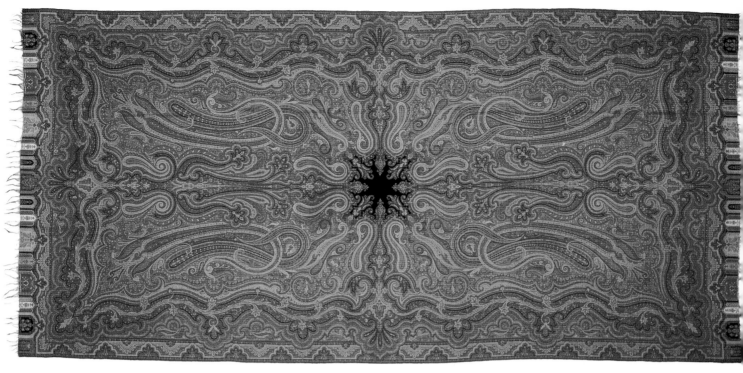

47. 63" x 127". Tight weave...wool. India, c. 1870. $500-800

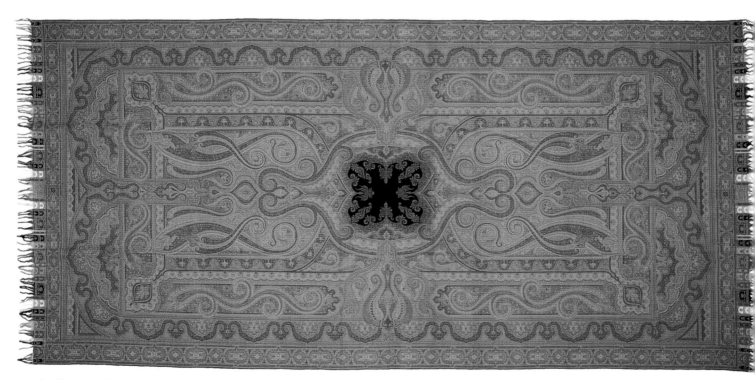

48. 62.5" x 135". Tight weave...wool/silk blend. Signed in center field. India, c. 1865. $500-800

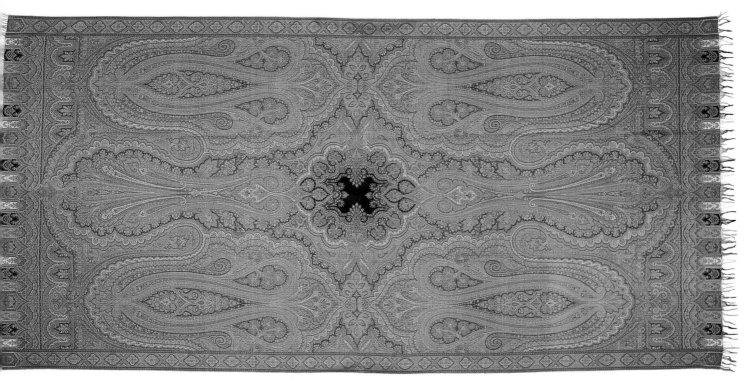

49. 64" x 134". Tight weave...wool/silk blend with white accents.
India, c. 1870. $500-800

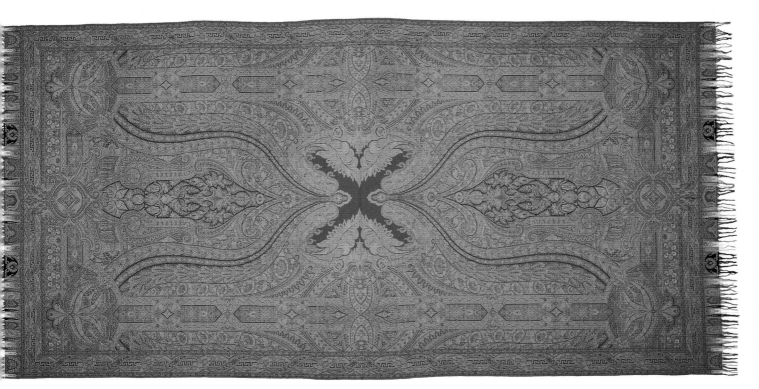

50. 65" x 134". Tight weave...wool/silk blend. India, c. 1865.
$500-800

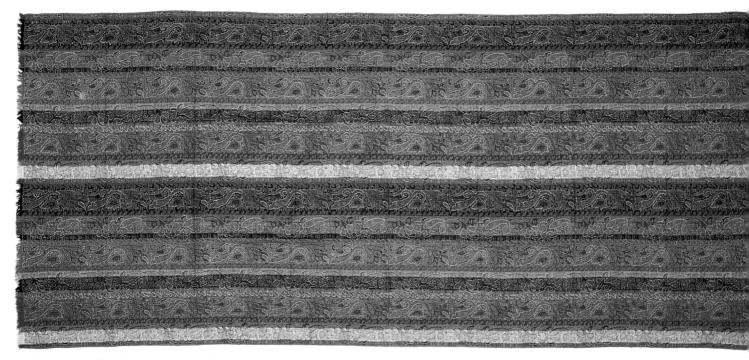

51. 55.5" x 122". Heavy woven wool. Roman stripe, signed.
Scotland, c. 1870. $600-900

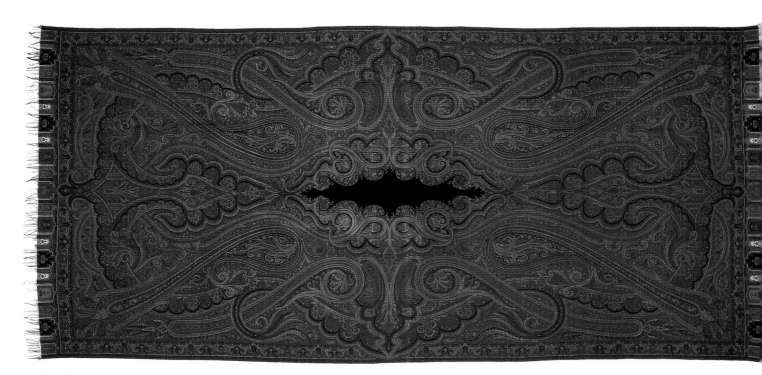

52. 60" x 130". Tight weave...wool/silk blend. India, c. 1870.
$500-800

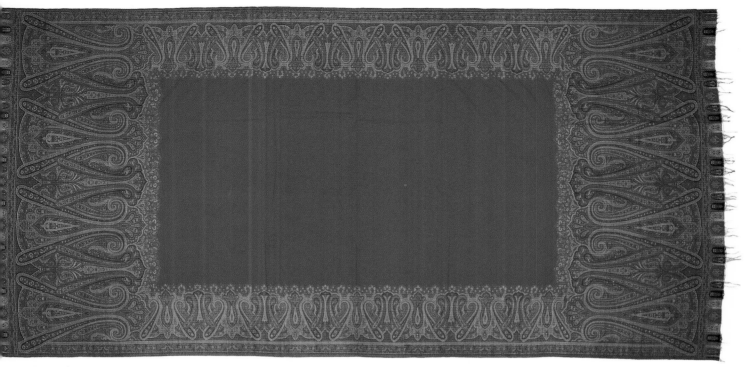

53. 62.5" x 126". Loose weave...wool. (Of note, this shawl was my grandmother's and she was from County Cork, Ireland.) India, c. 1870. $400-700

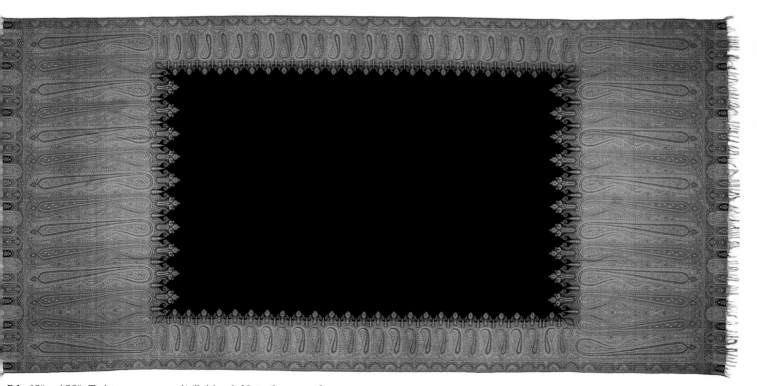

54. 63" x 129". Tight weave...wool/silk blend. Note the row of botehs at each end; only one pair face each other. England, c. 1865. $500-800

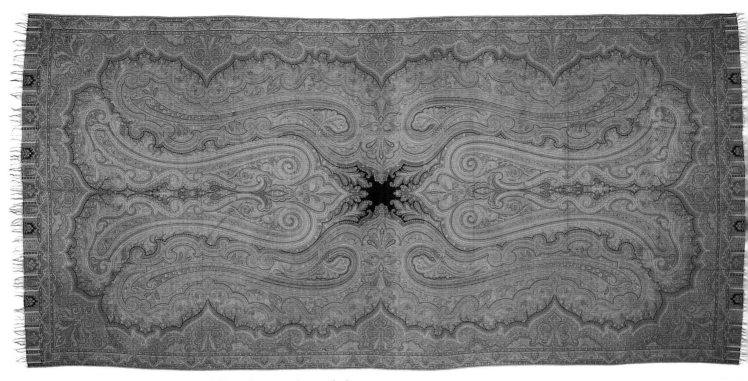

55. 63.5" x 127". Tight weave...wool. Very dramatic design. India, c. 1870. $500-800

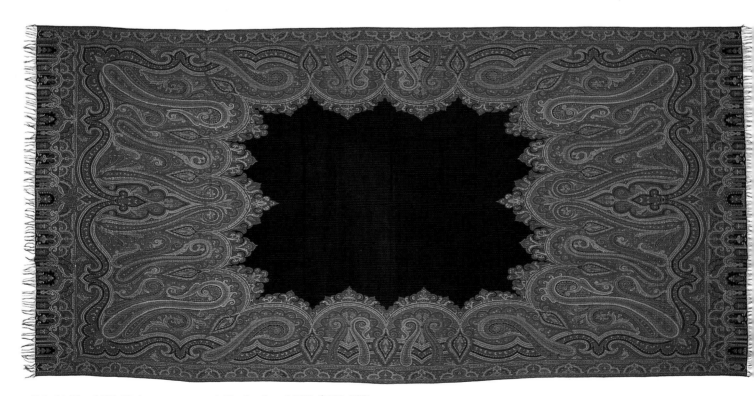

56. 61.5" x 122". Tight weave...wool. England, c. 1860. $400-700

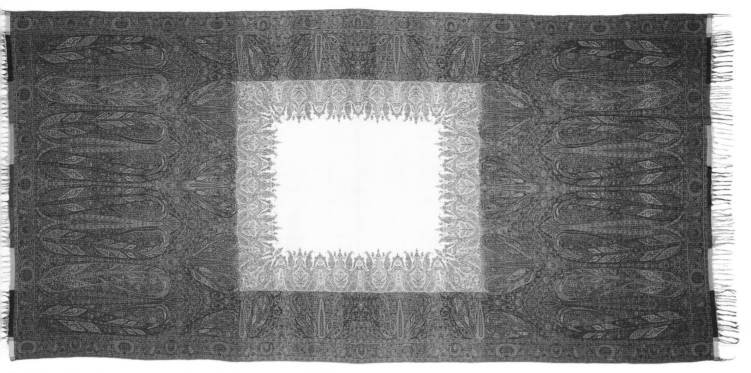

57. 62.5" x 134". Tight weave...wool. England, c. 1850. $600-900

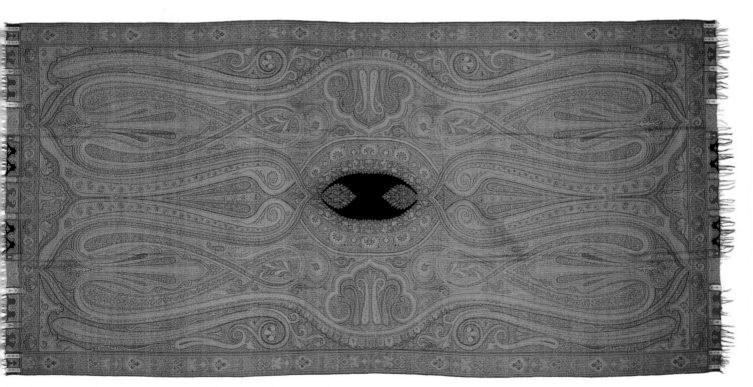

58. 63.5" x 128". Loose weave...wool. India, c. 1865. $500-800

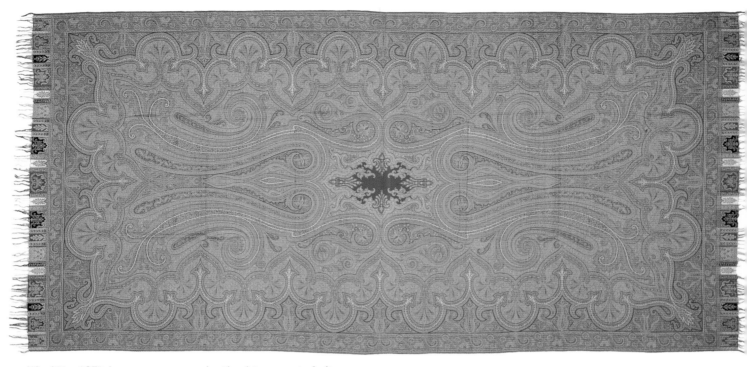

59. 61" x 125". Loose weave...wool with white accents. India, c. 1865. $500-800

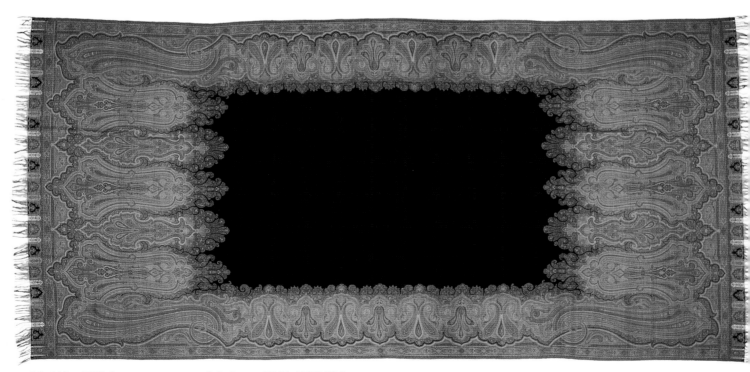

60. 61" x 127". Loose weave...wool. India, c. 1865. $500-800

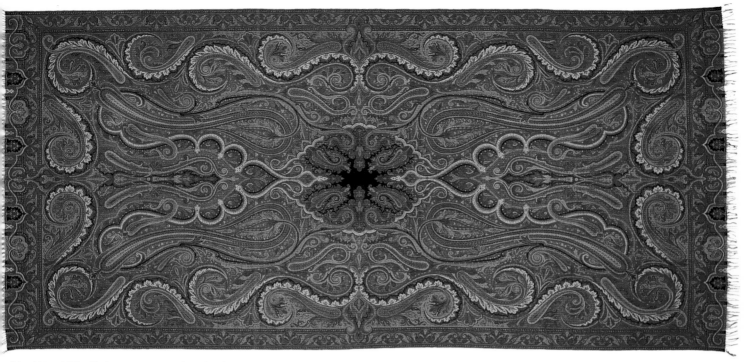

61. 61" x 127". Tight weave...wool with white accents. India, c. 1870. $600-900

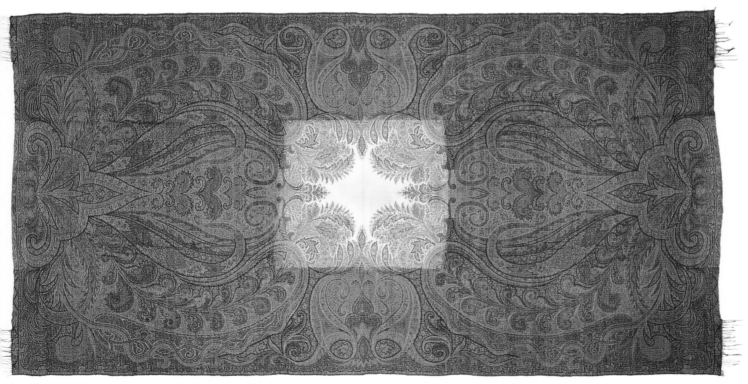

62. 62.5" x 110". Loose weave...cashmere wool with dramatic boteh design. Most fringe removed. See long shawl #168 for same design with blue center field. England, c. 1850. $500-800

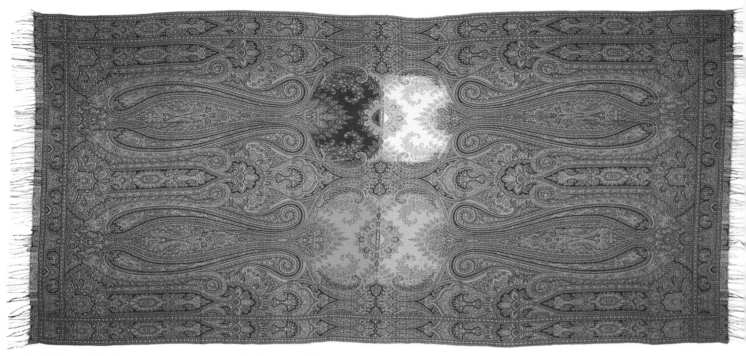

63. 59.5" x 124". Tight weave...wool. Attached gates and fringe.
Four season shawl. England, c. 1855. $600-900

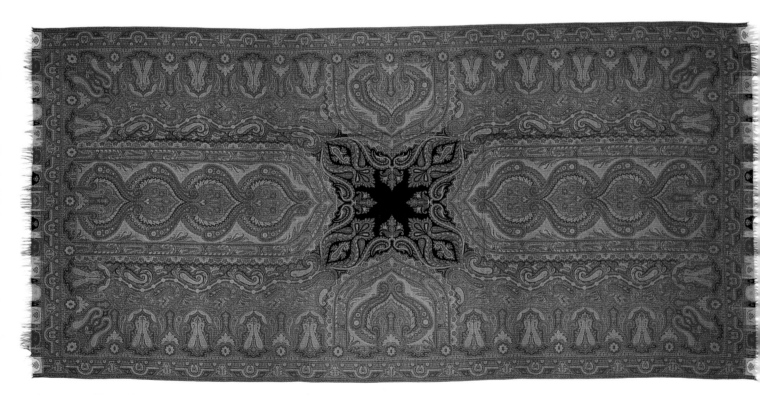

64. 65" x 132". Tight weave...wool. France, c. 1865. $600-900

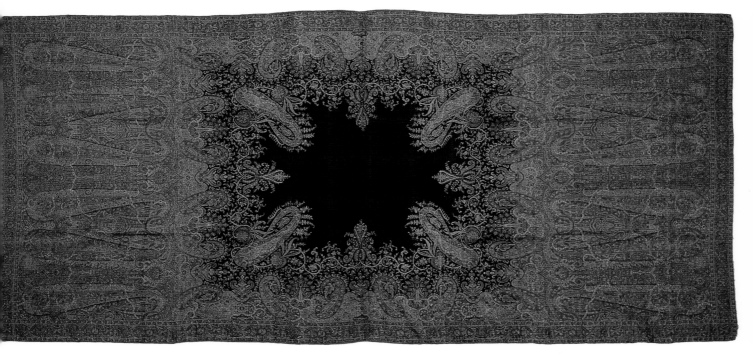

65. 56" x 124". Tight weave...wool. Fringe removed. Very heavy
weight. India, c. 1850. $500-800

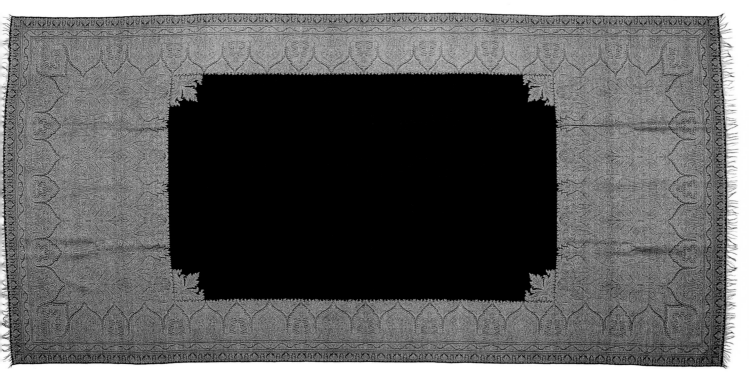

66. 62.5" x 126". Tight weave...cashmere wool/silk blend. England,
c. 1855. $400-700

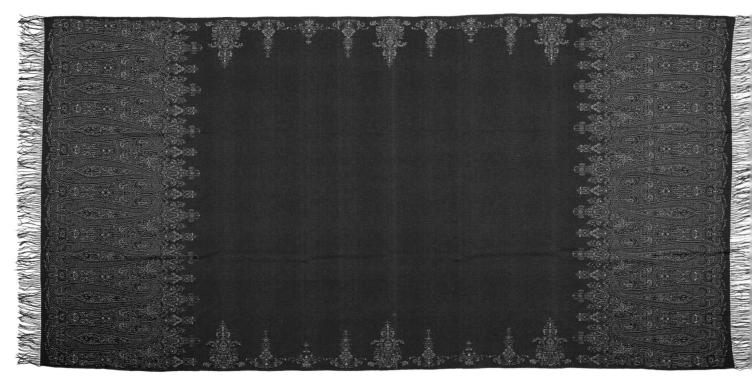

67. 60" x 114". Tight weave...cashmere wool/silk blend. 4" knotted fringe added later, after completion of the loomed process. England, c. 1870. $500-700

68. 62" x 125". Loose weave...wool. Four season shawl. England, c. 1855. $900-1200

54

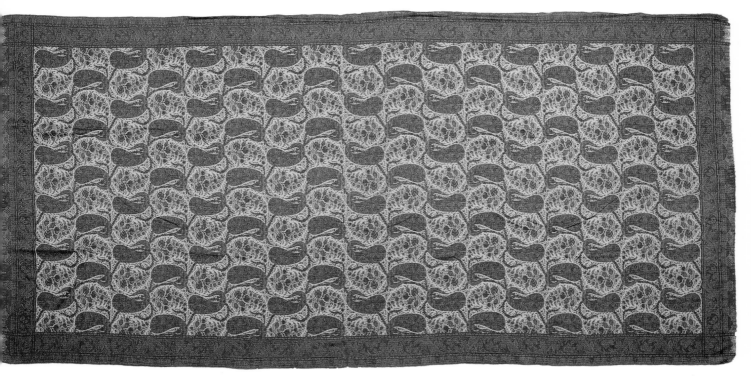

69. 63.5" x 128". Tight weave...wool. Continuous run of floral and boteh design on cream background with border on all four sides. England, c. 1855. $700-1000

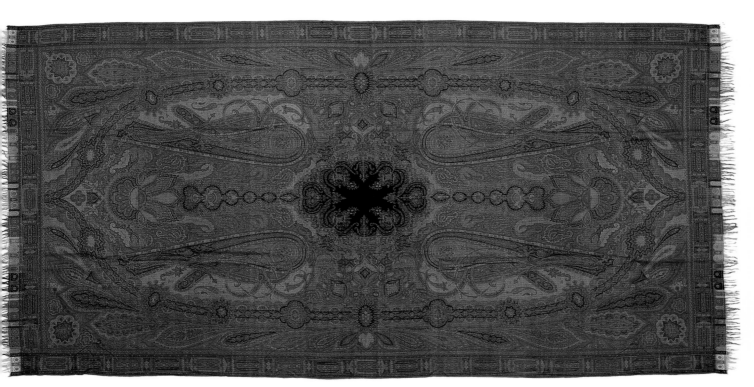

70. 64.5" x 130". Tight weave...wool. France, c. 1865. $900-1200

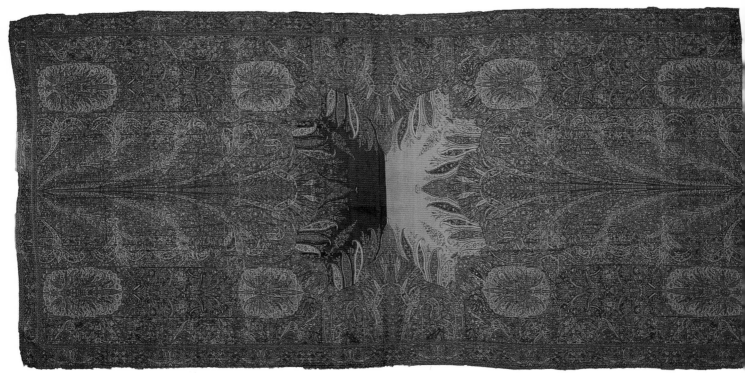

71. 63" x 121". Tight weave...wool. Rare yellow/green center field.
Fringe has been removed. France, c. 1850. $600-900

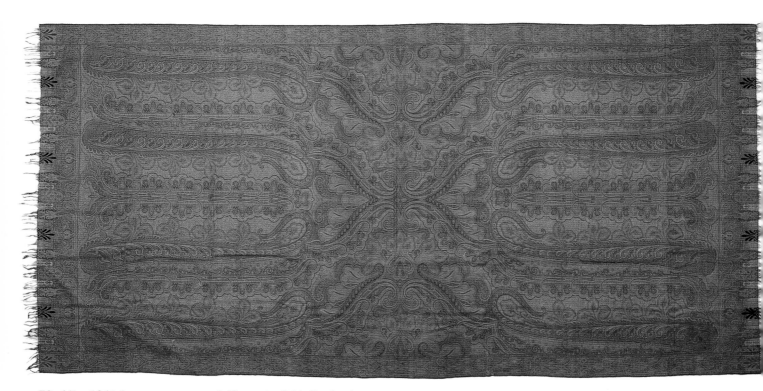

72. 64" x 134". Loose weave...wool. No center field. Scotland, c.
1880. $400-700

56

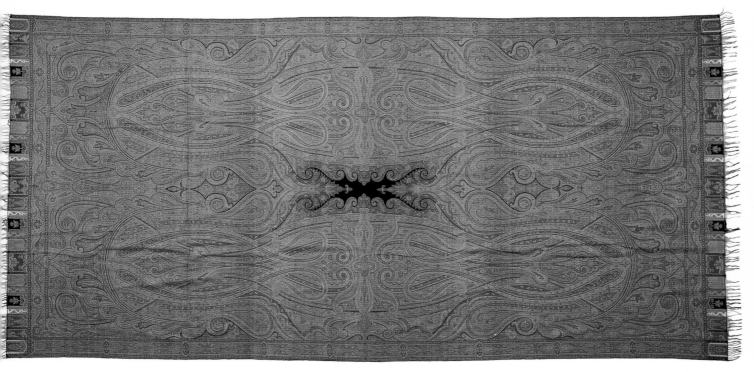

73. 62" x 129". Loose weave...wool. India, c. 1870. $500-800

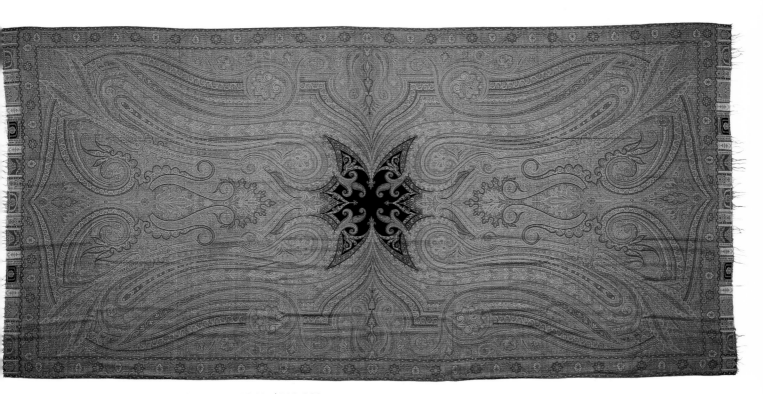

74. 66" x 136". Tight weave...wool. India, c. 1860. $500-800

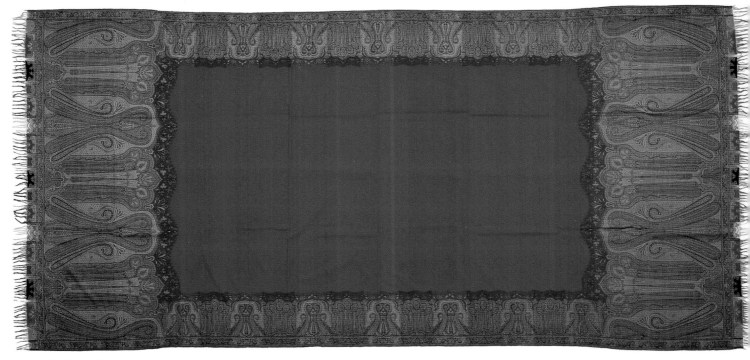

75. 60.5" x 128". Tight weave...wool. France, c. 1855. $400-600

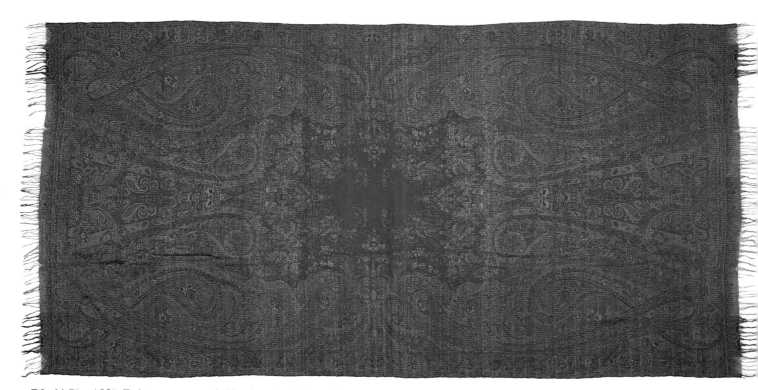

76. 64.5" x 122". Tight weave...wool. Floral and paisley pattern.
France, c. 1850. $800-1000

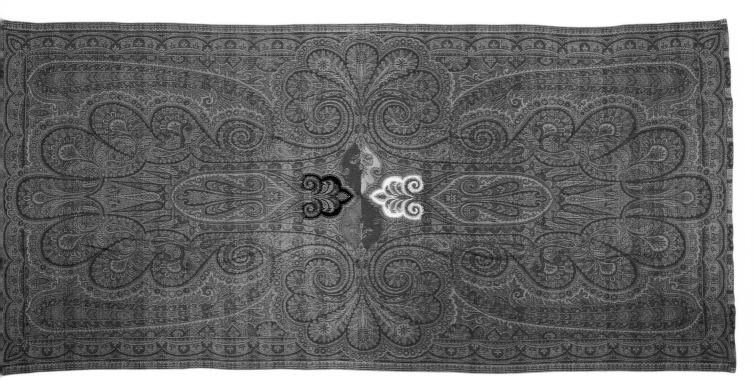

77. 56.5" x 121". Loose weave...cashmere wool. Four season shawl. France, c. 1850. $600-900

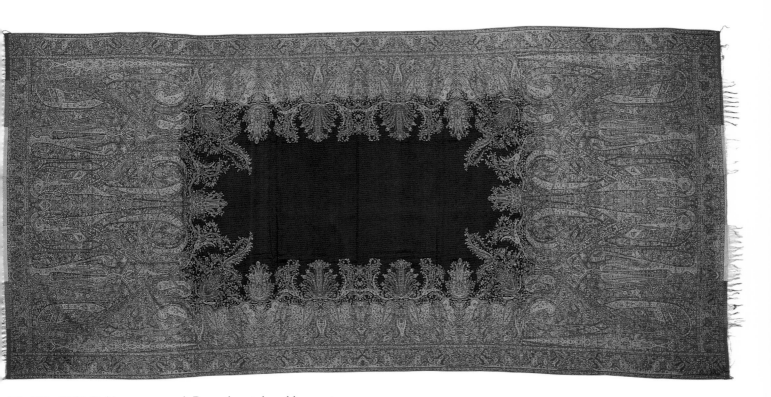

78. 65" x 134". Tight weave...wool. Rare vibrant deep blue center field. France, c. 1840. $800-1000

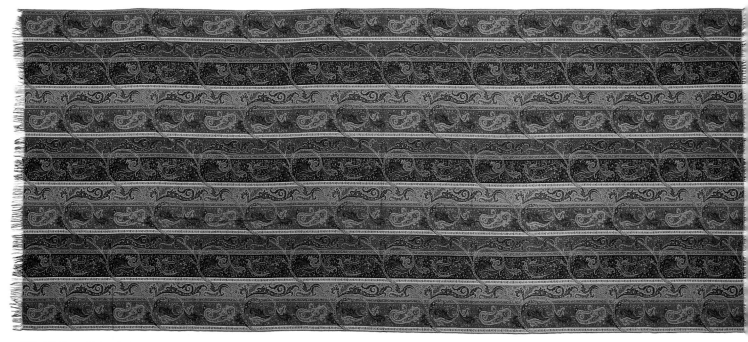

79. 57.5" x 125". Tight weave...wool/silk blend. Roman stripe.
Scotland, c. 1885. $600-900

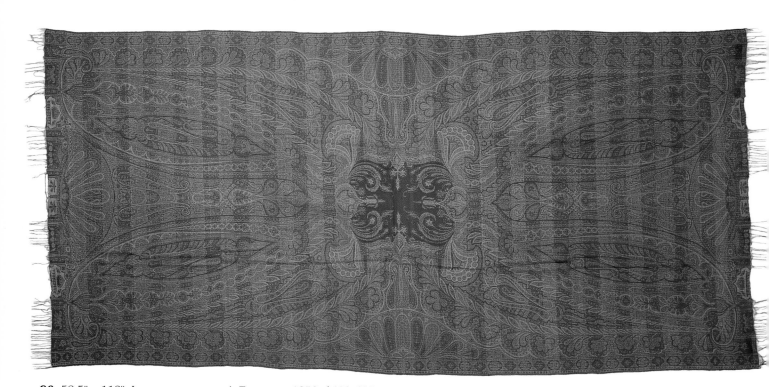

80. 58.5" x 118". Loose weave...wool. France, c. 1850. $400-600

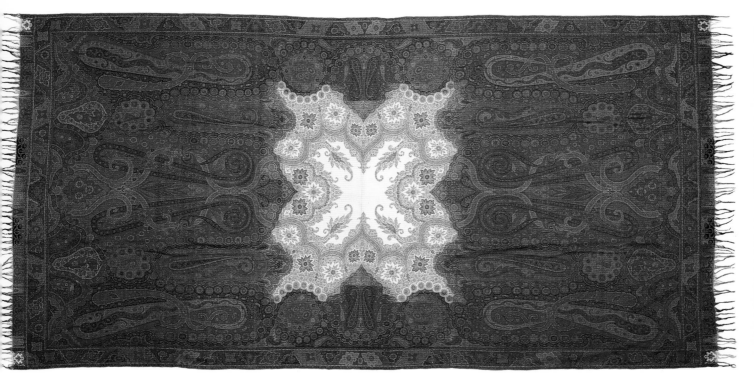

81. 66" x 127". Tight weave...wool. Floral and paisley pattern.
France, c. 1850. $800-1000

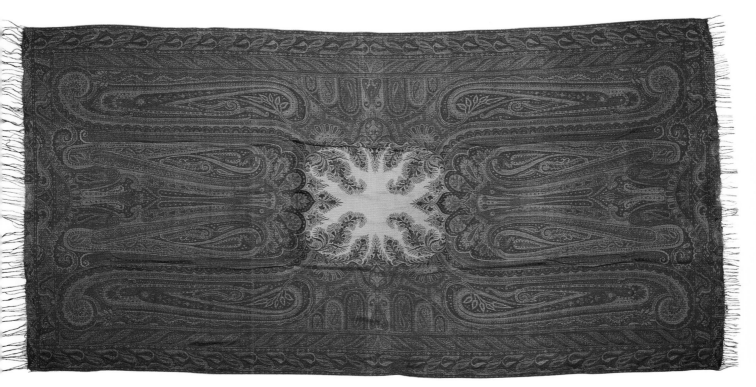

82. 61.5" x 121". Loose weave...wool. France, c. 1860. 500-800

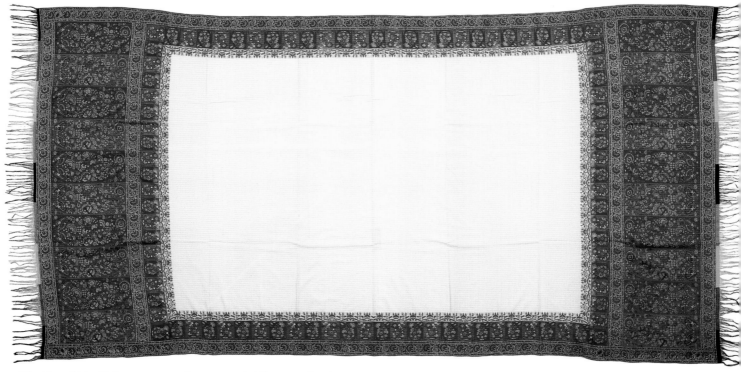

83. 62" x 111". Tight weave...cashmere wool. All woven floral design. Museum quality piece. England, c. 1845. $900-1200

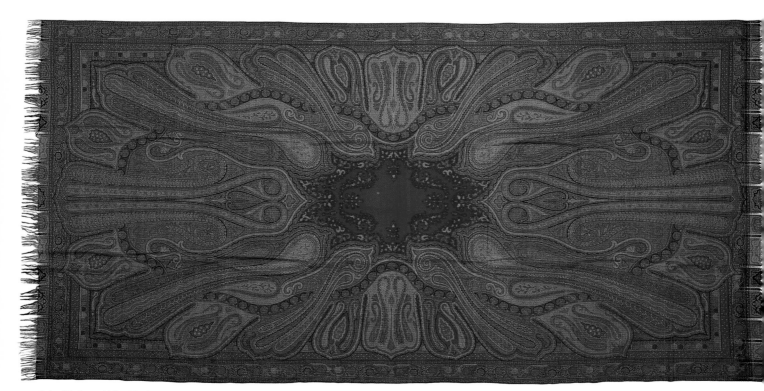

84. 65.5" x 130". Tight weave...wool. Museum quality piece. France, c. 1860. $900-1200

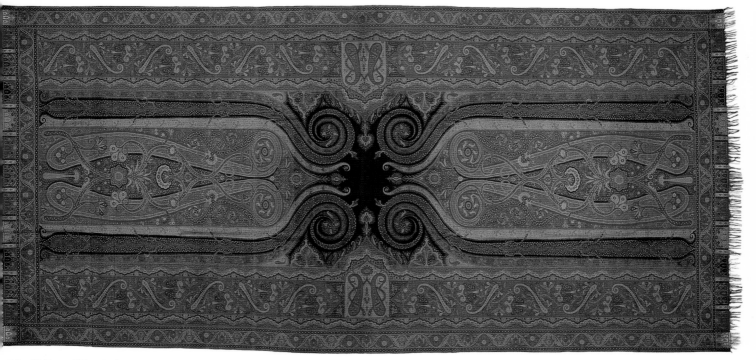

85. 62.5" x 155". Tight weave...wool/silk blend. This design is also known as a Tillikar shawl. This is a reproduction, done on a loom, and is a museum quality piece with the overall dramatic design. See long shawl #161, which is a handmade Tillikar shawl. India, c. 1860. $1200-1500

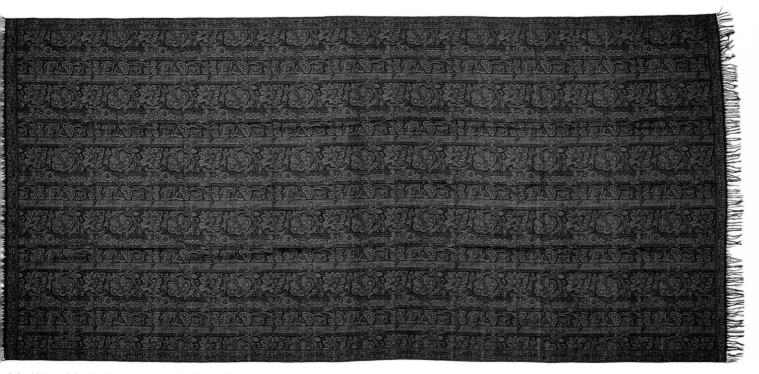

86. 60" x 126". Tight weave...wool. Floral Roman stripe. England, c. 1870. $500-800

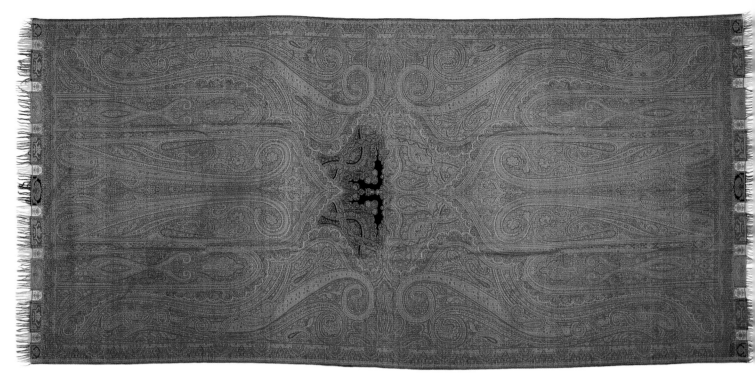

87. 64.5" x 131". Tight weave...wool/silk blend. Half center field.
Scotland, c. 1870. $600-900

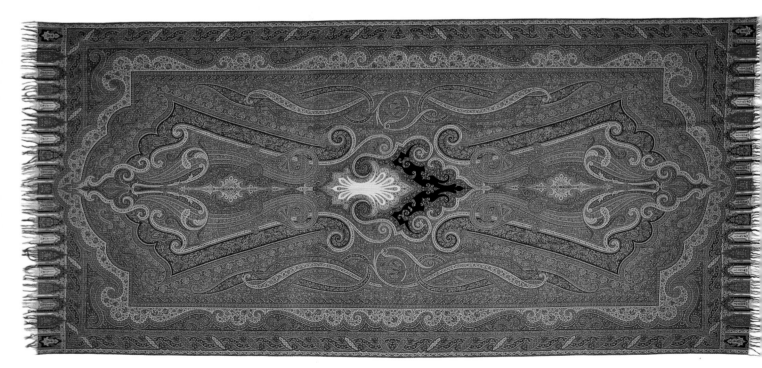

88. 63" x 136". Tight weave...wool/silk blend. Signed in the black
field. This shawl is very heavy in weight. Museum quality piece.
India, c. 1870. $1200-1500

64

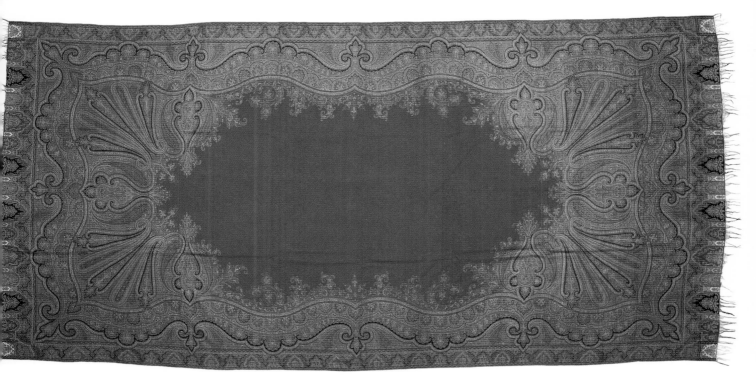

89. 61" x 128". Loose weave...wool. India, c. 1865. $500-800

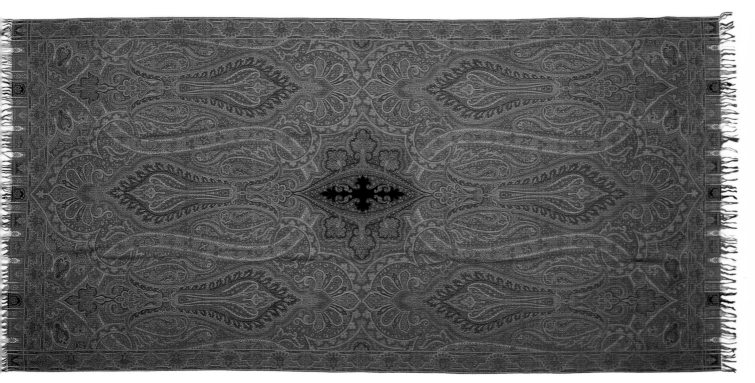

90. 64" x 129". Tight weave...wool/silk blend. India, c. 1870. $500-800

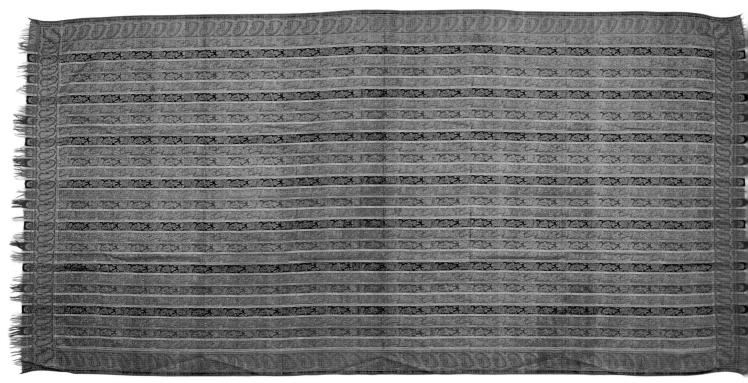

91. 66.5" x 130" Tight weave...cashmere wool/silk blend. Roman stripe, multicolor background with all silk embroidered design. England, c. 1870. $1000-1200

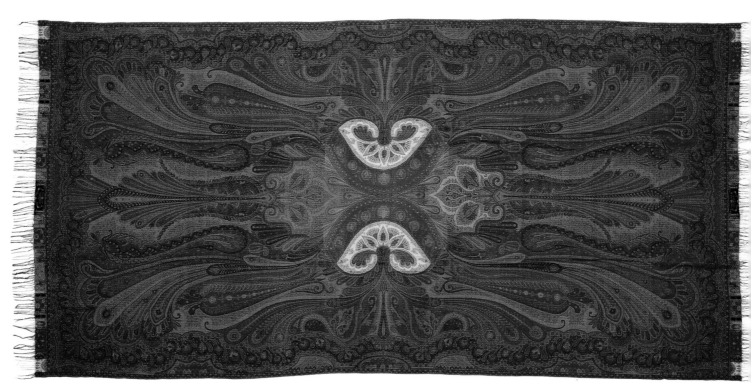

92. 64" x 125". Loose weave...wool. Four season shawl with rare unusual center design. France, c. 1880. $1000-1200

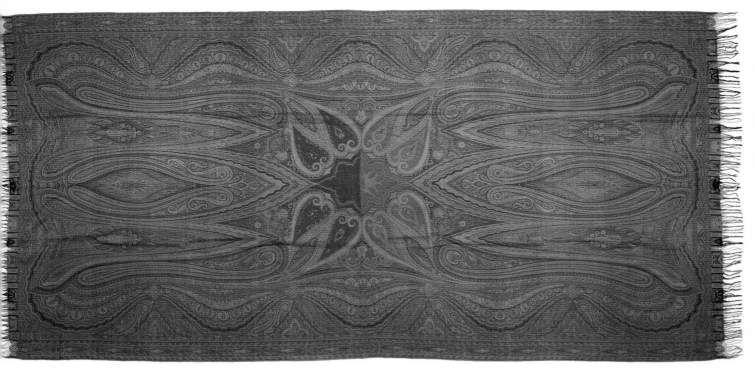

93. 66.5" x 136". Tight weave...wool. Museum quality piece. Rare
unusual bi-color center design. France, c. 1875. $1200-1500

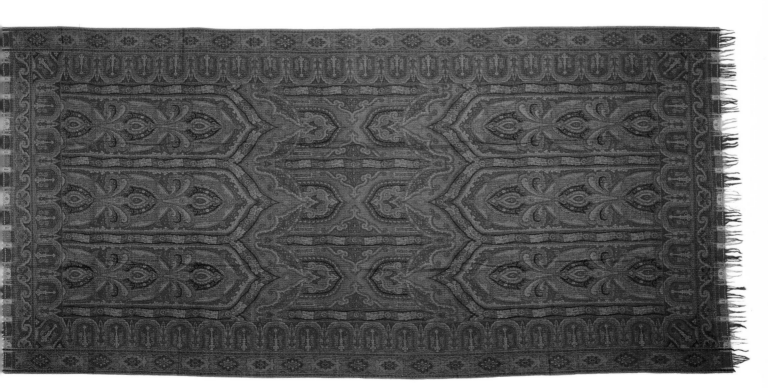

94. 62.5" x 127". Tight weave...wool/silk blend. Scotland, c. 1850.
$500-800

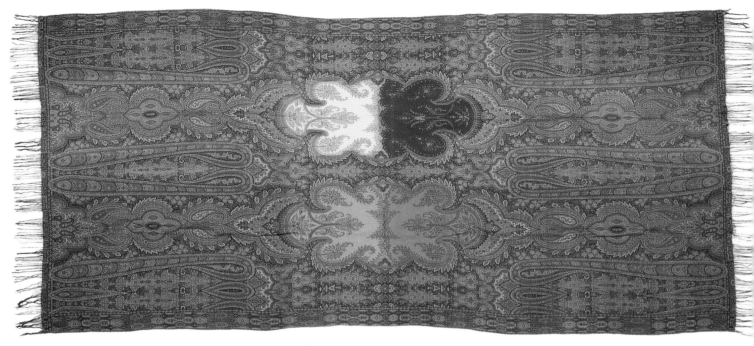

95. 58" x 122". Loose weave...wool. Four season shawl with gates and fringe added. France, c. 1850. $600-900

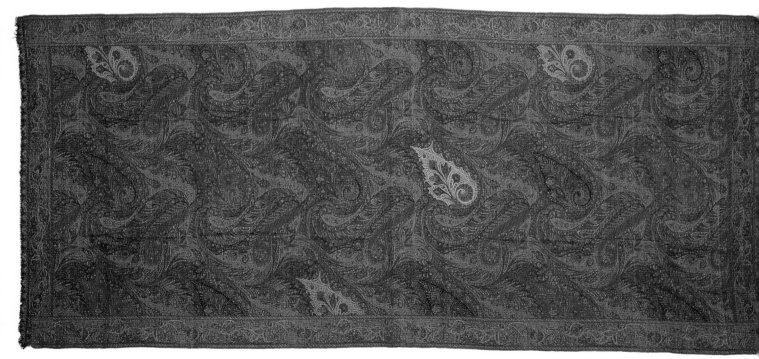

96. 62" x 132". Tight weave...cashmere wool. Unusual intricate pattern design. This shawl has a border on all four sides. The all black fringe on both ends is missing. England, c. 1860. $600-900

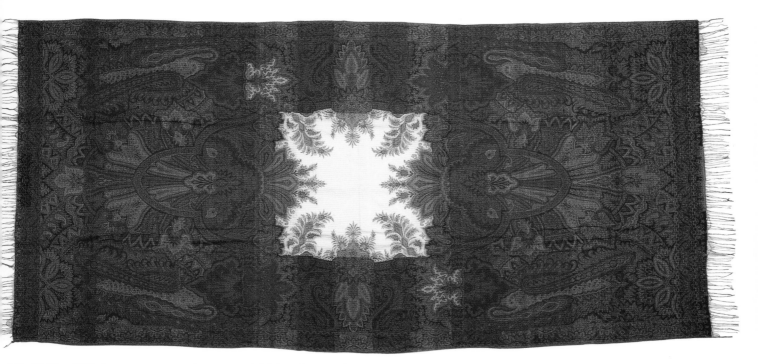

97. 58.5" x 121". Loose weave...cashmere wool. Multi colors used for the intricate complex design. France, c. 1845. $700-1000

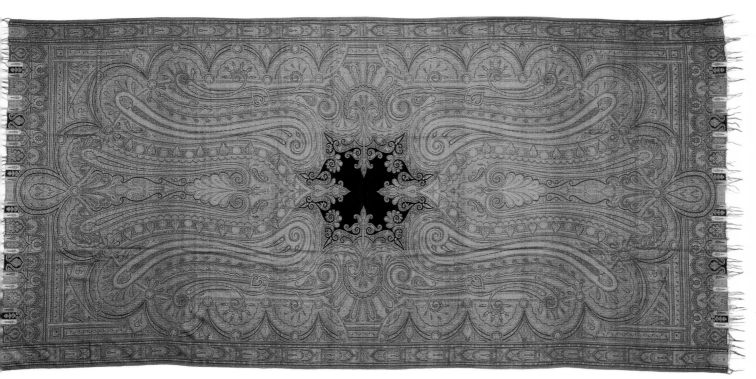

98. 63.5" x 128". Loose weave...wool. India, c. 1870. $500-800

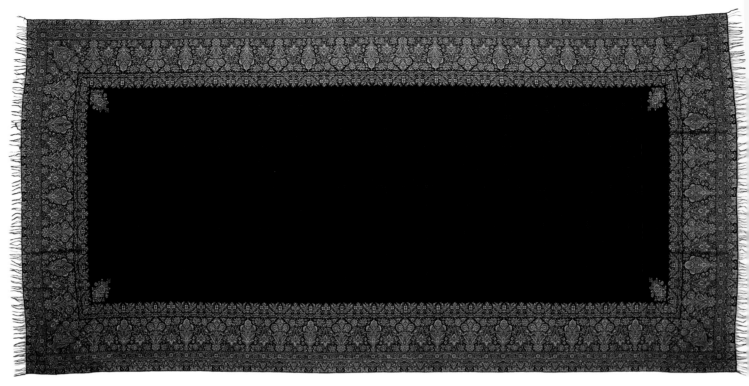

99. 64" x 126". Tight weave...wool. Close intricate embroidery all around four borders. This shawl is exceptionally heavy in weight. England, c. 1875. $600-900

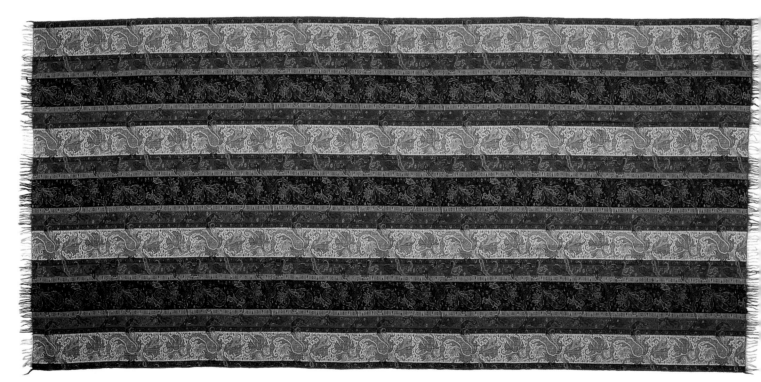

100. 61.5" x 122". Tight weave...wool. Roman stripe utilizing a very heavy wool mixture. Scotland, c. 1880. $600-900

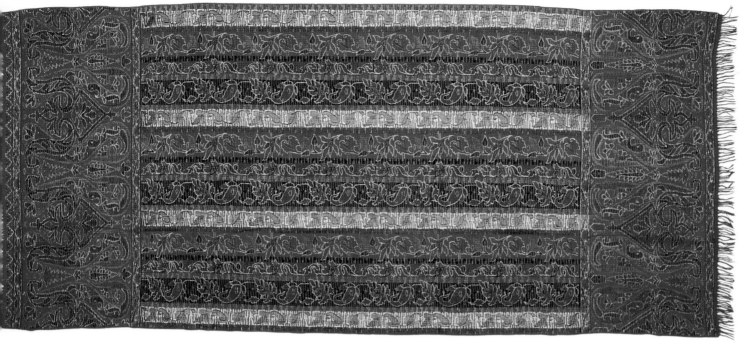

101. 55" x 120". Tight weave...wool. Roman stripe. This shawl utilizes two variations of weaving. The 23" borders at each end are a different weave from the familiar stripe section. The shawl is from Scotland and dated 1893. $800-1000

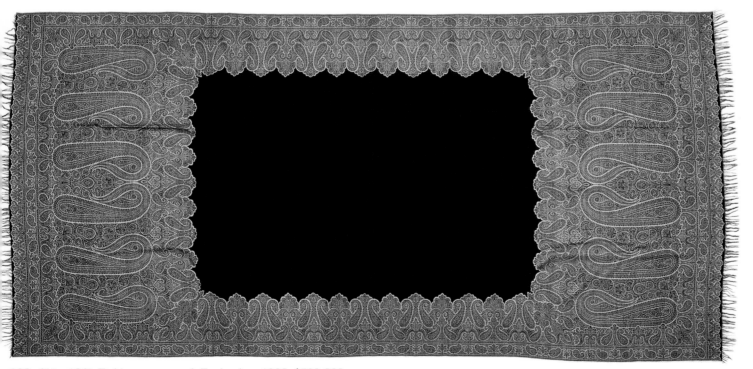

102. 61" x 124". Tight weave...wool. England, c. 1880. $500-800

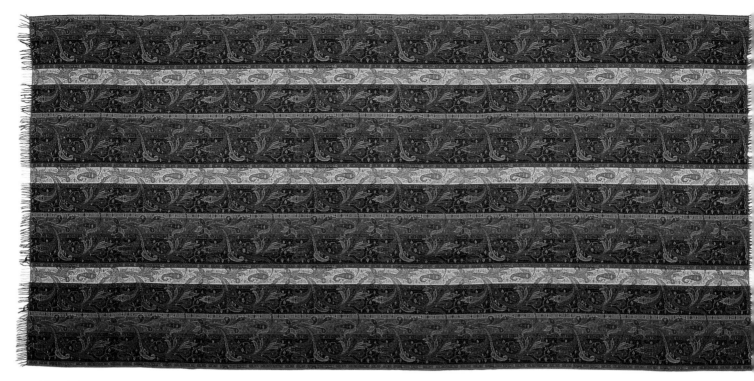

103. 59.5" x 114". Tight weave...wool. Scotland, c. 1870.
$600-900

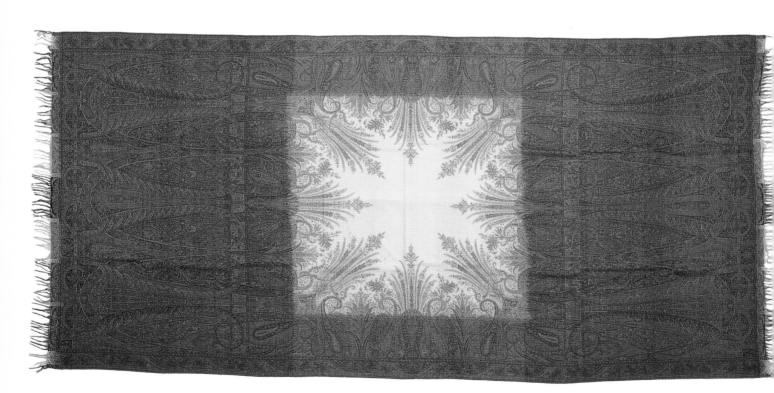

104. 62.5" x 128". Tight weave...wool. Museum quality piece.
France, c. 1850. $900-1200

72

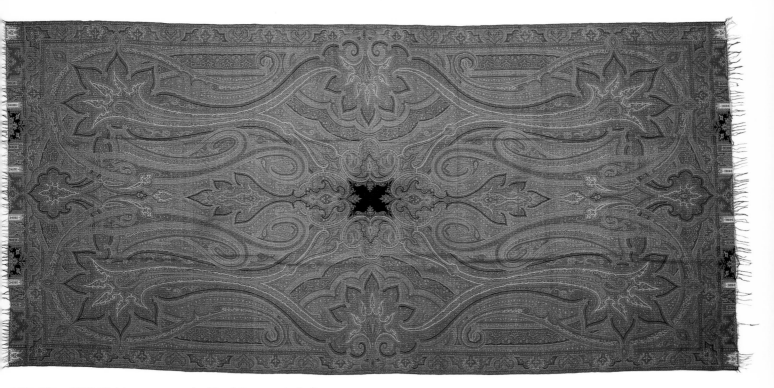

105. 63" x 128". Tight weave...wool with white accents. India, c. 1870. $500-800

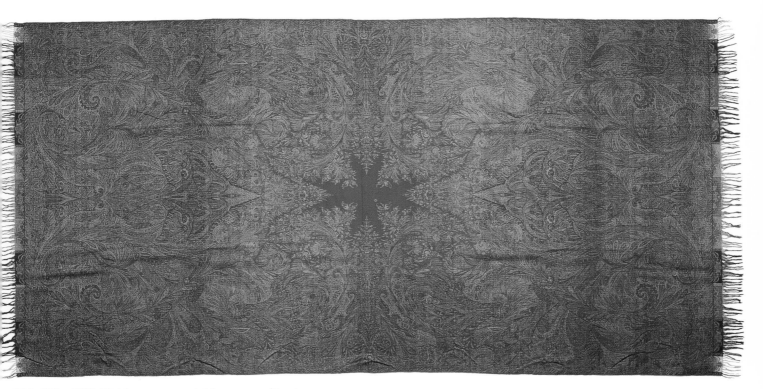

106. 65" x 128". Tight weave...wool. Museum quality piece. France, c. 1860. $1200-1500

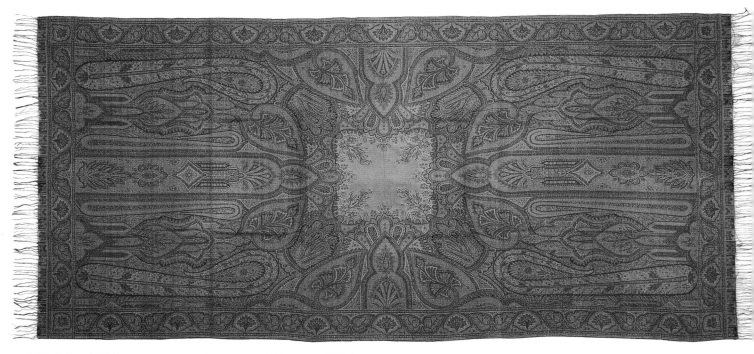

107. 58" x 123". Loose weave...cashmere wool. France, c. 1860.
$500-800

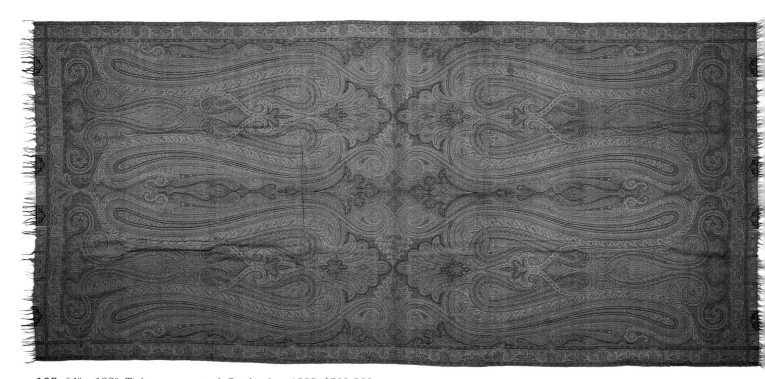

108. 64" x 133". Tight weave...wool. Scotland, c. 1880. $500-800

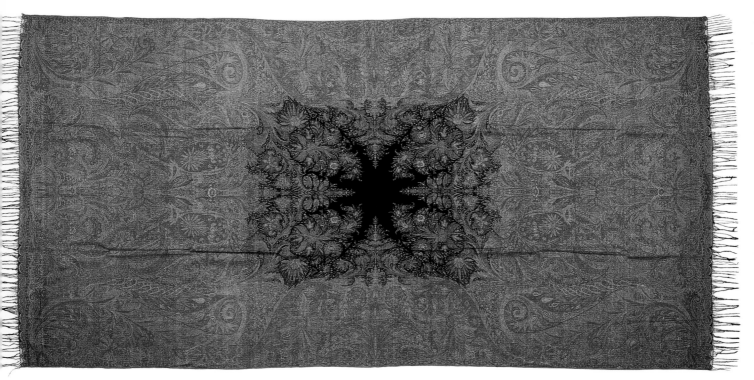

109. 62" x 126". Tight weave...wool. Museum quality piece.
England, c. 1850. $1000-1200

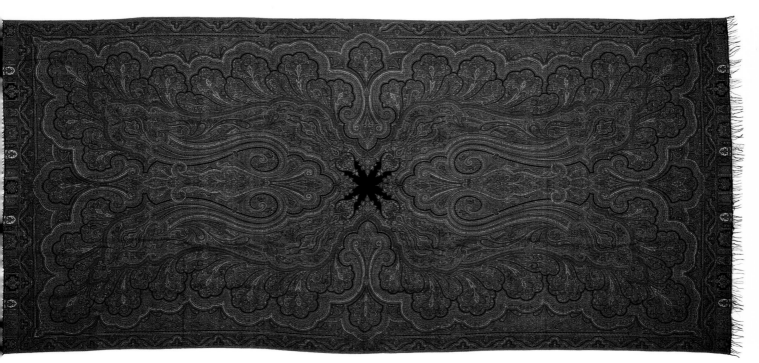

110. 57" x 122". Loose weave...wool. India, c. 1865. $500-800

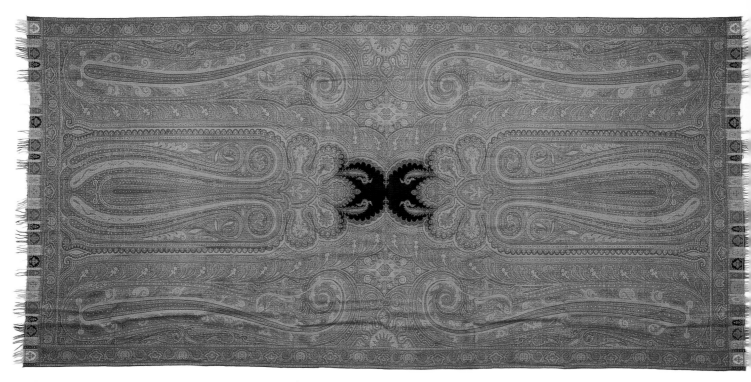

111. 64" x 126". Tight weave...wool. India, c. 1880. $600-900

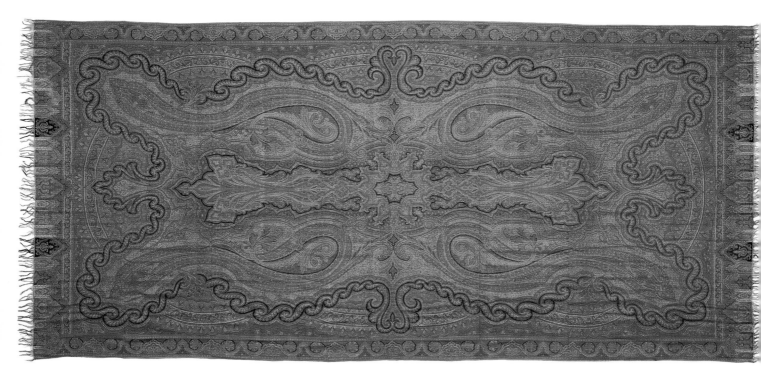

112. 61" x 128". Loose weave...wool. No center field. Scotland, c. 1890. $500-800

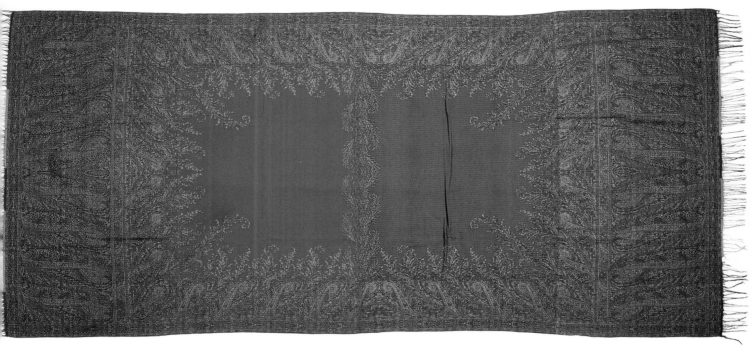

113. 58" x 130". Tight weave...wool. Rare bi-color center field.
France, c. 1835. $900-1200

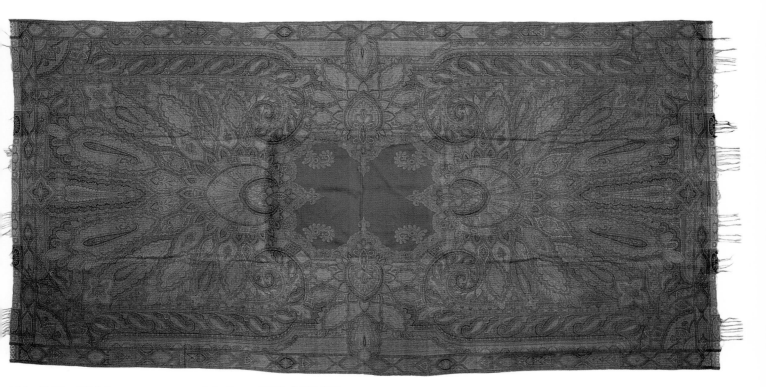

114. 60.5" x 120". Loose weave...wool. India, c. 1850. $600-900

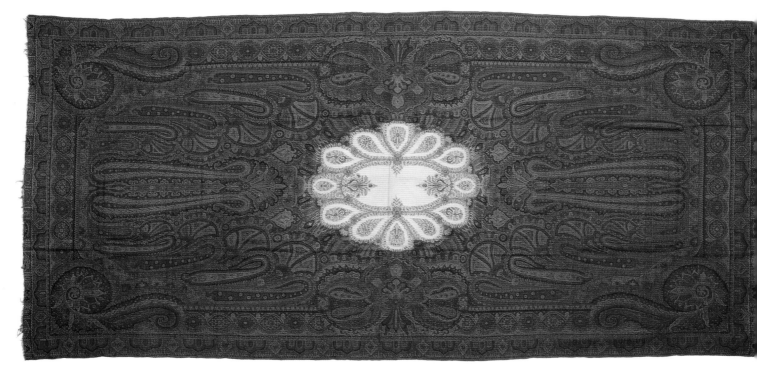

115. 57" x 124". Loose weave...cashmere wool. France, c. 1850.
$600-900

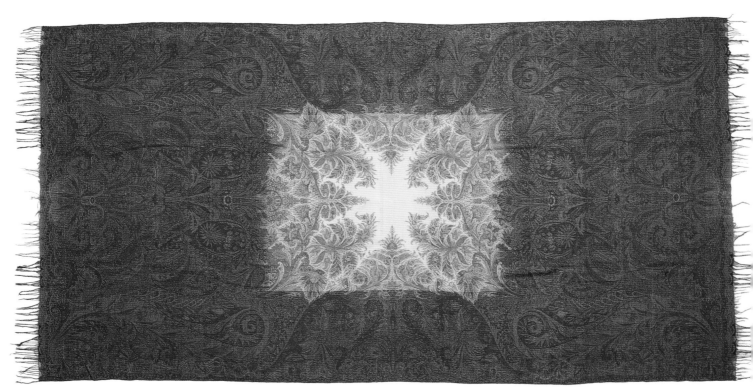

116. 65" x 122". Tight weave...wool. Floral and paisley design.
France, c. 1850. $800-1000

117. 57" x 130". Tight weave...wool/silk blend. All silk embroidery.
England, c. 1870. $600-900

118. 59" x 121". Tight weave...wool. Fringe added on. Rare six
color fields, red, beige and blue. England, c. 1850. $600-900

119. 63" x 126". Tight weave...wool. France, c. 1855. $800-1000

120. 56" x 118". Tight weave...wool. Fringe added on. England, c. 1870. $600-900

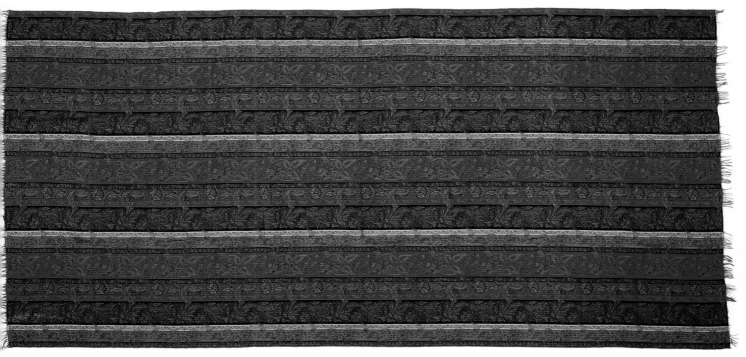

121. 56" x 118". Tight weave...wool. Roman stripe. Scotland, c. 1885. $500-800

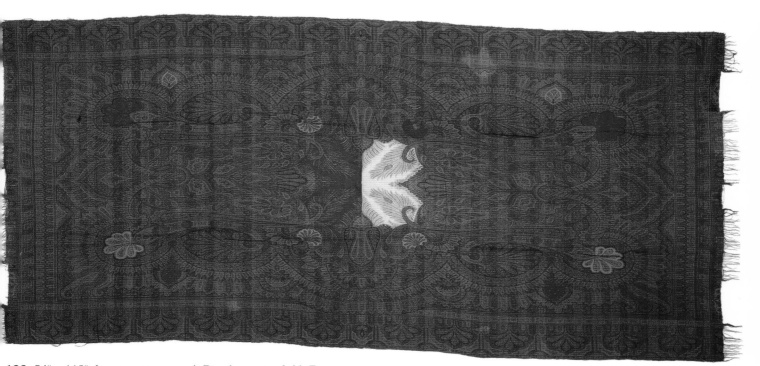

122. 54" x 118". Loose weave...wool. Bi-color center field. France, c. 1855. $500-800

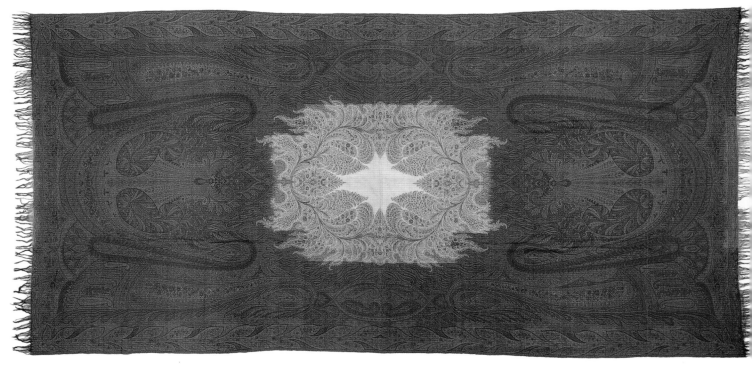

123. 62" x 126". Tight weave...wool. Museum quality piece. Floral and paisley design. France, c. 1845. $1000-1200

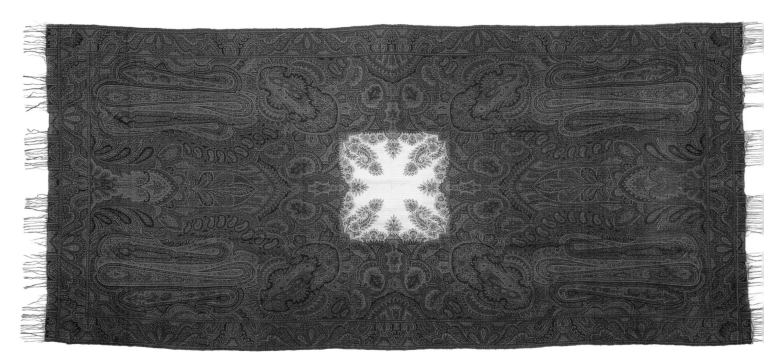

124. 57" x 126". Loose weave...cashmere wool. France, c. 1855. $500-800

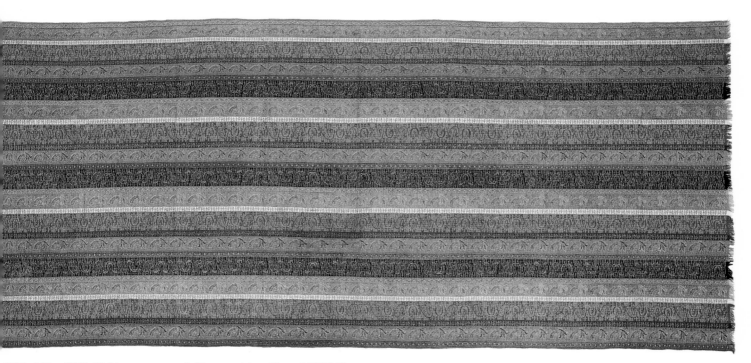

125. 54" x 121". Tight weave...wool. Roman stripe. Signed "2324".
Scotland, c. 1855. $600-900

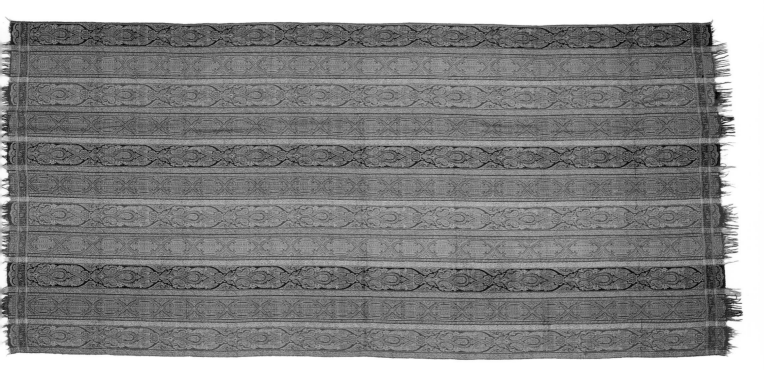

126. 60" x 127". Tight weave...wool/silk blend. Vibrant color silk
embroidery. Roman stripe. England, c. 1860. $800-1000

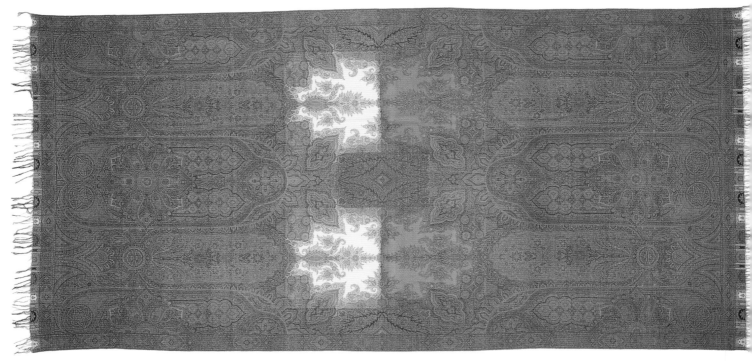

127. 60.5" x 128". Tight weave...wool. Museum quality piece. Four season shawl. France, c. 1865. $1200-1500

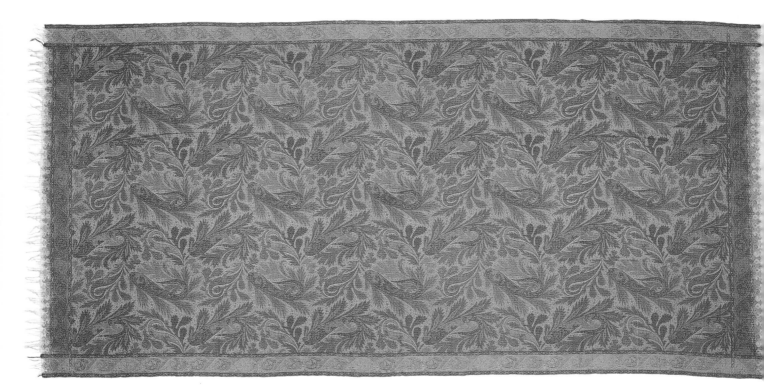

128. 64.5" x 128.5". Tight weave...wool. This is a continuous run pattern. England, c. 1870. $600-900

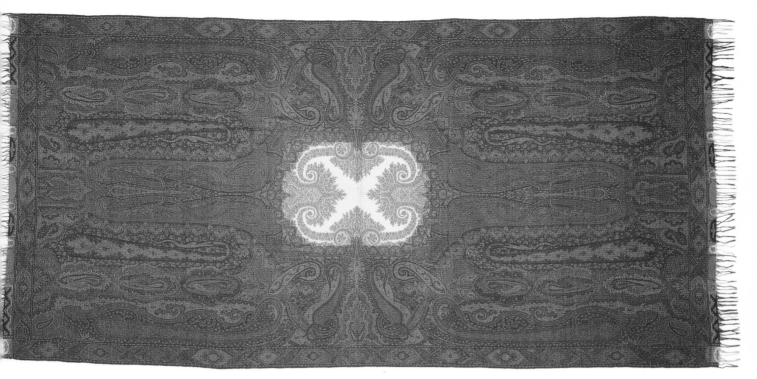

129. 63" x 126". Loose weave...cashmere wool. France, c. 1850.
$500-800

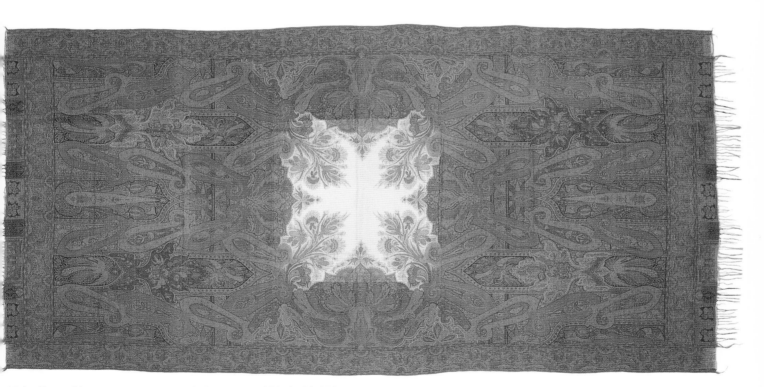

130. 60" x 123". Loose weave...wool. France, c. 1870. $500-800

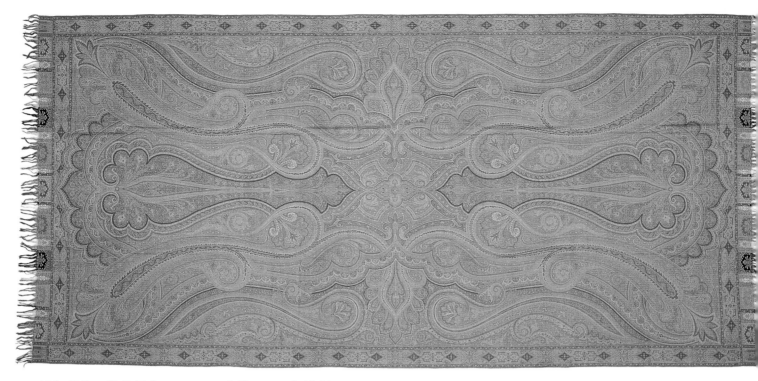

131. 63.5" x 126". Tight weave...wool. No center field. Museum quality piece. Scotland, c. 1865. $600-900

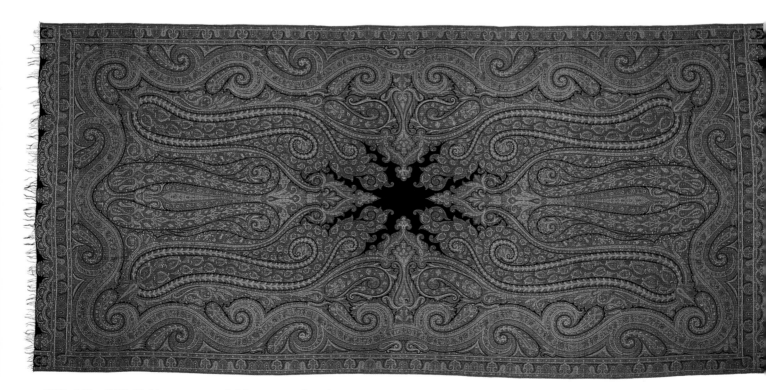

132. 64" x 127". Tight weave...wool. Museum quality piece. England, c. 1870. $600-900

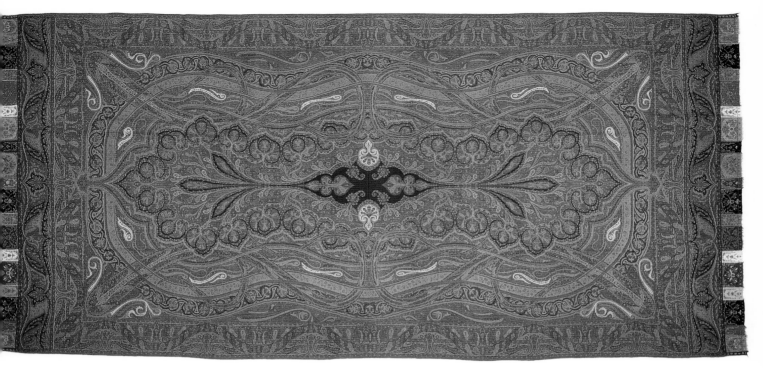

133. 61.5" x 132". Tight weave...wool/silk blend. Attached Kashmiri
gate border. White accents. Museum quality piece. India, c. 1855.
$800-1000

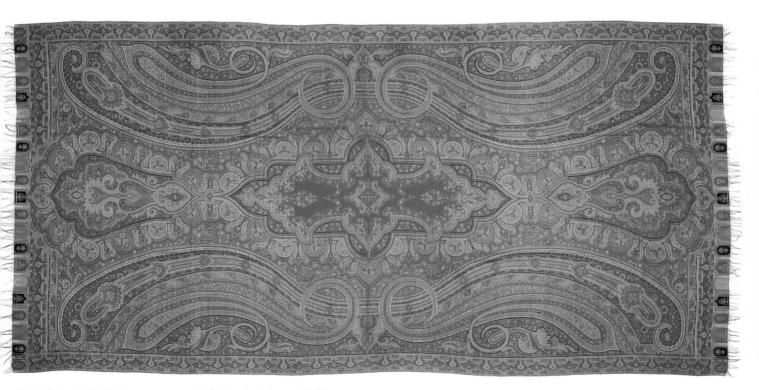

134. 63" x 126". Tight weave...wool/silk blend. India, c. 1865.
$600-900

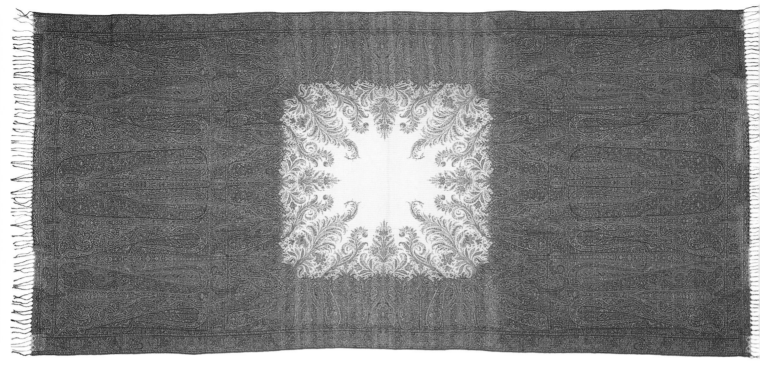

135. 62" x 126". Tight weave...wool. France, c. 1850. $800-1000

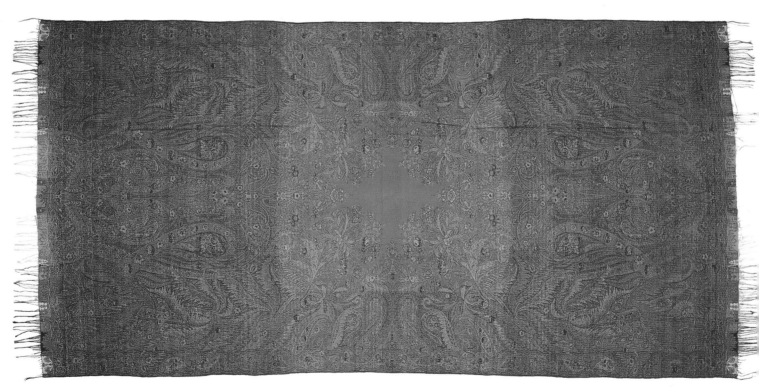

136. 65" x 123". Tight weave...wool. Roses and paisley design.
Museum quality piece. France, c. 1855. $900-1200

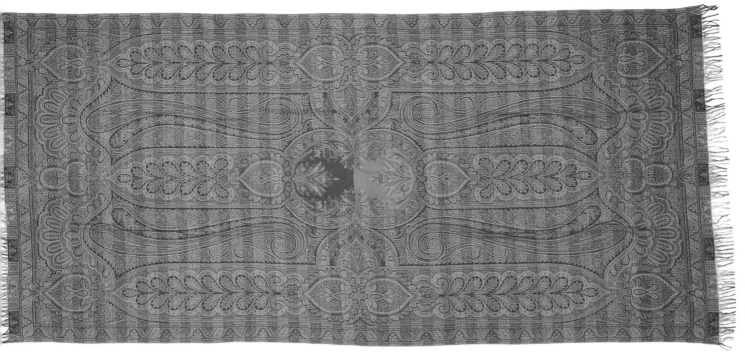

137. 56" x 112". Loose weave...cashmere wool. Bi-color center field. France, c. 1870. $600-900

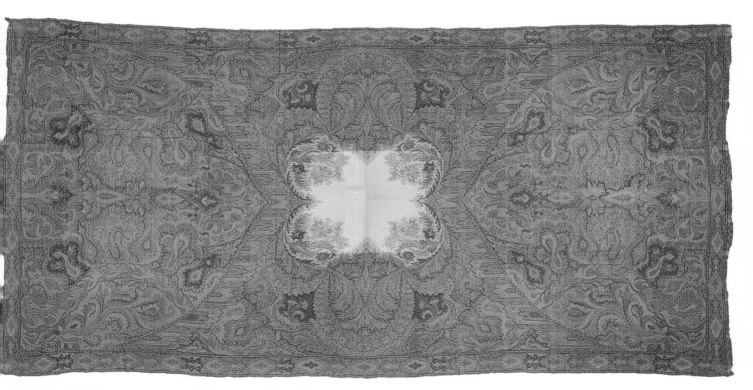

138. 58" x 116". Loose weave...wool. Blue center field with red accents. France, c. 1850. $500-800

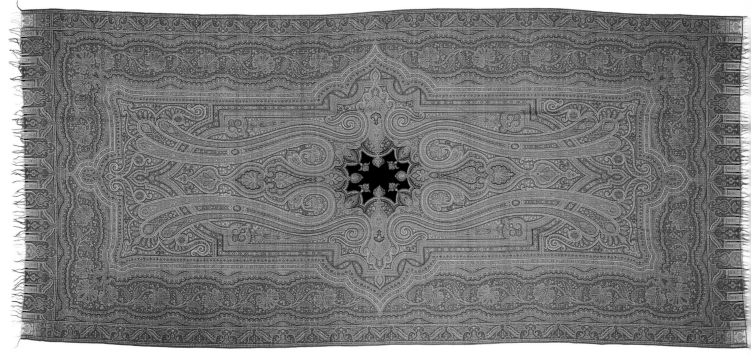

139. 63" x 127". Tight weave...wool. India, c. 1880. $600-900

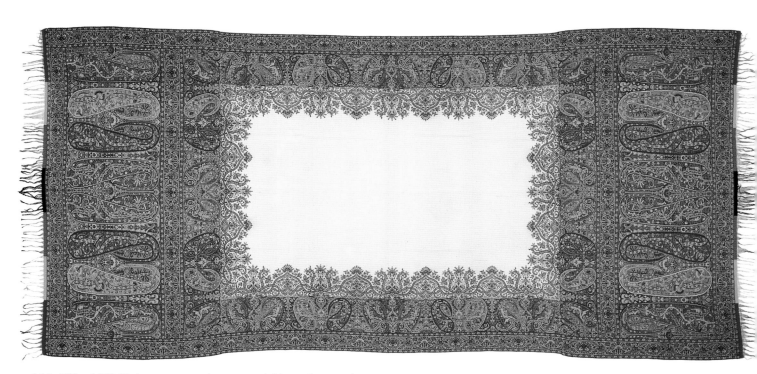

140. 55" x 120". Tight weave...cashmere wool. Very vibrant colors.
England, c. 1845. $900-1200

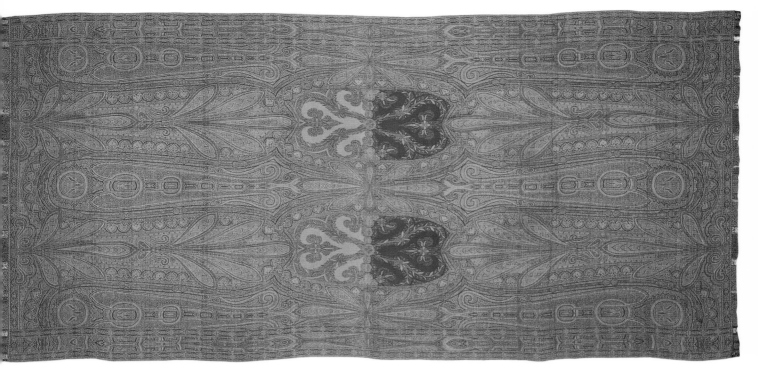

141. 56" x 127". Loose weave...wool. Attached gates, fringe
missing. Four fields utilizing two colors. England, c. 1860. $500-800

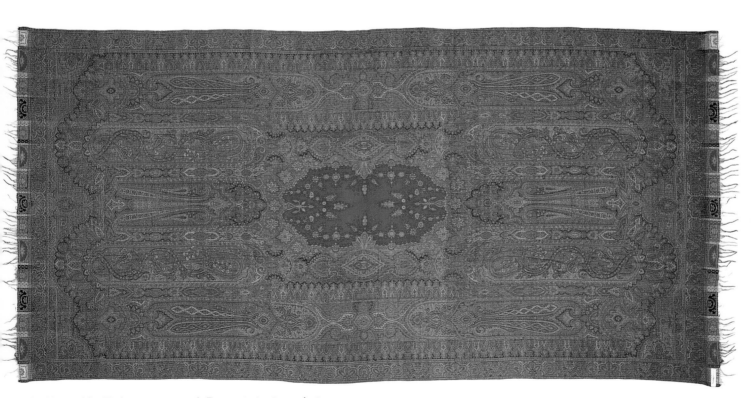

142. 60" x 120". Tight weave...wool. Dramatic intricate design.
France, c. 1865. $600-900

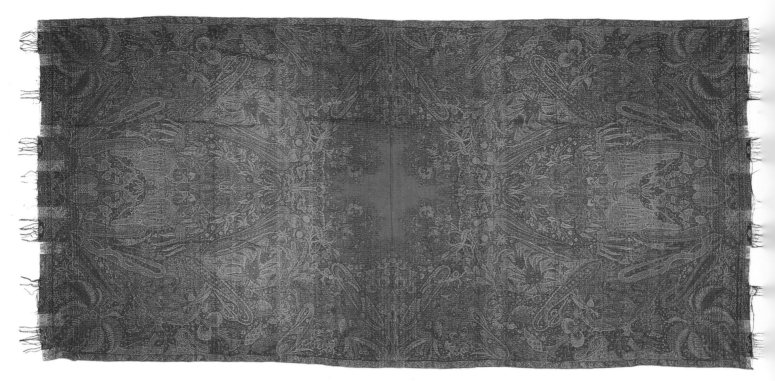

143. 59.5" x 122". Loose weave...wool. France, c. 1855. $600-900

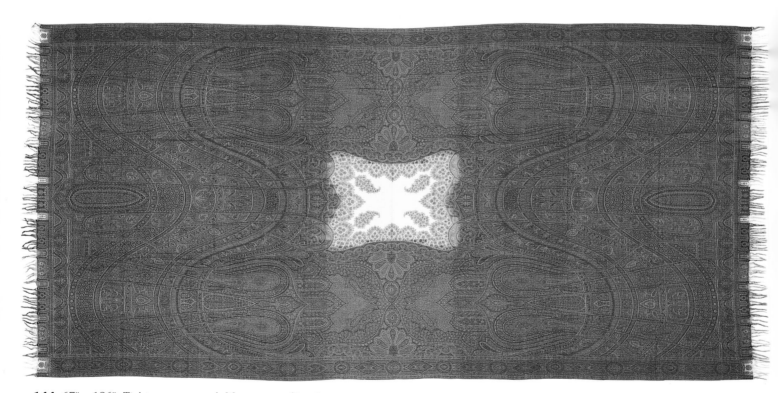

144. 67" x 126". Tight weave...wool. Museum quality piece.
France, c. 1870. $900-1200

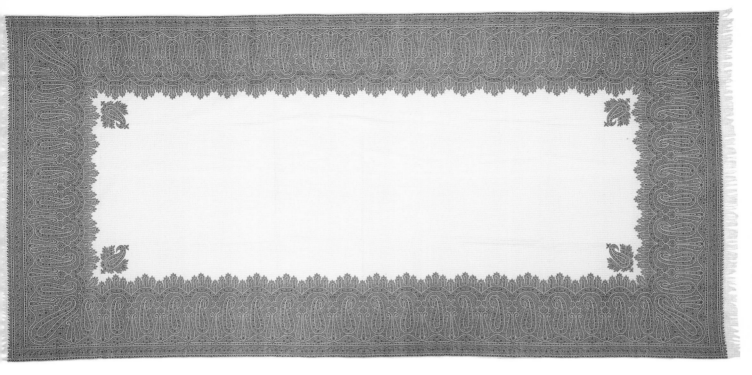

145. 62" x 130". Tight weave...wool/silk blend. England, c. 1880. $800-1000

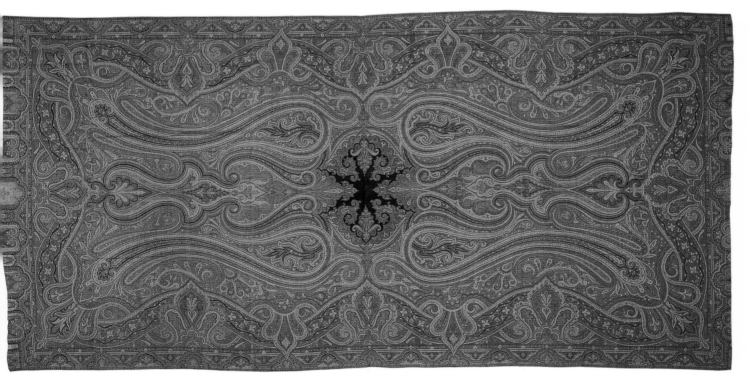

146. 61.5" x 124". Tight weave...wool/silk blend. Fringe all removed. Very heavy weight shawl. India, c. 1875. $500-800

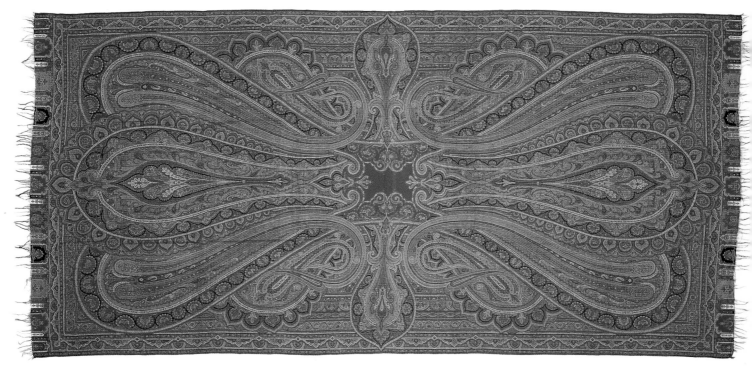

147. 60" x 124". Tight weave...wool. This was the first shawl I purchased, which started my collecting! India, c. 1885. $500-800.

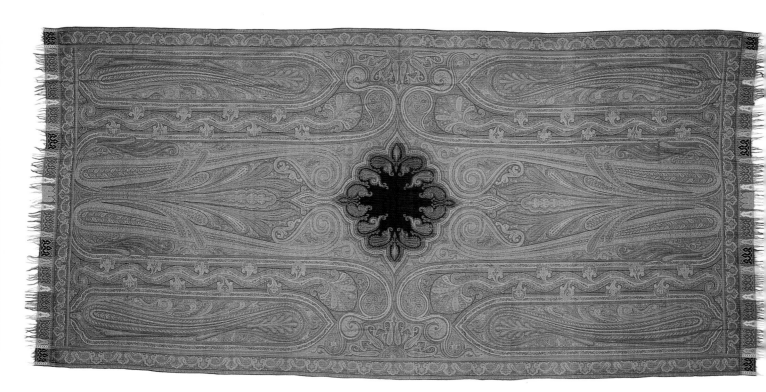

148. 64" x 129". Tight weave...wool/silk blend. India, c. 1880. $600-900

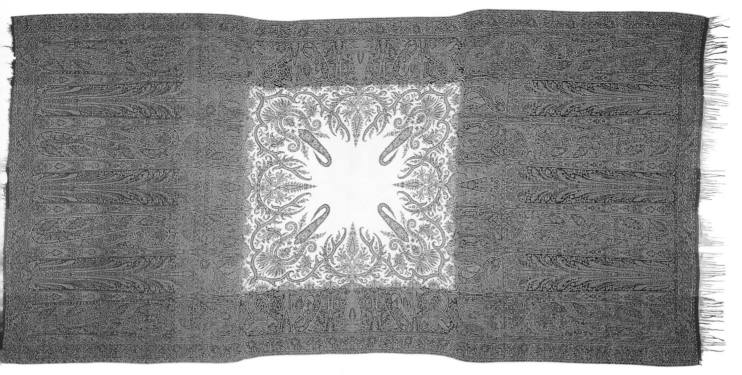

149. 66.5" x 124". Tight weave...wool. England, c. 1850. $600-900

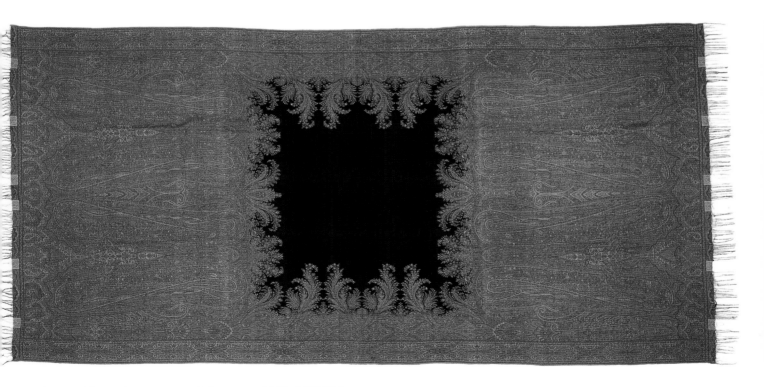

150. 58.5" x 122". Tight weave...wool. France, c. 1860. $600-900

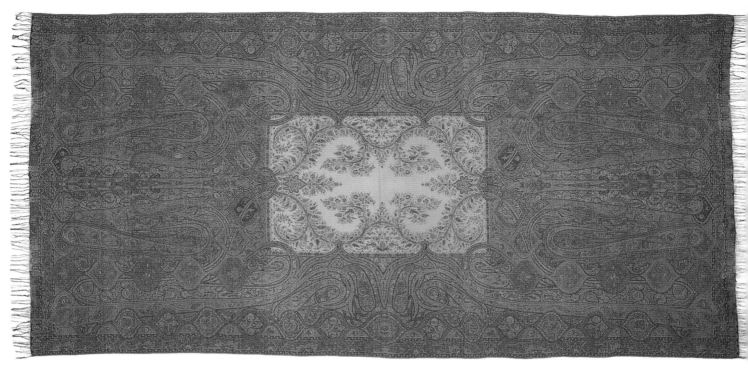

151. 60.5" x 124". Tight weave...wool. France, c. 1855. $600-900

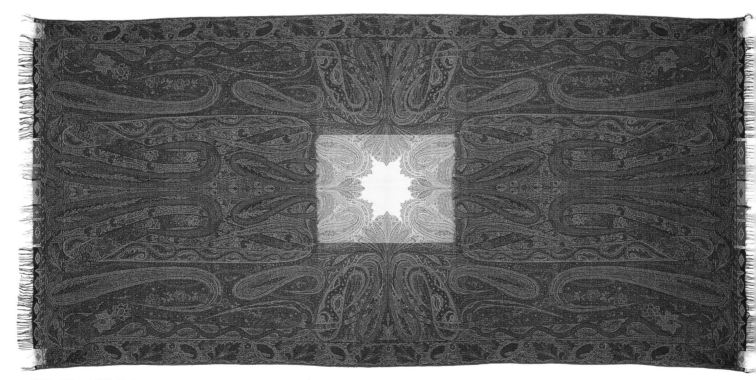

152. 63" x 125". Tight weave...wool. France, c. 1855. $600-900

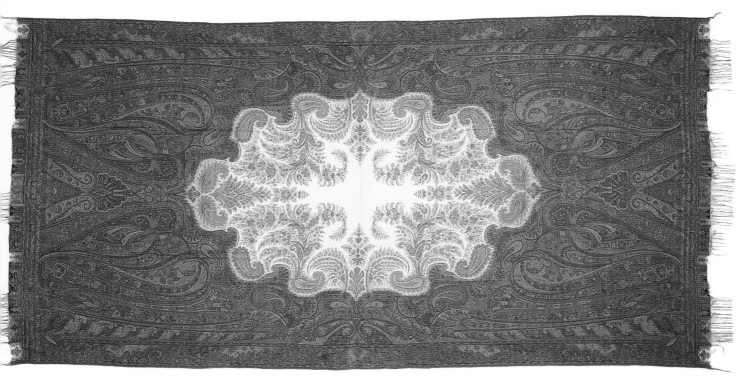

153. 61.5" x 125". Tight weave...wool. France, c. 1850. $700-1000

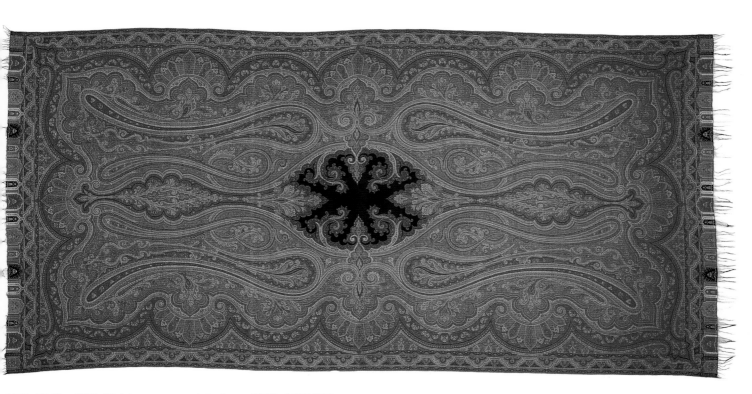

154. 60.5" x 128". Tight weave...wool. India, c. 1865. $600-900

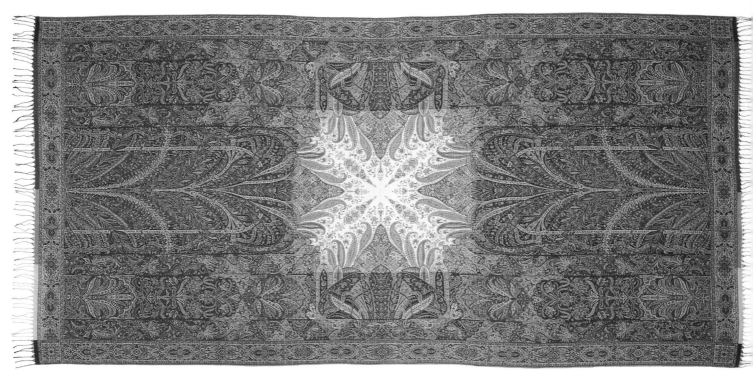

155. 64.5" x 132". Tight weave...wool. Vibrant colors. Museum quality piece. France, c. 1850. $1000-1500

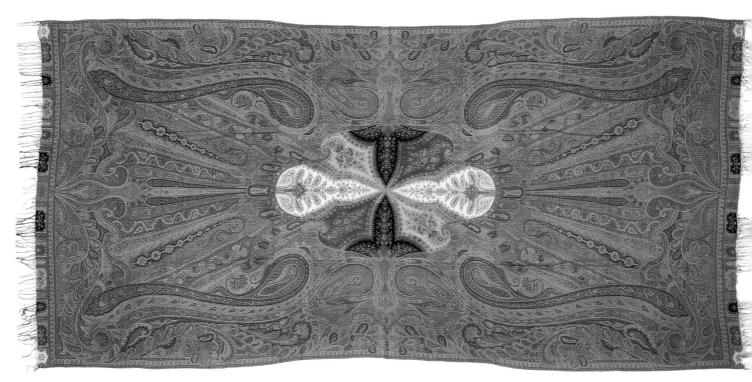

156. 63.5" x 124". Loose weave...wool. Four season shawl. India, c. 1860. $700-1000

157. 67.5" x 136". Loose weave...wool. England, c. 1850.
$600-900

158. 63.5" x 128.5". Tight weave...wool/silk blend. England, c.
1880. $700-1000

159. 62" x 120". Tight weave...wool with white accents. India, c. 1870. $700-1000

160. 60.5" x 132". Tight weave...wool/silk blend on the embroidered borders. England, c. 1870. $500-800

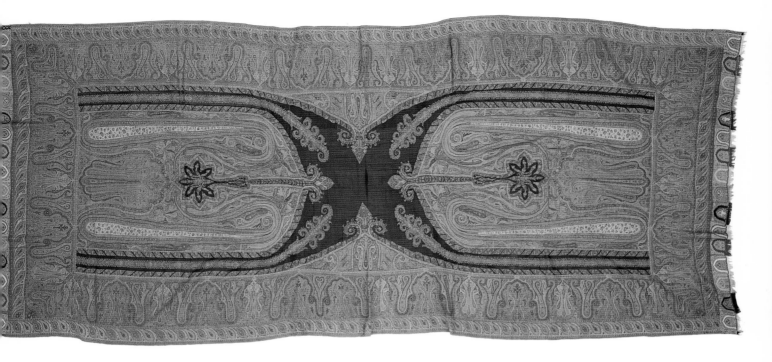

161. 55.5" x 130". Tight weave...wool/silk blend. This is a Kashmiri Tillikar shawl all hand pieced together and signed. It is "lumpy" lying on a table. Compare to #85, a machine made shawl. India, c. 1875. $2000-2500

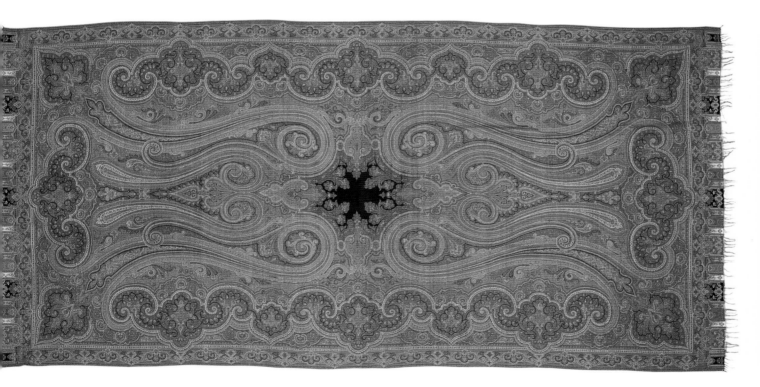

162. 59.5" x 126". Loose weave...wool. India, c. 1860. $500-800

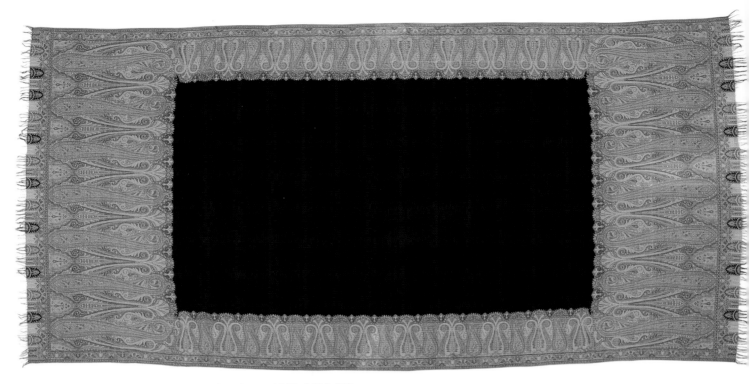

163. 60.5" x 120". Tight weave...wool. India, c. 1865. $500-800

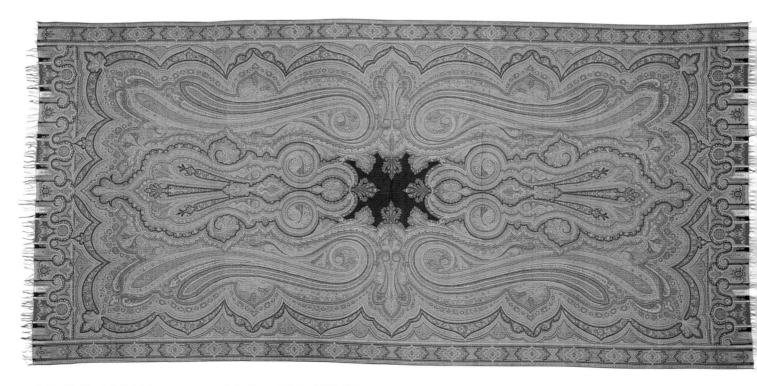

164. 61.5" x 127". Tight weave...wool. India, c. 1870. $600-900

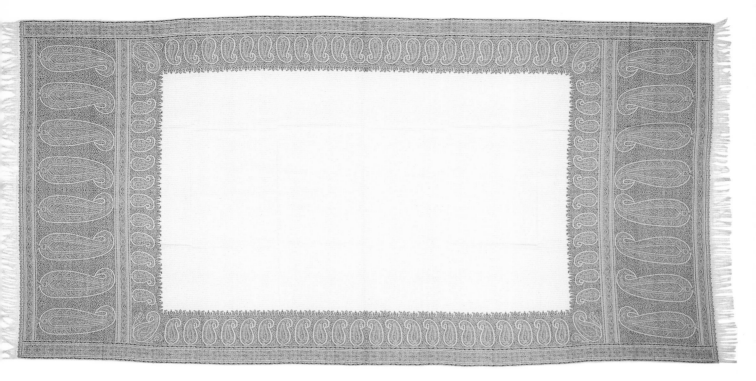

165. 61.5" x 123". Tight weave...cashmere wool. Norwich pattern.
Fringe added to both ends. England, c. 1880. $600-900

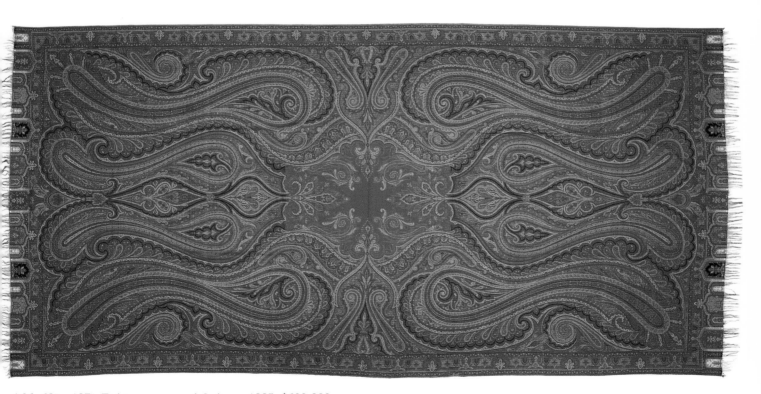

166. 62" x 127". Tight weave...wool. India, c. 1885. $600-900

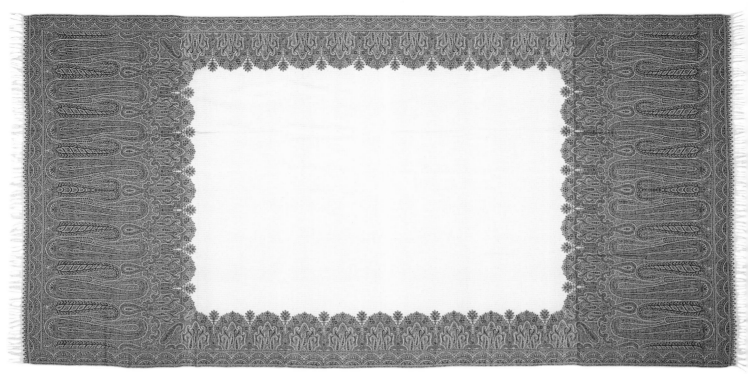

167. 63" x 120". Tight weave...wool. England, c. 1880. $700-900

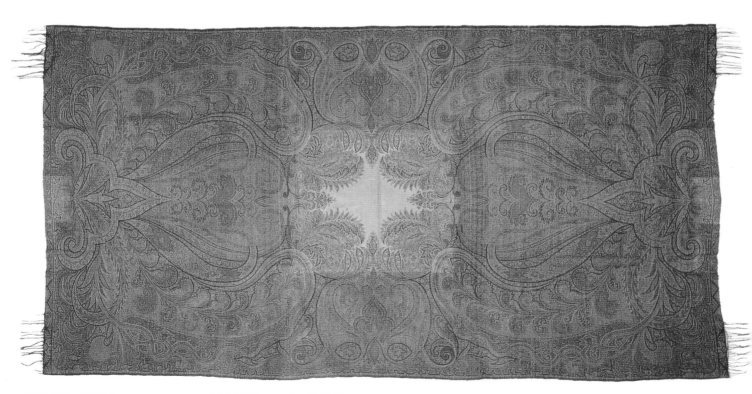

168. 62" x 112". Loose weave...wool. Light blue center field. See long shawl #62 for the same design with cream center field. France, c. 1850. $500-800

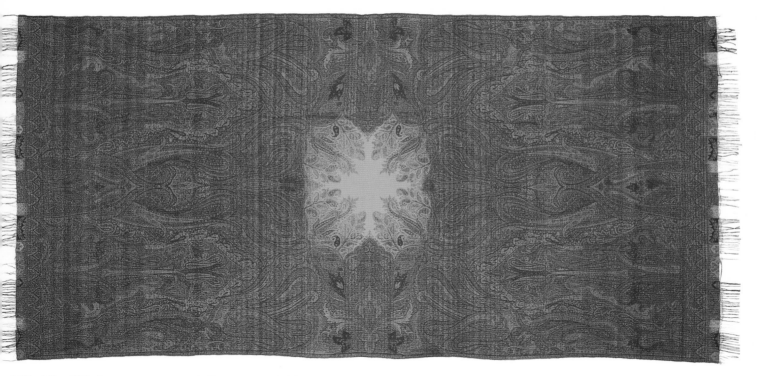

169. 60" x 123". Loose weave...wool. Green center field with red accents. France, c. 1855. $600-900

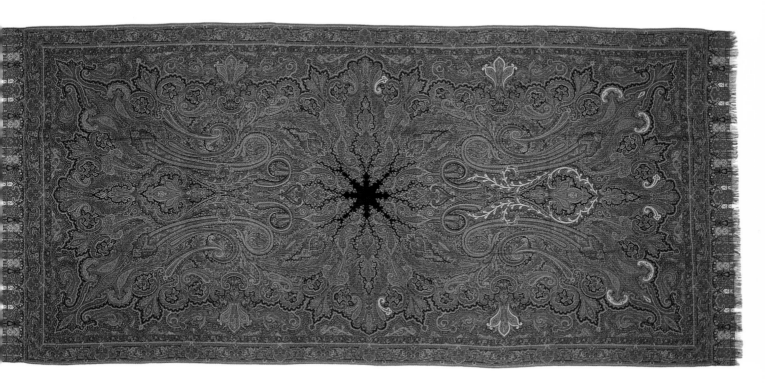

170. 60" x 129". Tight weave...wool. Attached 5.5" border gates at ends. White accents. Exceptionally heavy shawl. India, c. 1870. $700-1000

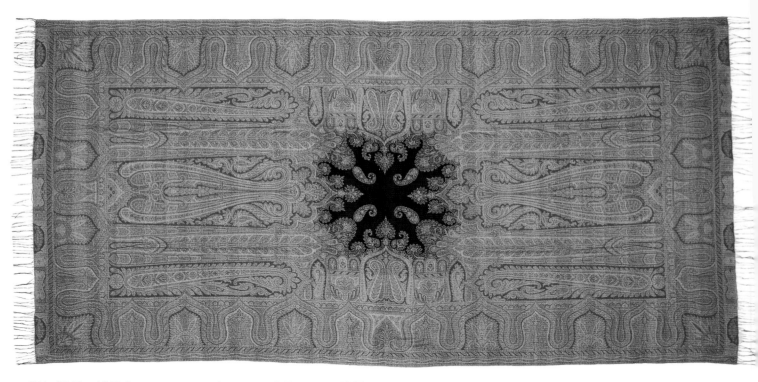

171. 59.5" x 123". Loose weave...cashmere wool. France, c. 1865.
$600-900

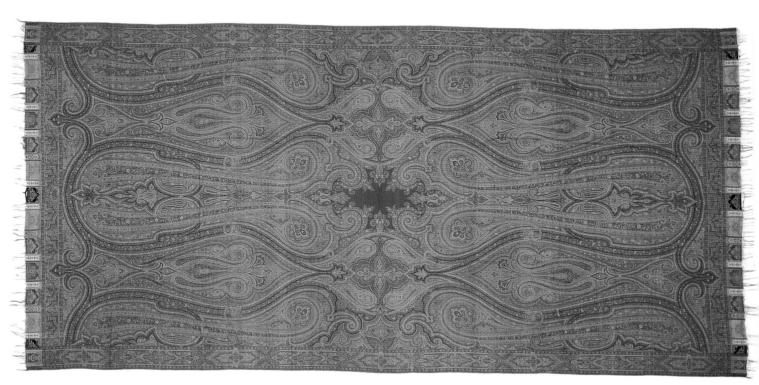

172. 60.5" x 124". Loose weave...wool. India, c. 1860. $600-900

173. 61" x 124". Tight weave...wool. Attached gate and fringe border. Bi-color center field of red and green. England, c. 1860. $700-1000

174. 64" x 124". Loose weave...wool. Four season shawl. France, c. 1860. $700-1000

175. 58.5" x 120". Loose weave...cashmere wool. England, c. 1850. $600-900

176. 60" x 124". Tight weave...wool. Rare beige center field. French, c. 1855. $600-900

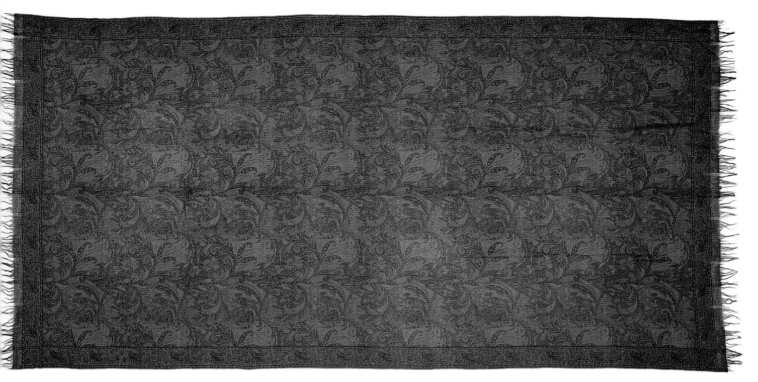

177. 65" x 128". Tight weave...wool. Continuous run pattern.
Scotland, c. 1855. $900-1200

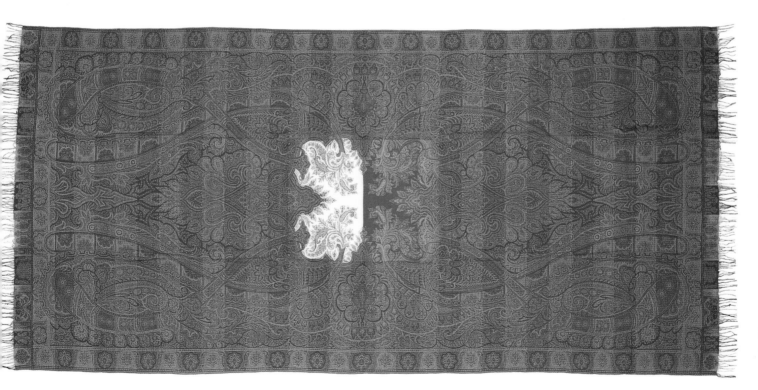

178. 57" x 119". Loose weave...cashmere wool. Bi-color center
field of red and white. England, c. 1865. $600-900

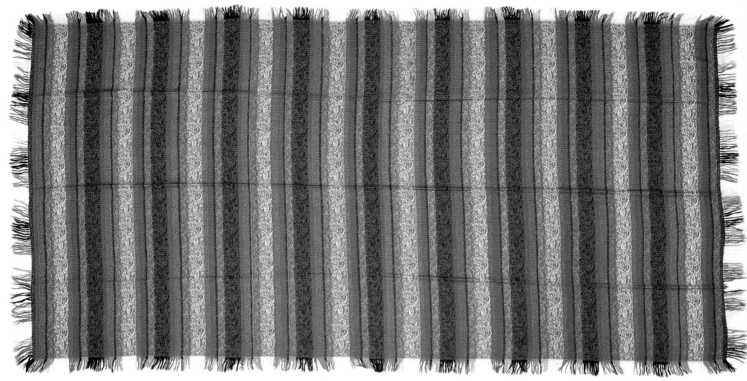

179. 61" x 114". Tight weave...wool. Horizontal stripe with fringe on all four sides. Vertical long ends have attached knotted fringe. Scotland, c. 1885. $400-600

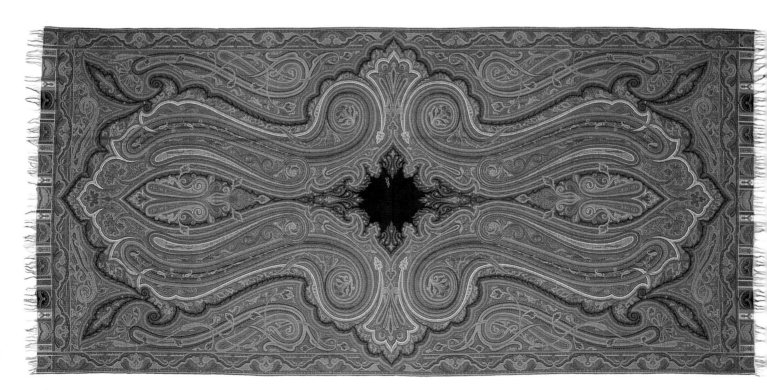

180. 61.5" x 127". Tight weave...wool. White accents, signed in black center field. India, c. 1865. $900-1000

181. 60.5" x 124". Loose weave...wool. France, c. 1850. $600-900

182. 83.5" x 128". Tight weave...wool. France, c. 1860. $700-1000

183. 66" x 124". Tight weave...wool. France, c. 1855. $500-800

184. 62" x 126". Tight weave...wool/silk blend. Intricate pattern utilizing a blue center field. France, c. 1870. $700-1000

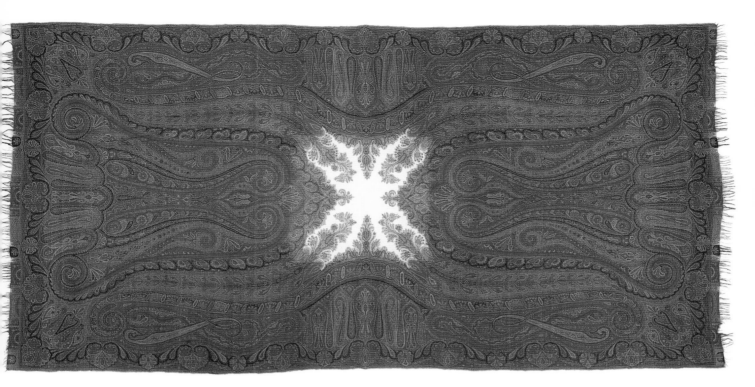

185. 59.5" x 120". Loose weave...cashmere wool. France, c. 1850.
$500-800

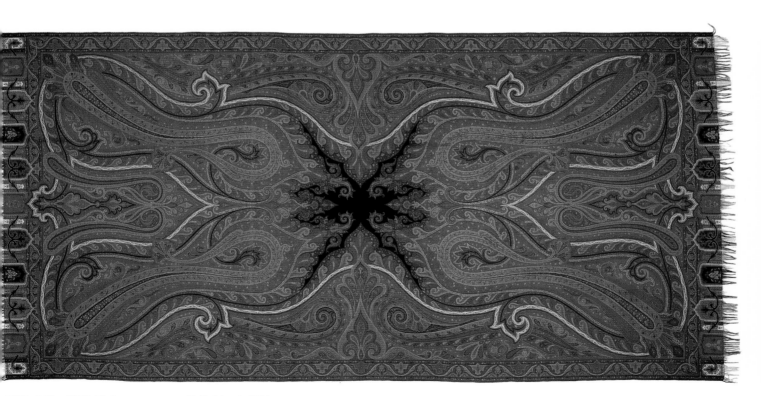

186. 64" x 134". Tight weave...wool/silk blend. White accents, very
heavy shawl. India, c. 1870. $600-900

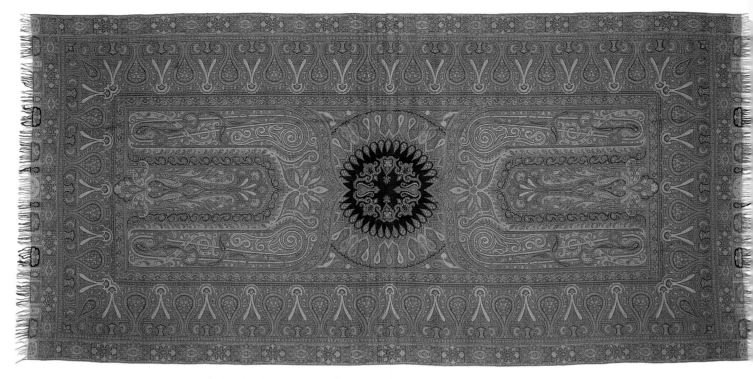

187. 64" x 133". Tight weave...wool/silk blend. Museum quality piece. France, c. 1860. $700-1000

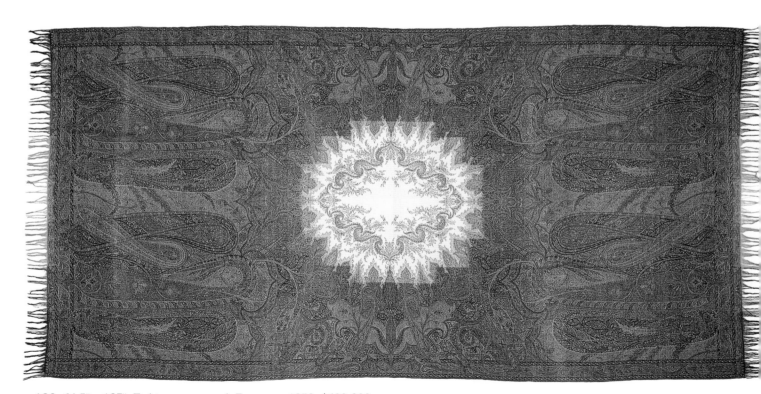

188. 64.5" x 127". Tight weave...wool. France, c. 1850. $600-900

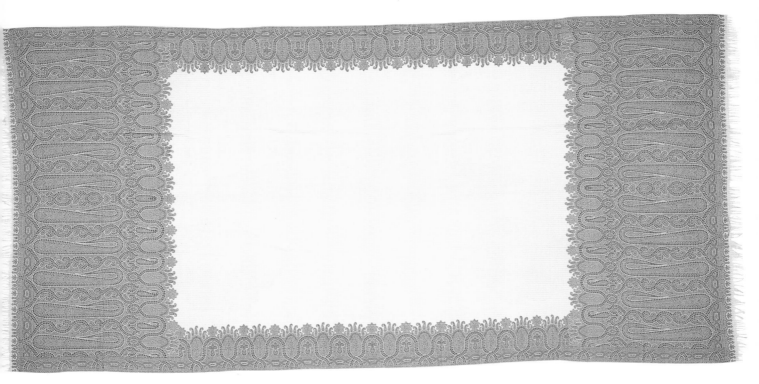

189. 59.5" x 123". Tight weave...cashmere wool. England, c. 1860.
$600-900

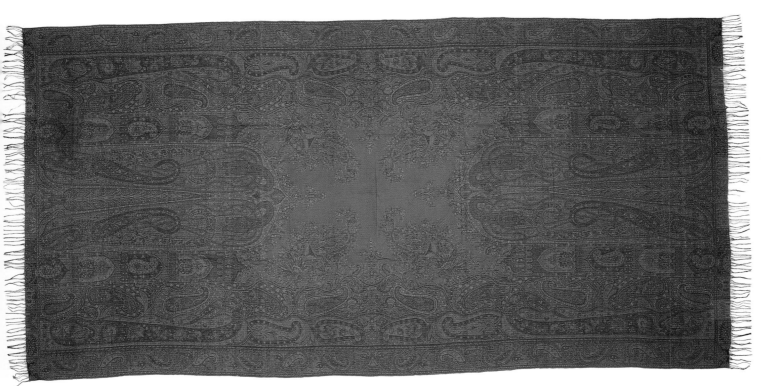

190. 63" x 128". Tight weave...wool. France, c. 1860. $700-1000

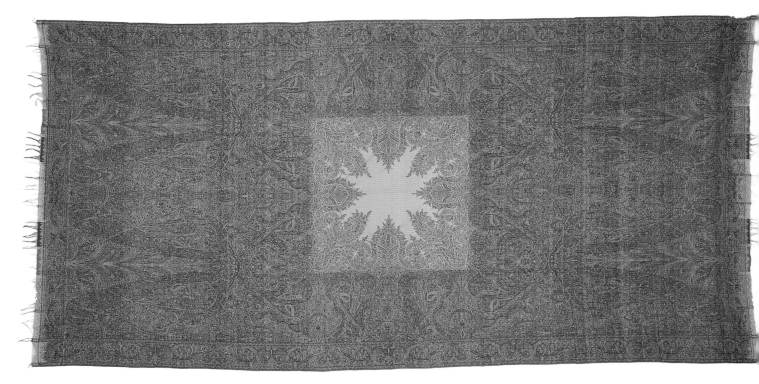

191. 63.5" x 134". Tight weave...wool. Rare blue center field. France, c. 1850. $700-1000

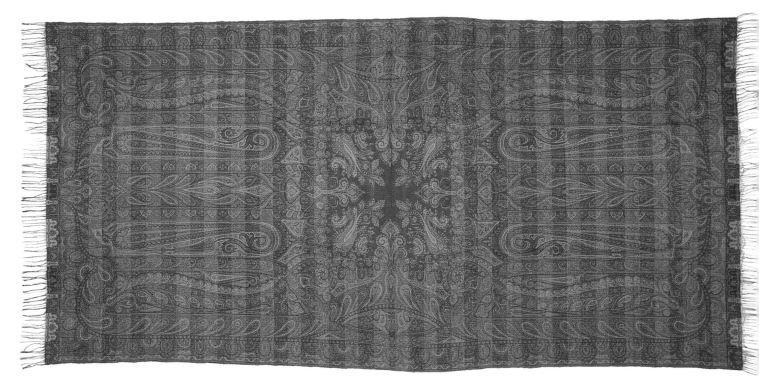

192. 58" x 120". Loose weave...cashmere wool. France, c. 1870. $500-800

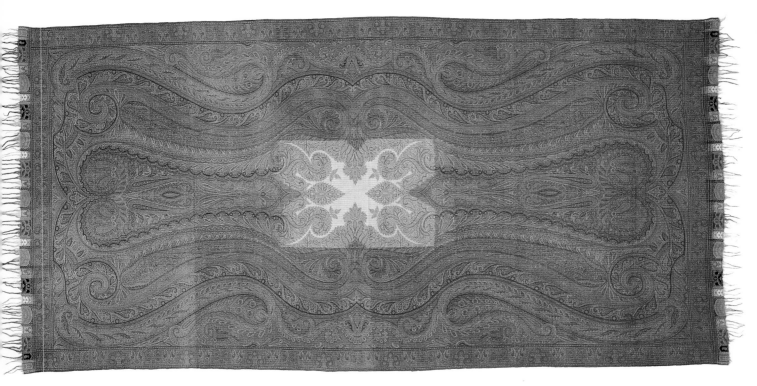

193. 59" x 112". Loose weave...wool. Rare beige center field. France, c. 1860. $500-800

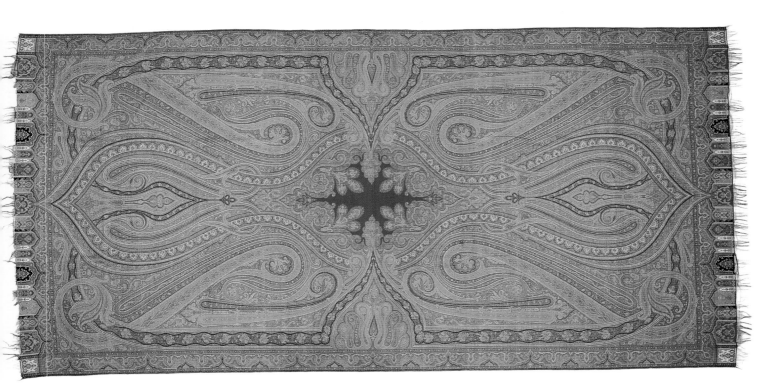

194. 61.5" x 133". Tight weave...wool. Scotland, c. 1880. $600-900

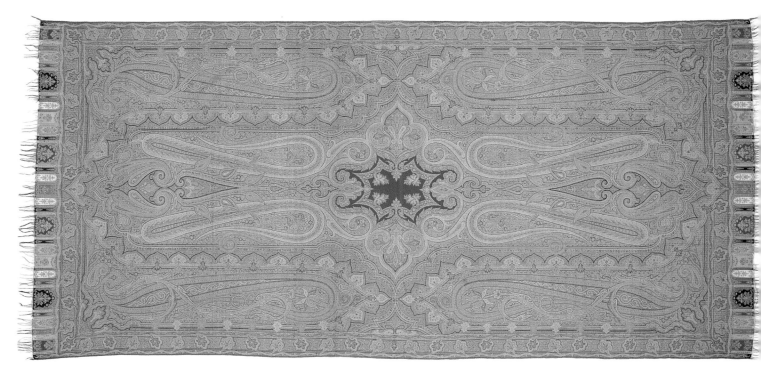

195. 60" x 130". Tight weave...wool. Scotland, c. 1880. $600-900

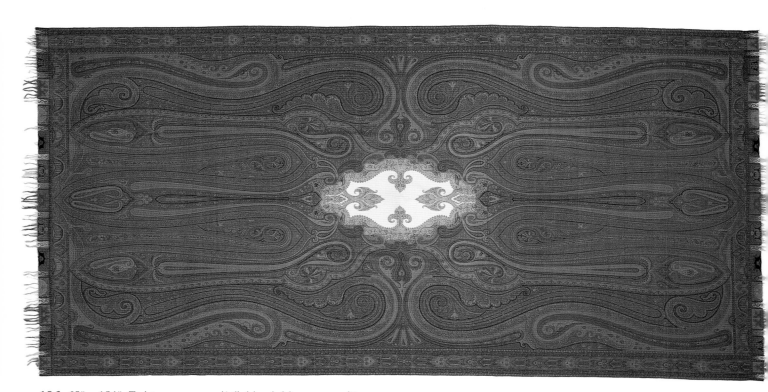

196. 63" x 131". Tight weave...wool/silk blend. Museum quality
piece. Very heavy shawl. France, c. 1860. $600-900

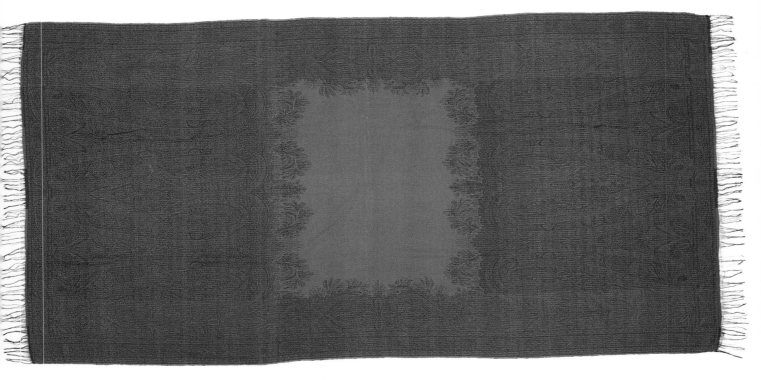

197. 60" x 121". Tight weave...wool. Attached hand knotted fringe at both ends. Museum quality piece. England, c. 1840. $700-1000

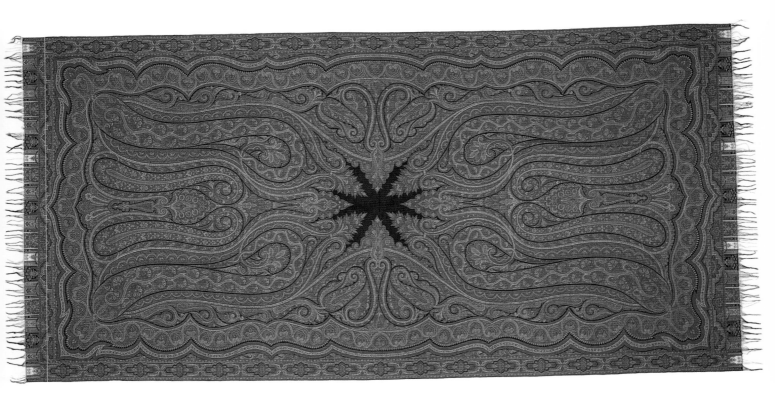

198. 61" x 126". Tight weave...wool/silk blend. Very heavy shawl. England, c. 1860. $600-900

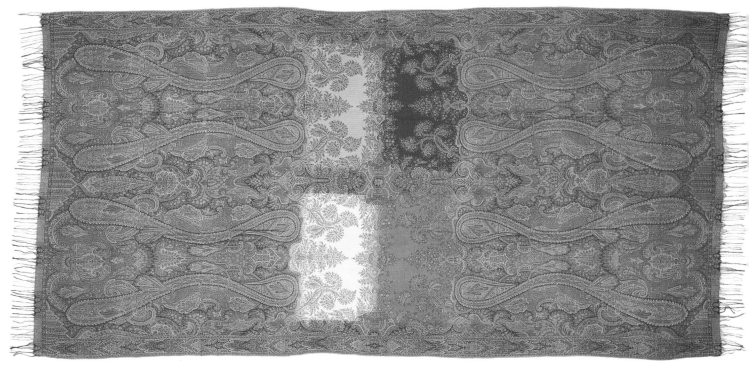

199. 62" x 120". Loose weave...wool. Four season shawl. Added gate with fringe on the long ends. France, c. 1860. $700-1000

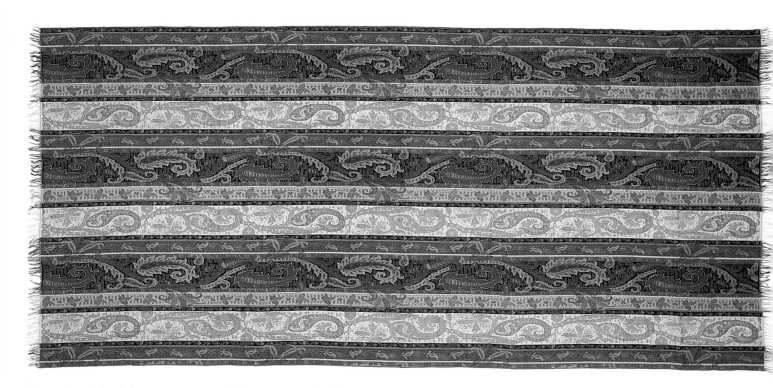

200. 58" x 126". Loose weave...wool. Roman stripe. Scotland, c. 1880. $600-900

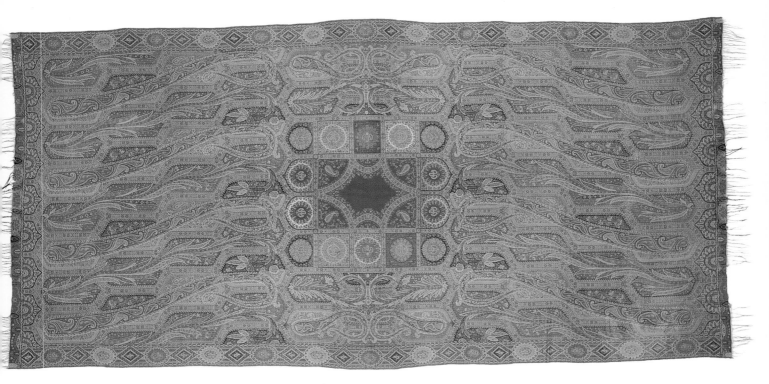

201. 61" x 125". Loose weave...wool. Unusual geometric utilizing multicolor circular designs bordering the red center field. France, c. 1850. $900-1200

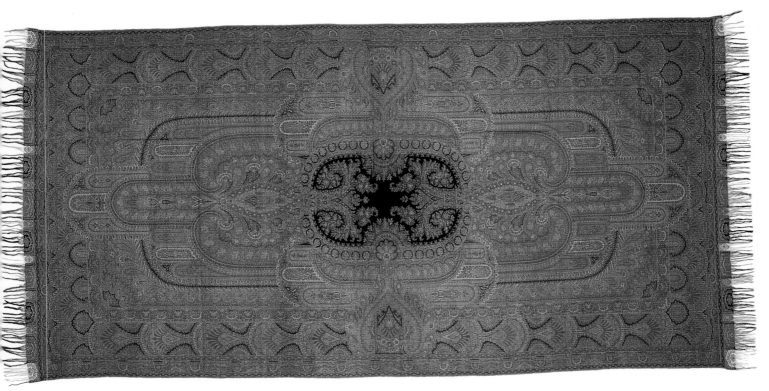

202. 61.5" x 124". Tight weave...wool. Very intricate design. See long shawl #1 for the identical design with a cream color center field. France, c. 1860. $600-900

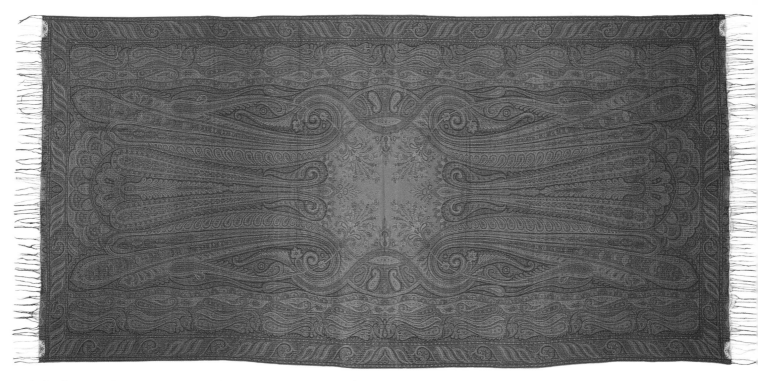

203. 60.5" x 117". Loose weave...cashmere wool. Museum quality piece. France, c. 1850. $900-1200

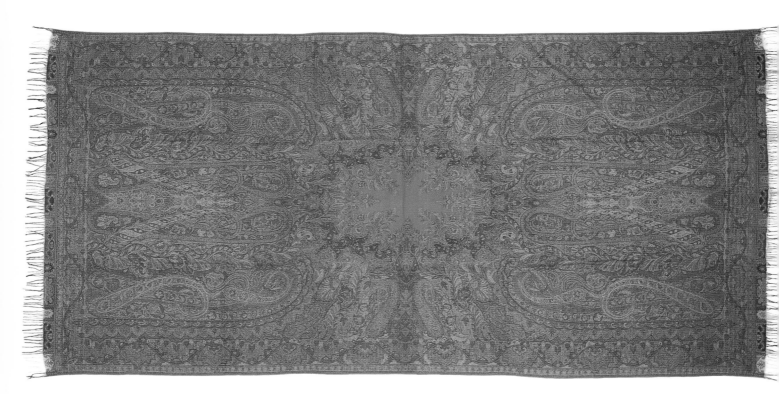

204. 60.5" x 127". Tight weave...wool. Museum quality piece. France, c. 1860. $900-1200

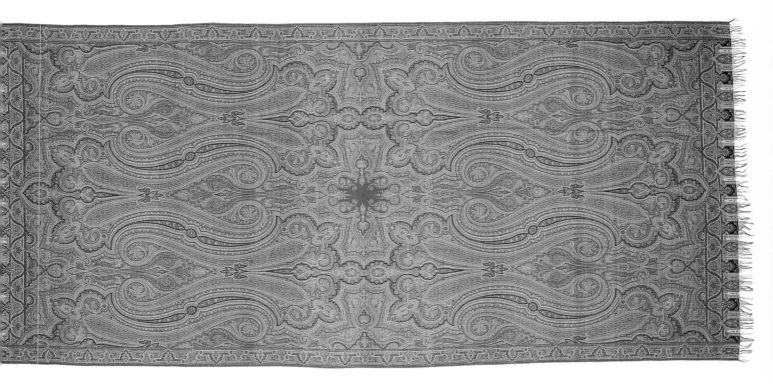

205. 61" x 132". Tight weave...wool/silk blend. Heavy shawl.
Scotland, c. 1860. $600-900

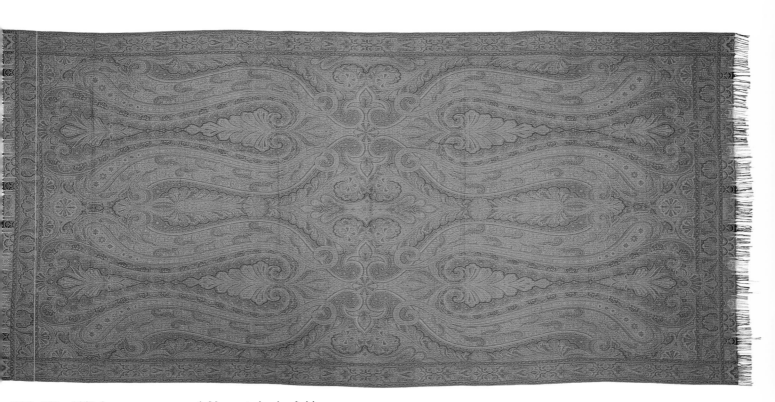

206. 65" x 132". Loose weave...wool. No central color field.
Scotland, c. 1870. $600-900

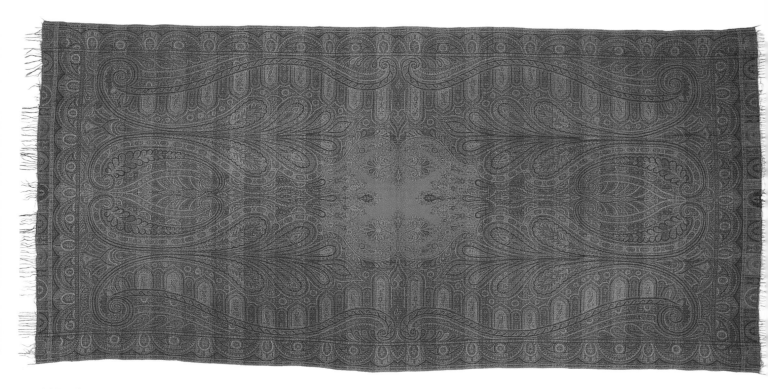

207. 52" x 111". Loose weave…cashmere wool. France, c. 1860.
$600-900

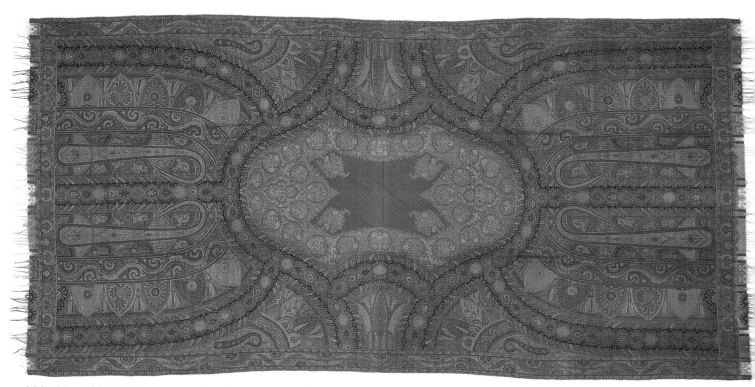

208. 66" x 123". Tight weave...wool. Museum quality piece.
France, c. 1850. $900-1200

209. 58" x 119". Tight weave...cashmere wool. Vibrant colors.
England, c. 1840. $600-900

210. 60.5" x 134". Tight weave...wool. England, c. 1840. $700-
1000

211. 61" x 127". Loose weave...wool. Scotland, c. 1880. $600-900

212. 64" x 124". Tight weave...wool. France, c. 1860. $700-1000

Square and Various Size Shawls

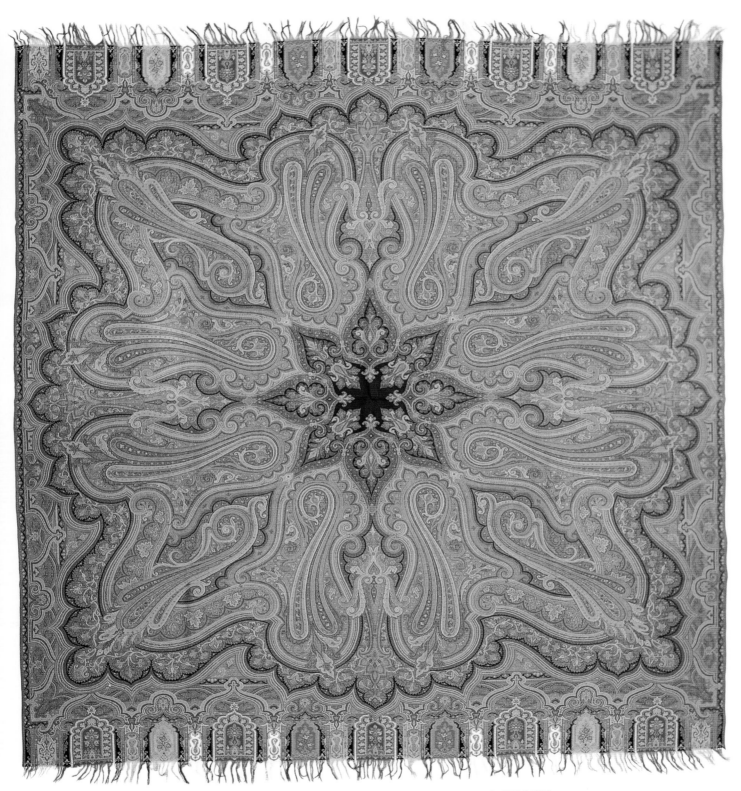

1 . 73" x 73". Tight weave...wool/silk blend. India, c. 1870. $500-700

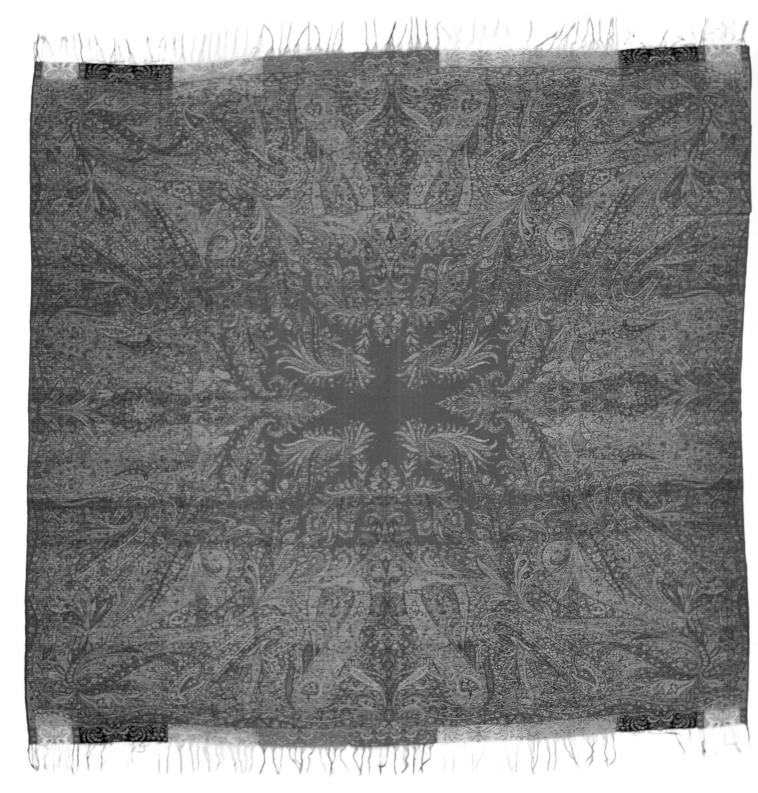

2. 67" x 72". Tight weave...wool. France, c. 1855. $500-700

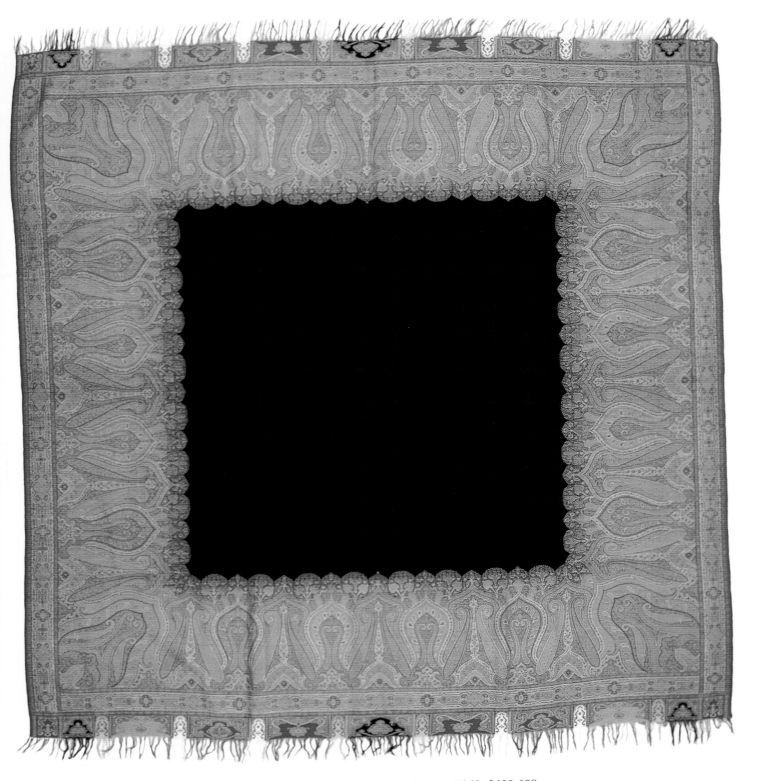

3. 70" x 72". Loose weave...wool. Scotland, c. 1860. $400-600

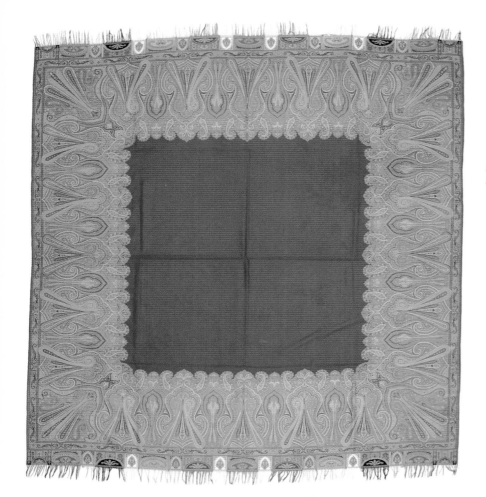

4. 74" x 74". Tight weave...wool. Scotland, c. 1865. $400-600

5. 67" x 67". Loose weave...wool. Scotland, c. 1865. $400-600

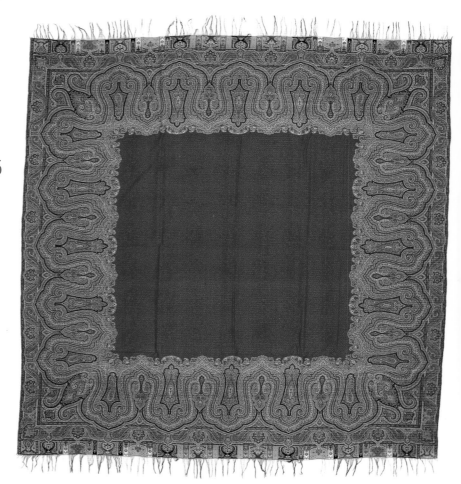

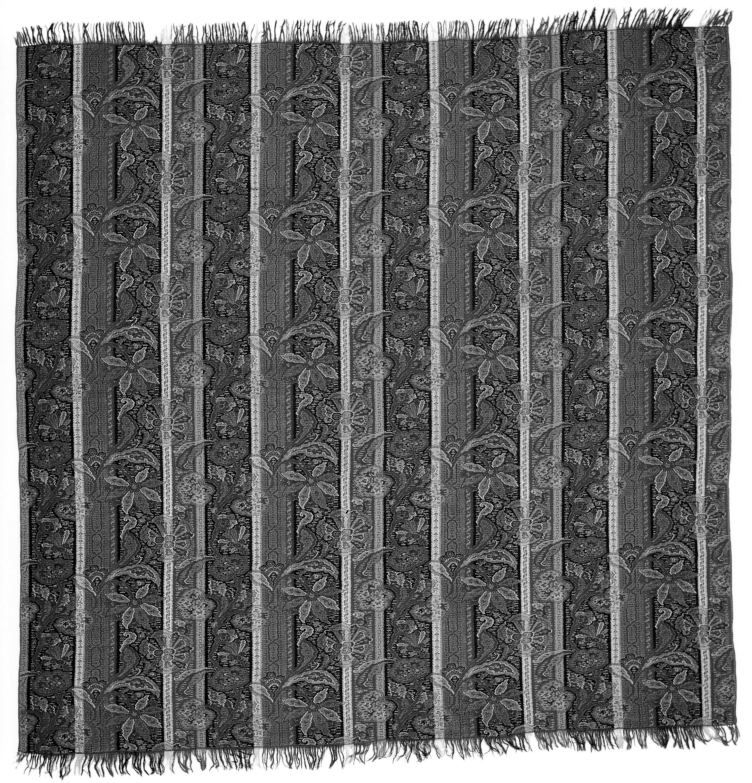

6. 67" x 67". Tight weave...wool. Roman stripe. Scotland, c. 1870. $500-700

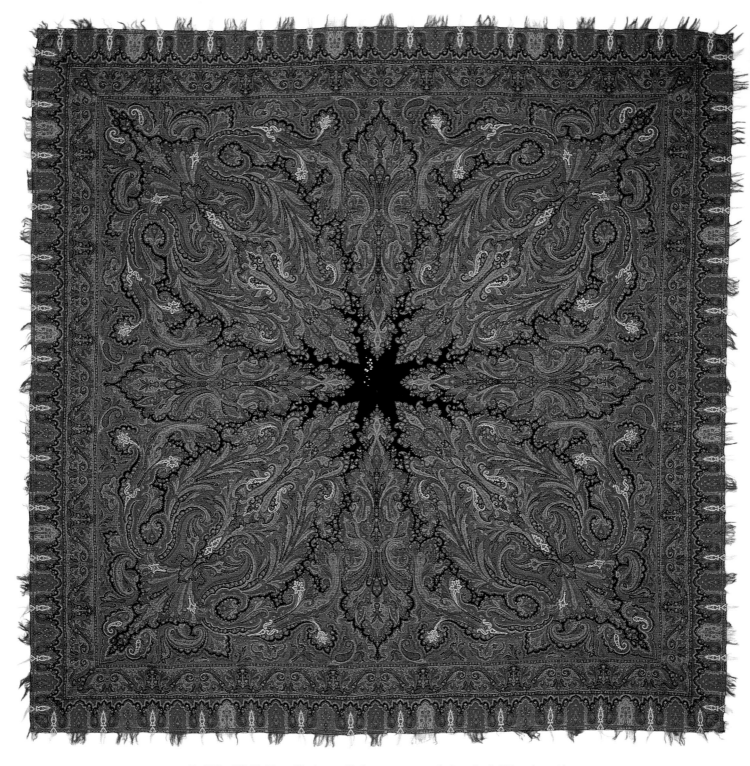

7. 70" x 70.5". Faux Kashmiri. Tight weave...wool. Attached 4" border with
fringe on all four sides. Signed in black center field. White accents. India, c. 1870. $500-800

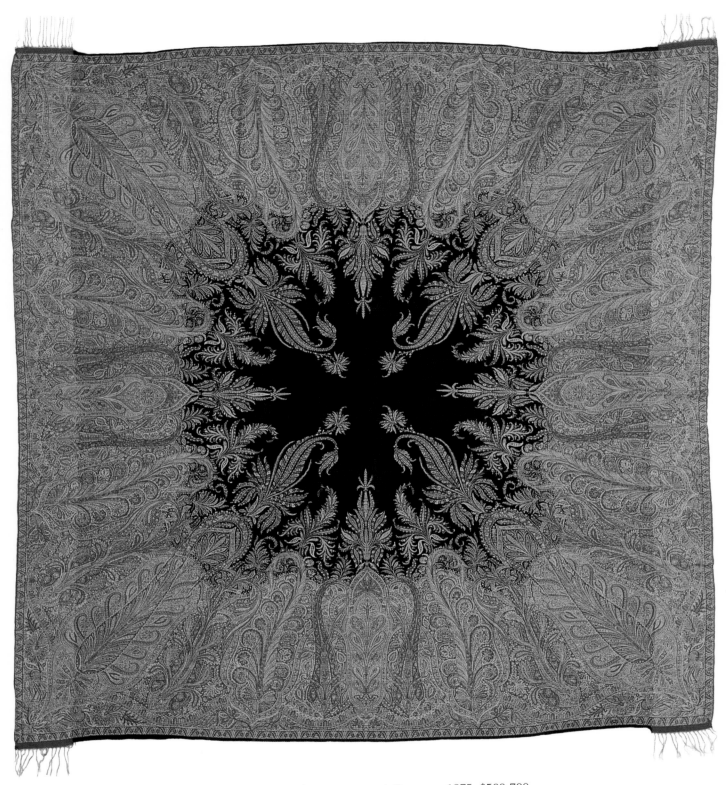

8. 70" x 74". Tight weave ...wool. France, c. 1875. $500-700

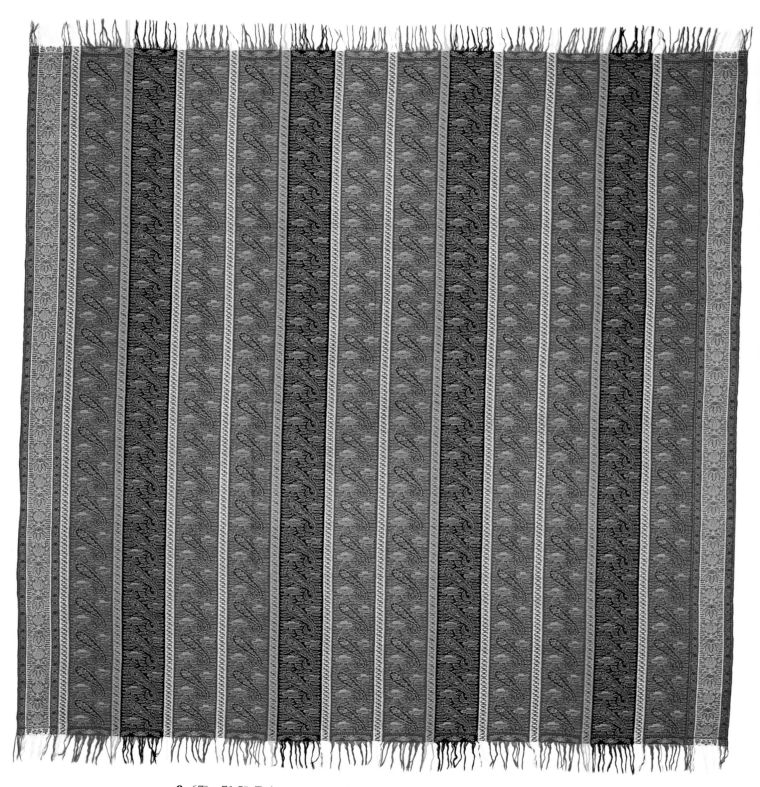

9. 67" x 71.5". Tight weave...wool. Roman stripe. Scotland, c. 1880. $500-700

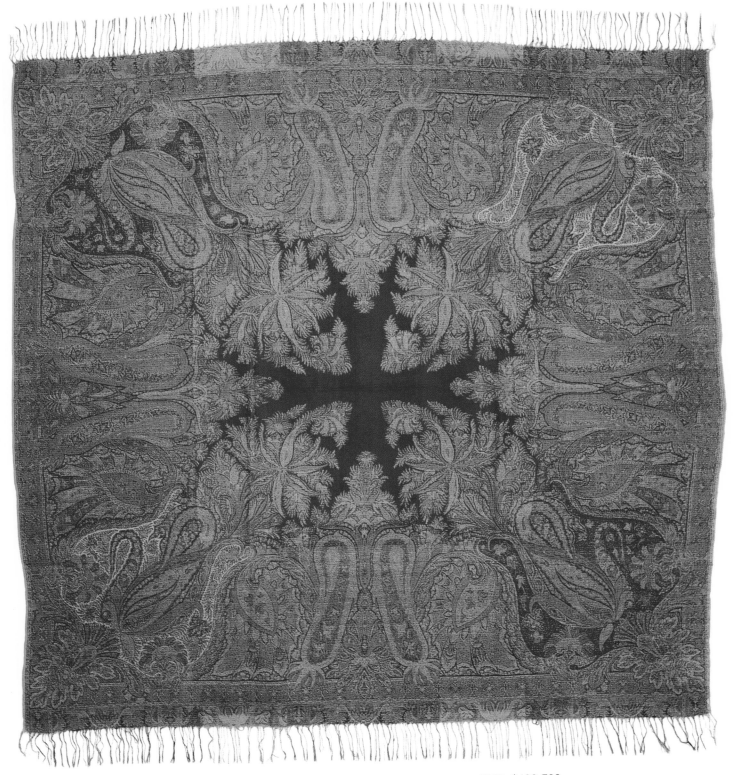

10. 60" x 61". Loose weave…cashmere wool. France, c. 1860. $400-700

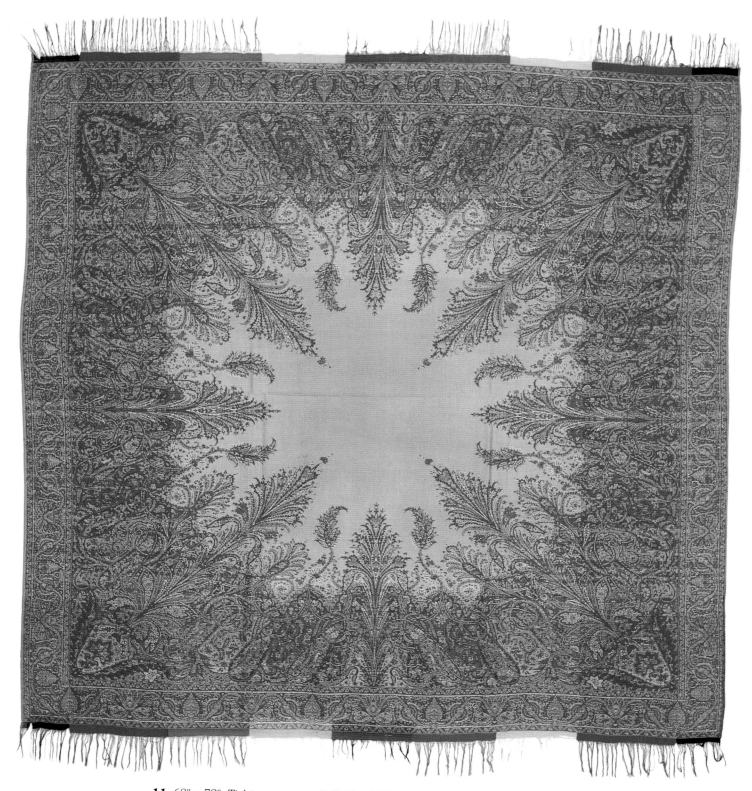

11. 68" x 72". Tight weave...wool/silk blend. Vibrant color. France, c. 1845. $600-800

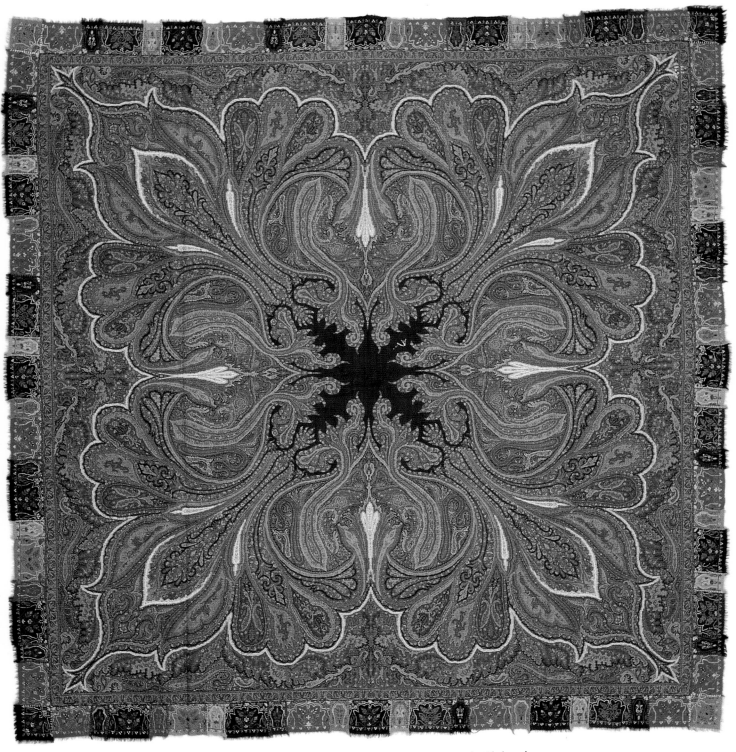

12. 66" x 67". Faux Kashmiri. Tight weave...wool with hand
embroidered gates added to four sides. Signed in black center field. White accents. India, c. 1870. $600-800

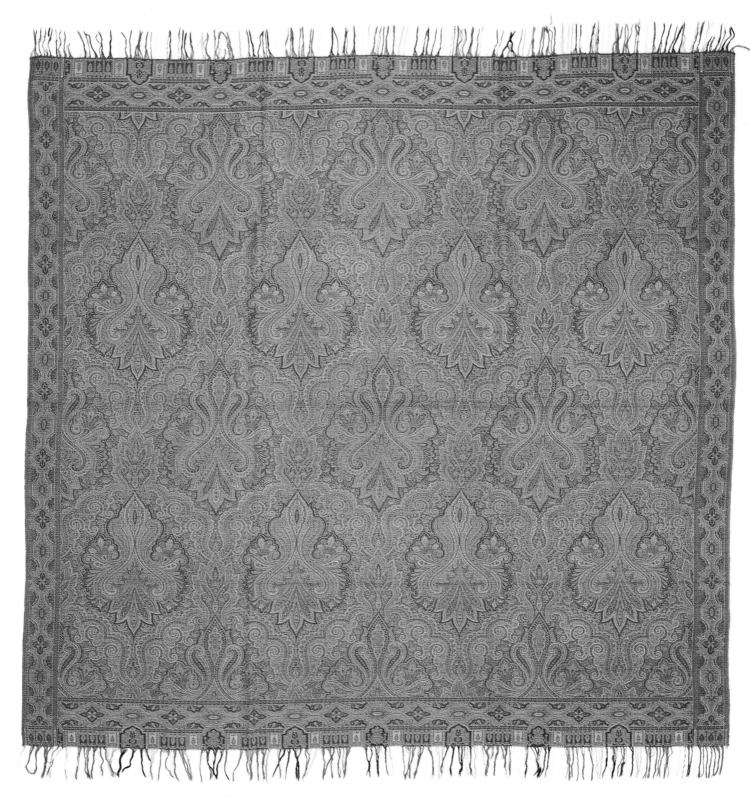

13. 67" x 67". Double weave...wool/silk blend. Reversible shawl
with added hand knotted fringe. Scotland, c. 1865. $400-600

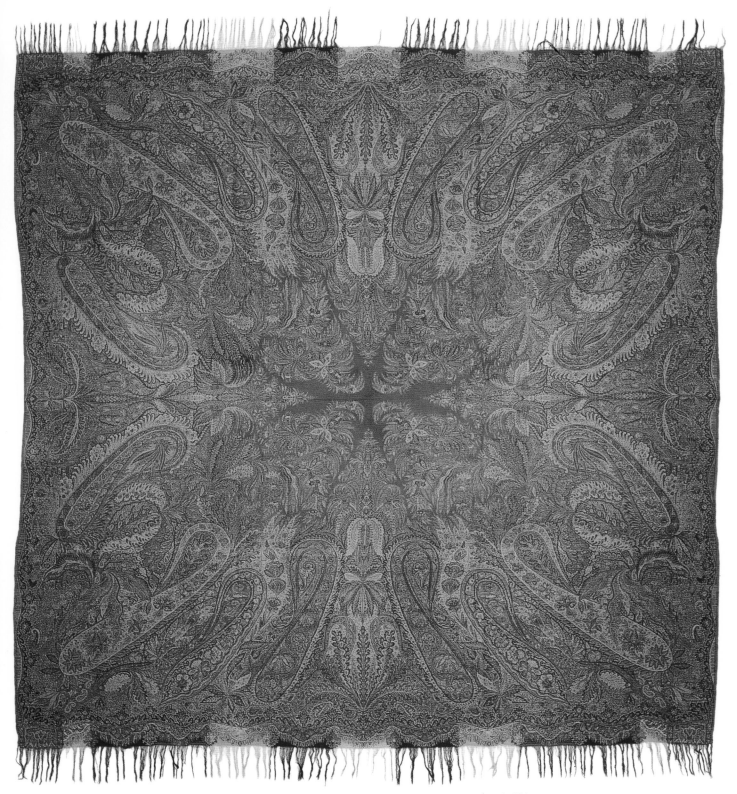

14. 68" x 69". Loose weave...wool. France, c. 1860. $400-600

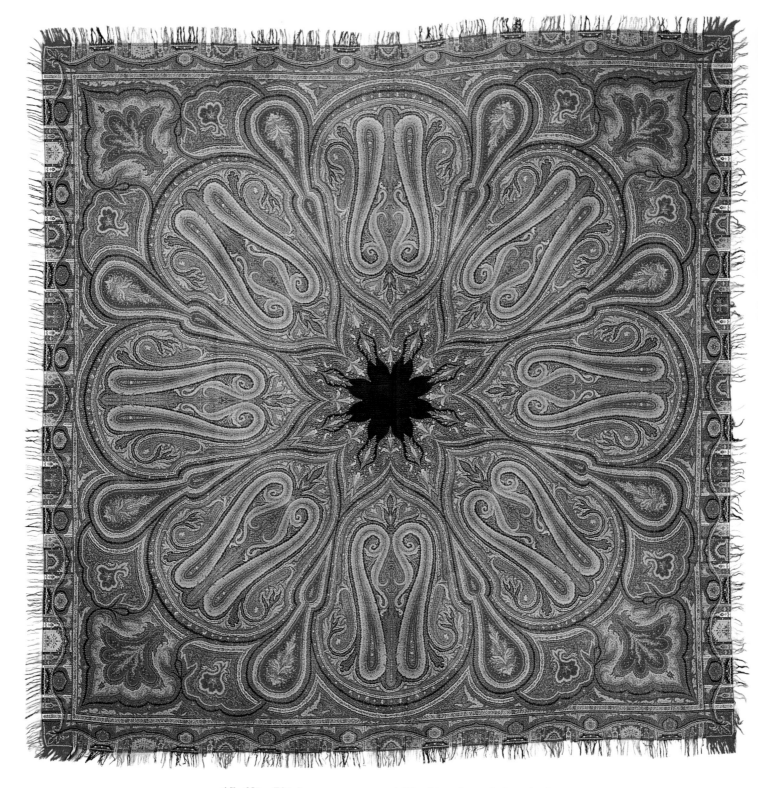

15. 68" x 70". Loose weave...wool. The fringe is made from both
the weft and warp ends to have it present on all four sides. England, c. 1865. $500-700

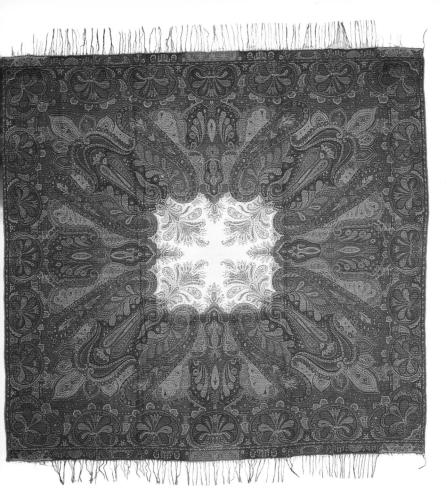

16. 65" x 66". Loose weave...cashmere wool. England, c. 1855. $400-600

17. 62" x 64". Loose weave...wool. England, c. 1875. $400-600

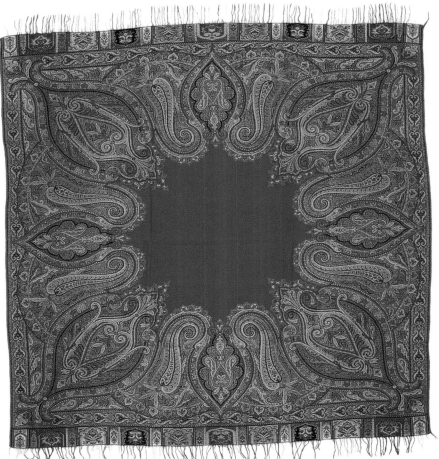

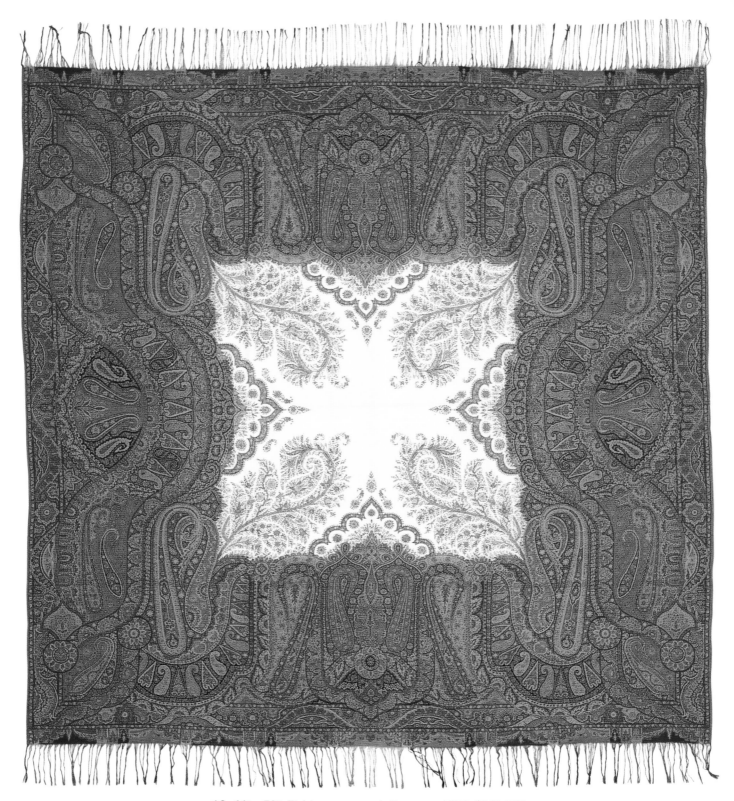

18. 66" x 70". Tight weave...wool. France, c. 1860. $500-700

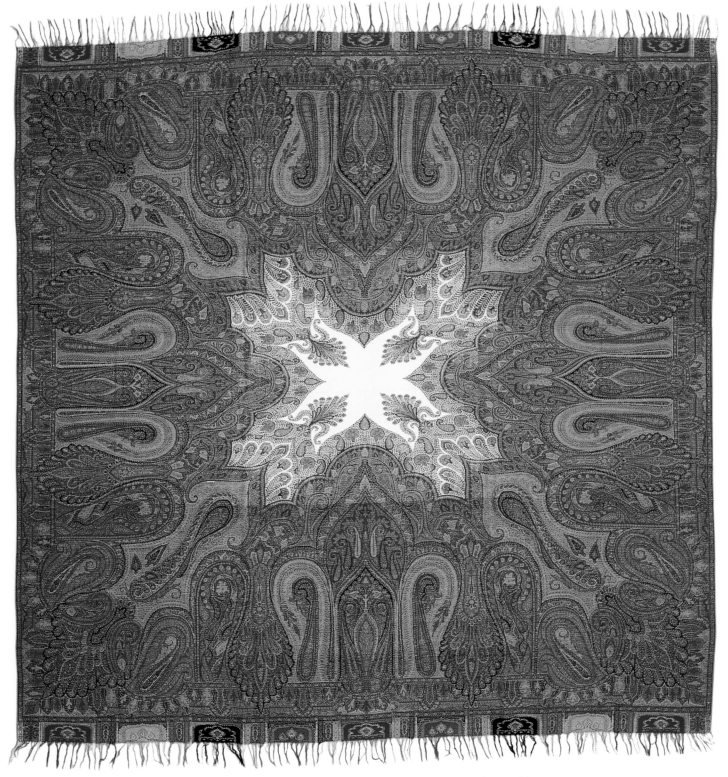

19. 66" x 67". Tight weave...wool. England, c. 1865. $500-700

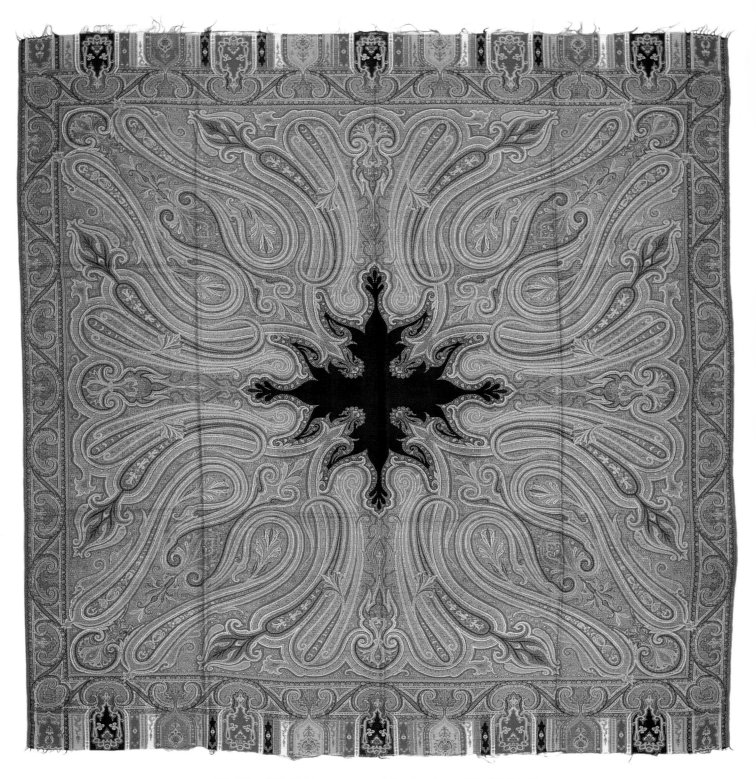

20. 69" x 69". Tight weave...wool. Scotland, c. 1880. $600-800

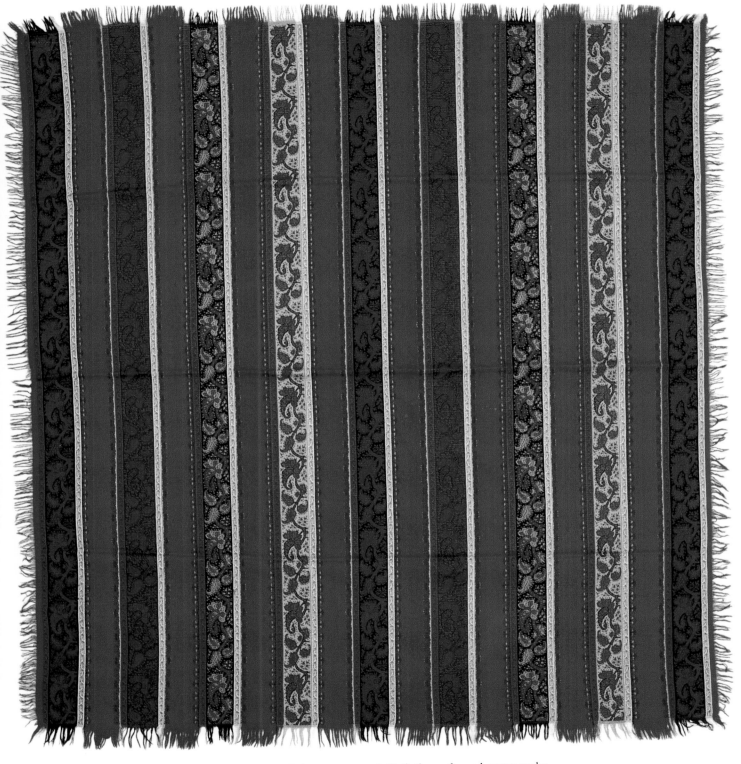

21. 66.5" x 69". Tight weave...wool. Both the wefts and warps make
up the fringe on all four sides. Vibrant red background. Scotland, c. 1880. $500-700

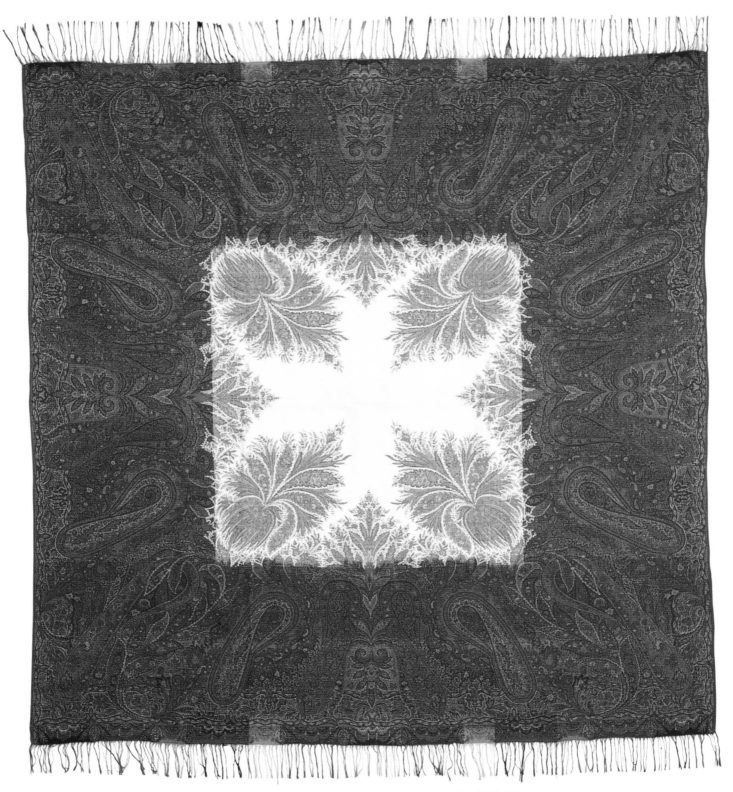

22. 64" x 68". Tight weave …wool. France, c. 1865. $500-700

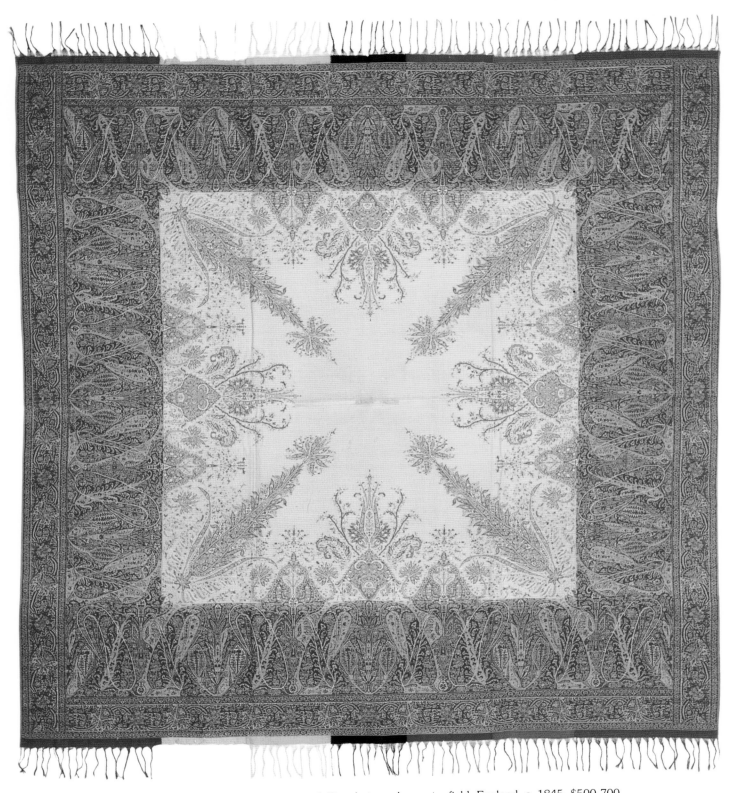

23. 68.5" x 70.5". Tight weave...wool. Rare beige color center field. England, c. 1845. $500-700

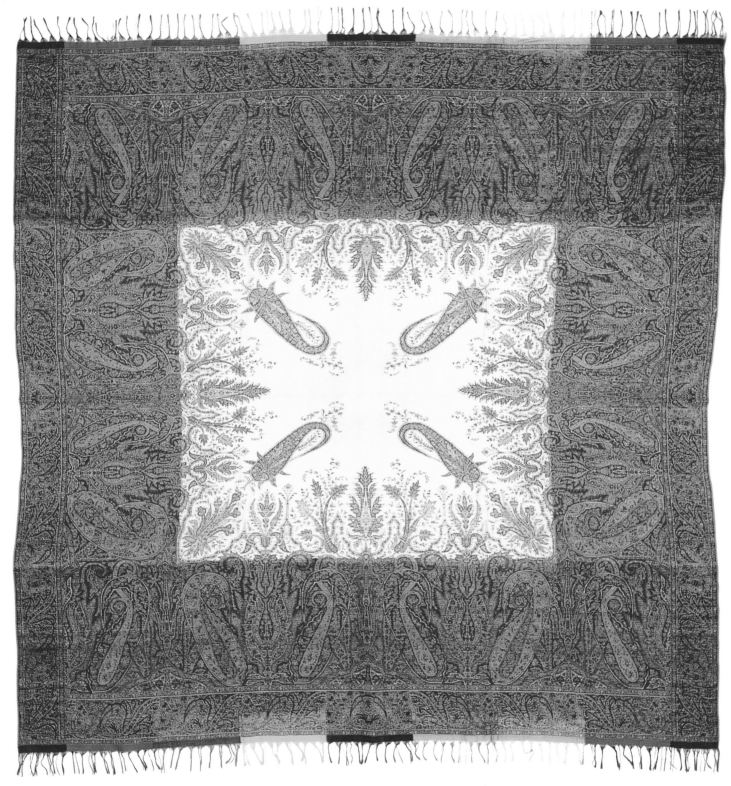

24. 69" x 70". Loose weave...wool. England, c. 1845. $500-700

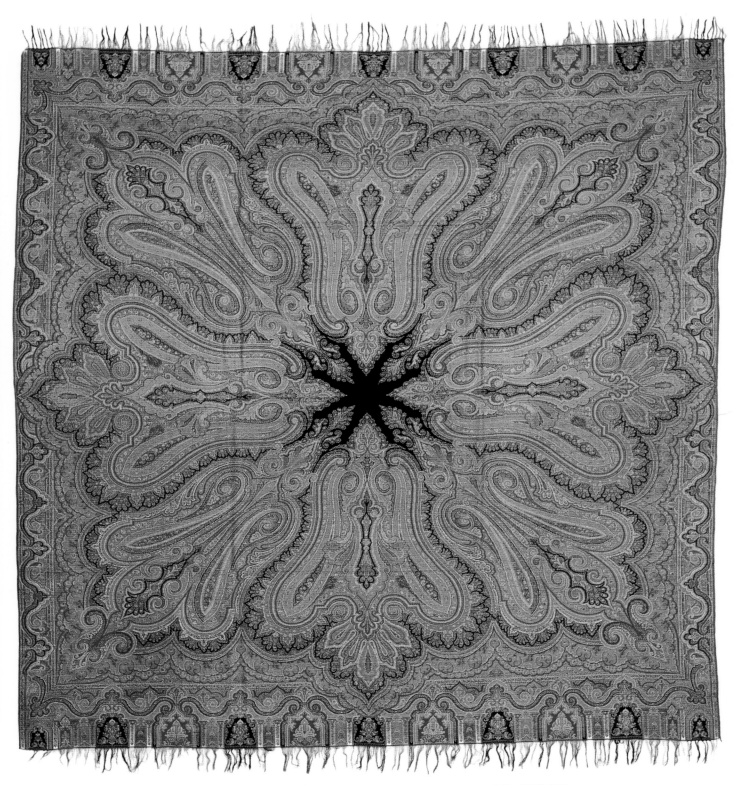

25. 68" x 69.5". Tight weave...wool/silk blend. Scotland, c. 1870. $600-800

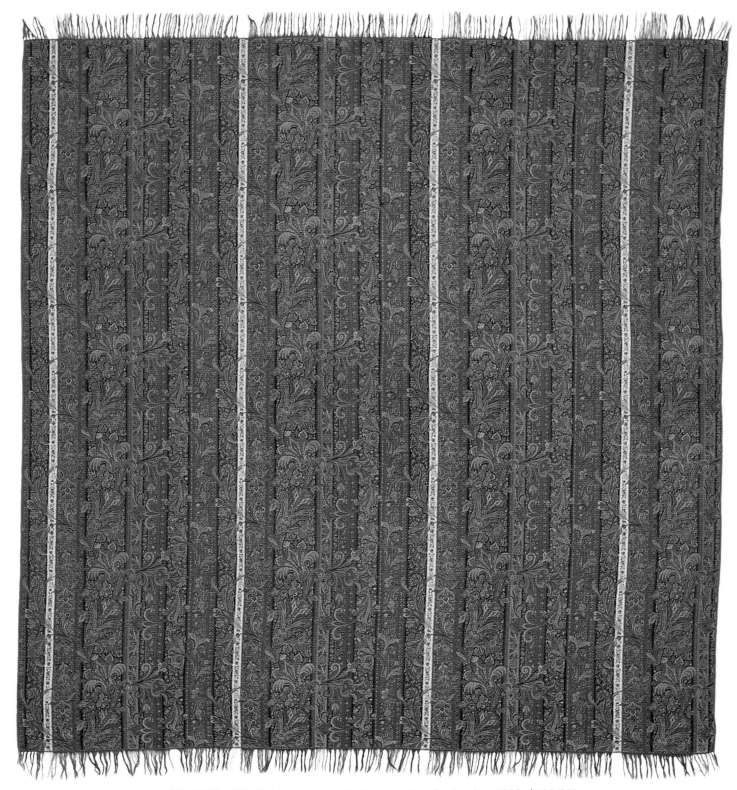

26. 66.5" x 70". Tight weave...wool. Roman stripe. Scotland, c. 1880. $500-700

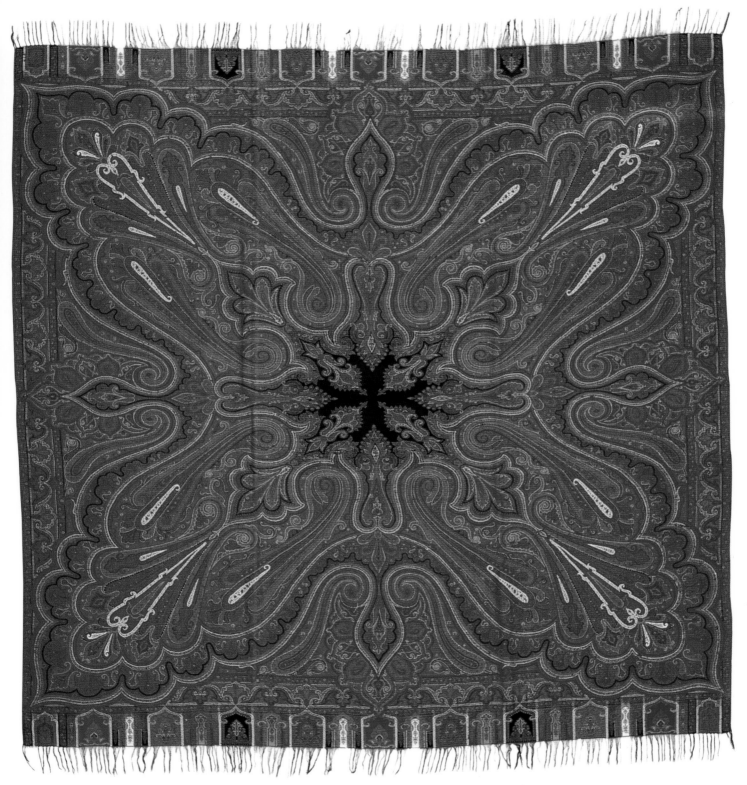

27. 68" x 69". Loose weave...wool. White accents. India, c. 1880. $600-800

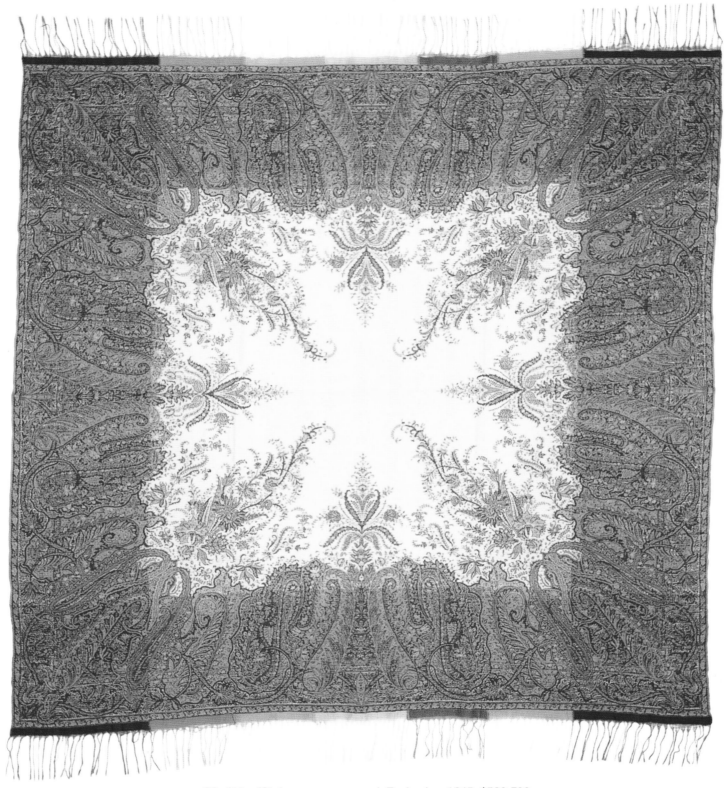

28. 61" x 62". Loose weave...wool. England, c. 1845. $500-700

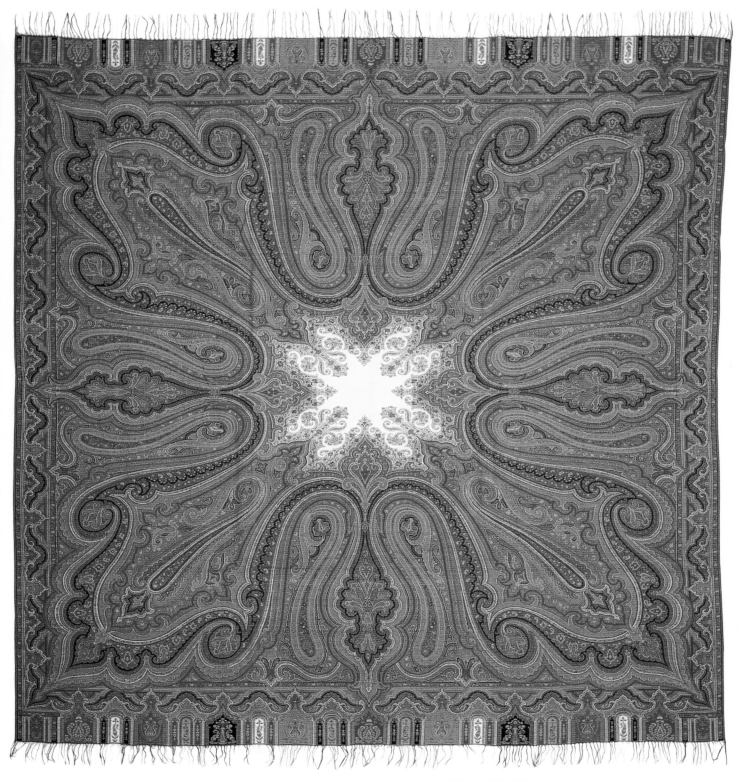

29. 70.5" x 74". Tight weave...wool. India, c. 1880. $400-600

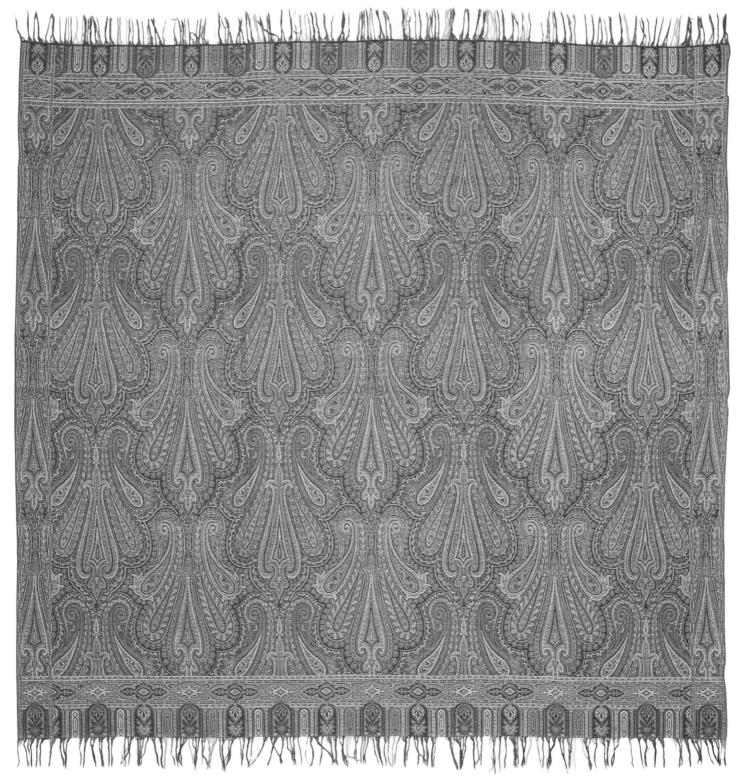

30. 64" x 66.5" Double weave...wool. Reversible shawl.
Individual hand knotted fringe added. Scotland, c. 1885. $400-600

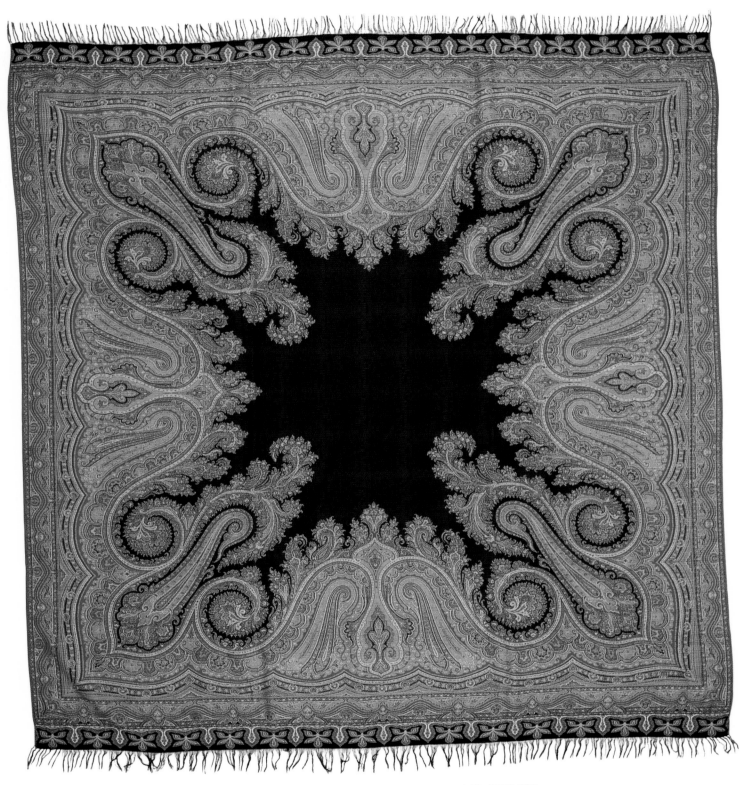

31. 70" x 70". Tight weave...wool. England, c. 1860. $500-700

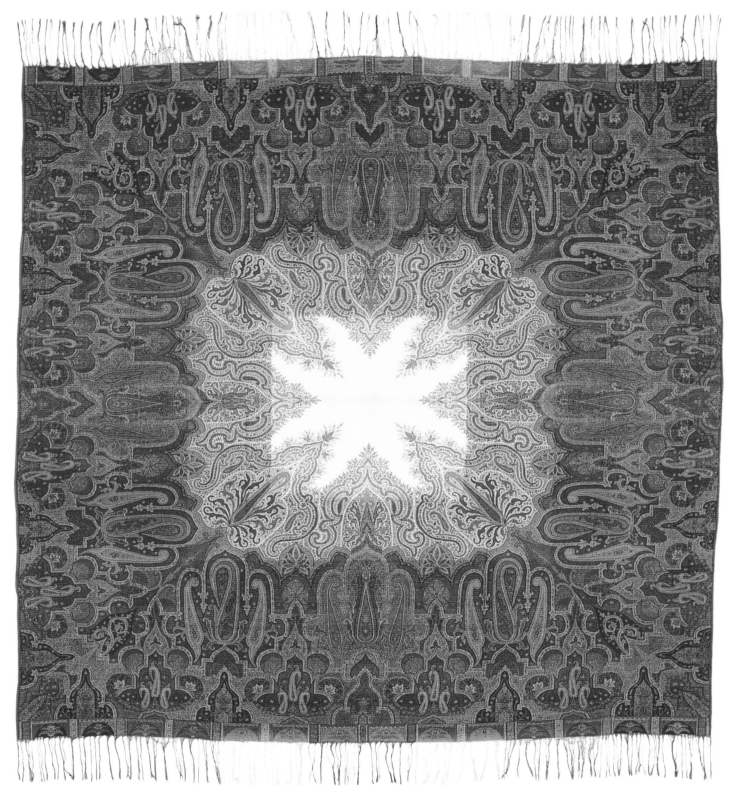

32. 65" x 66". Loose weave...wool. India, c. 1850. $500-700

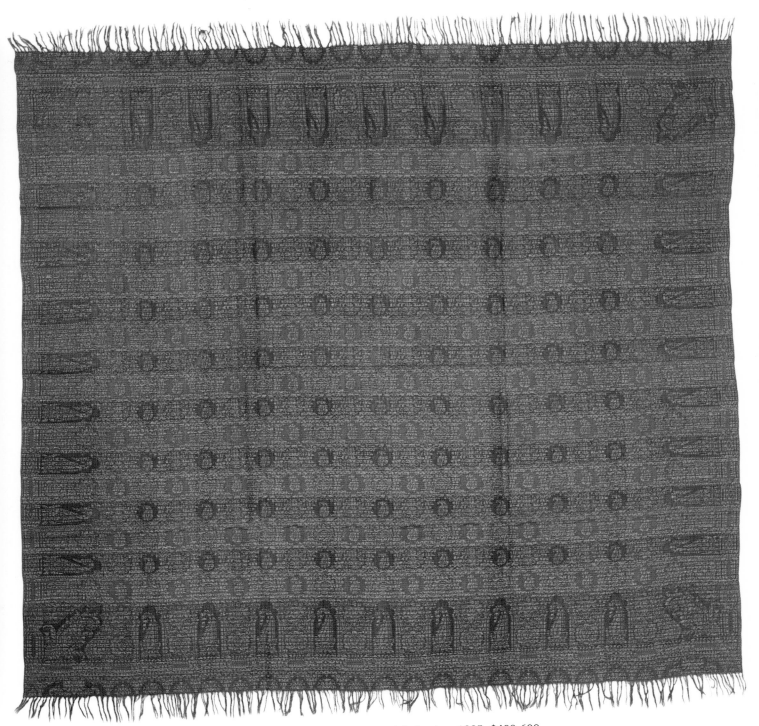

33. 60" x 68". Tight weave...wool. Ireland, c. 1885. $400-600

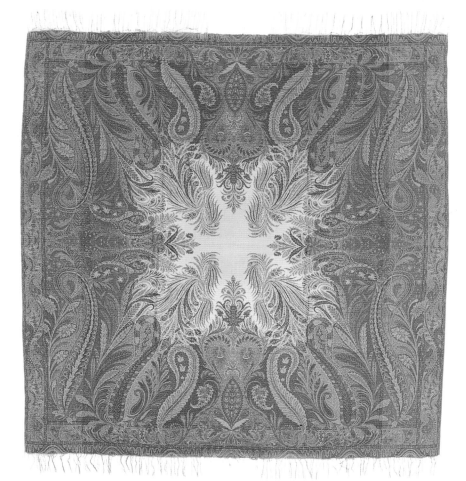

34. 65" x 68". Loose weave...cashmere wool. Note that #35 and #36 have the same design with different color center fields. France, c. 1850. $400-600

35. 65" x 68". Loose weave...cashmere wool. France,1850. $400-600

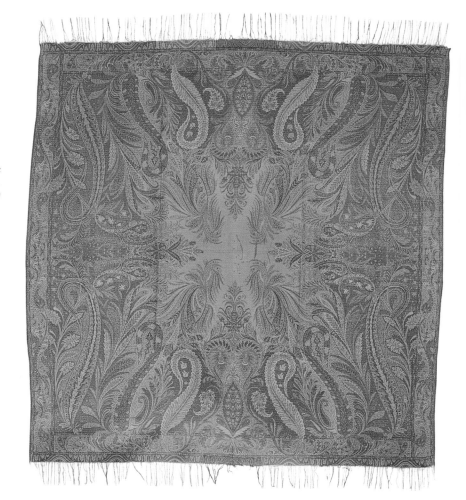

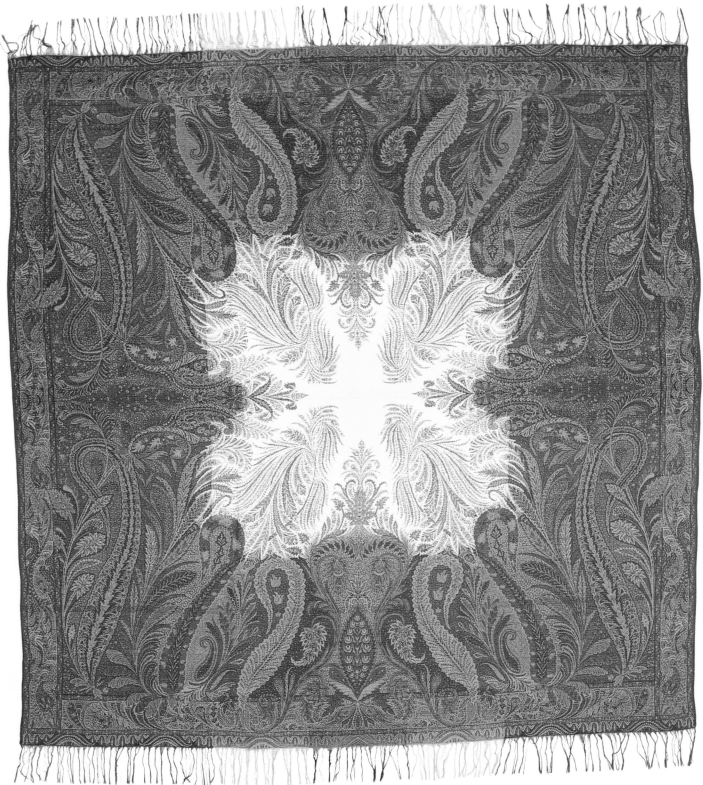

36. 67" x 72". Tight weave...wool. This shawl has a different weave
from both #34 and #35. France, c. 1850. $500-700

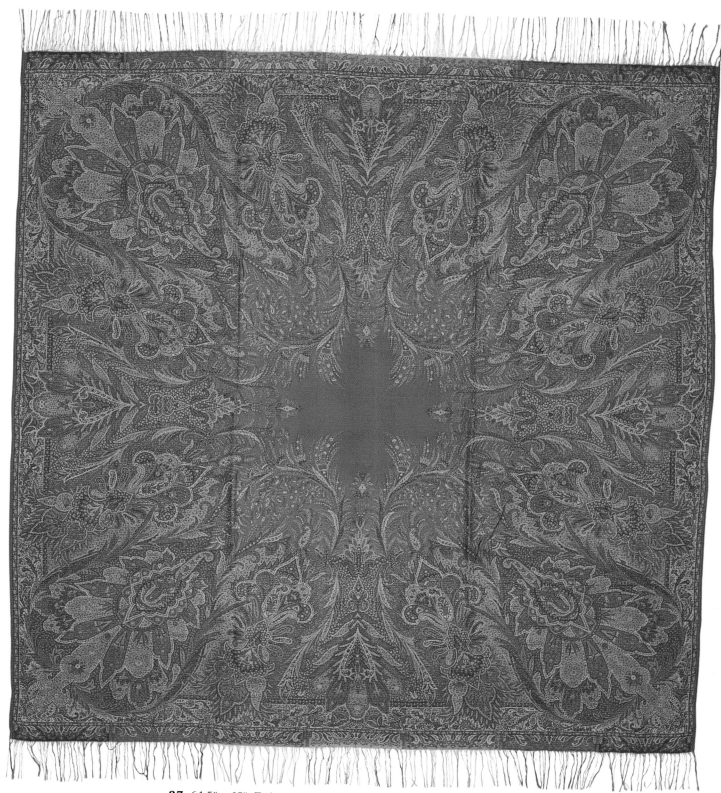

37. 64.5" x 68". Tight weave...cashmere wool. France, c. 1855. $600-800

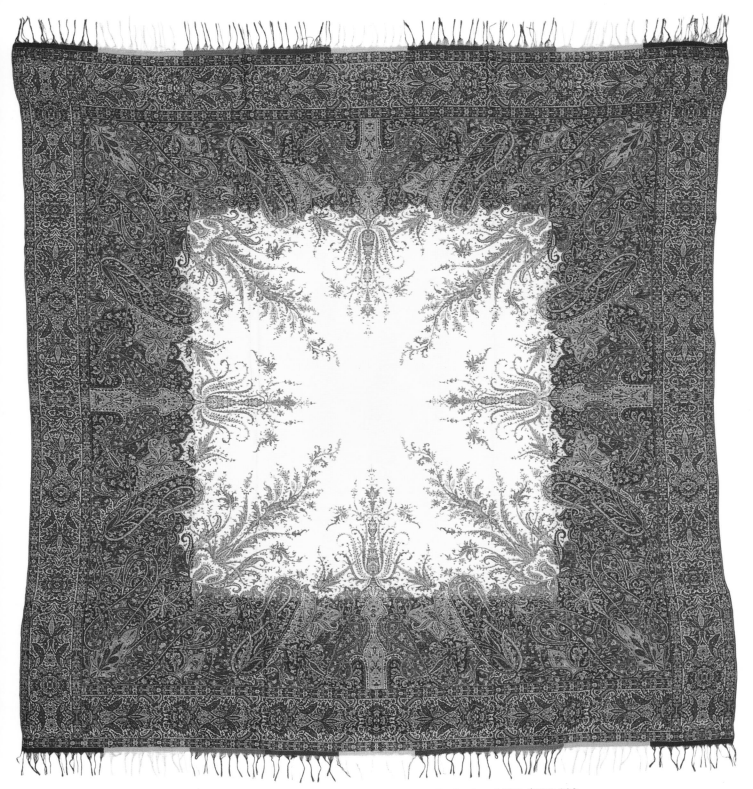

38. 66" x 68". Tight weave...wool. Vibrant colors. England, c. 1850. $600-800

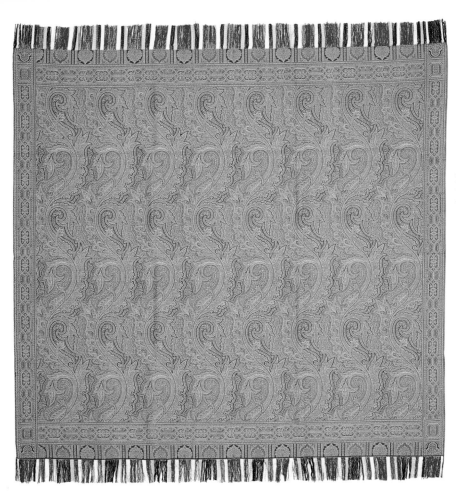

39. 68" x 70" Double weave...wool/silk blend. Reversible shawl with individual knotted fringe attached. Very heavy shawl. Scotland, c. 1880. $400-600

40. 60.5" x 64". Tight weave...wool. Vibrant colors. England, c. 1840. $500-700

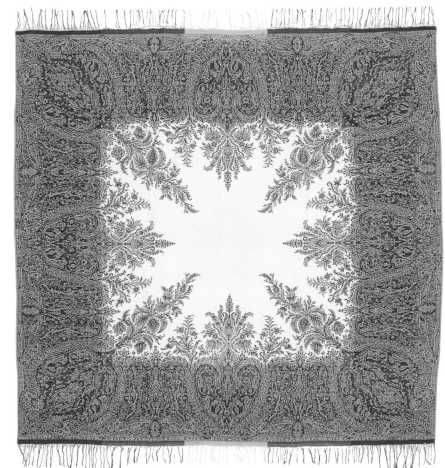

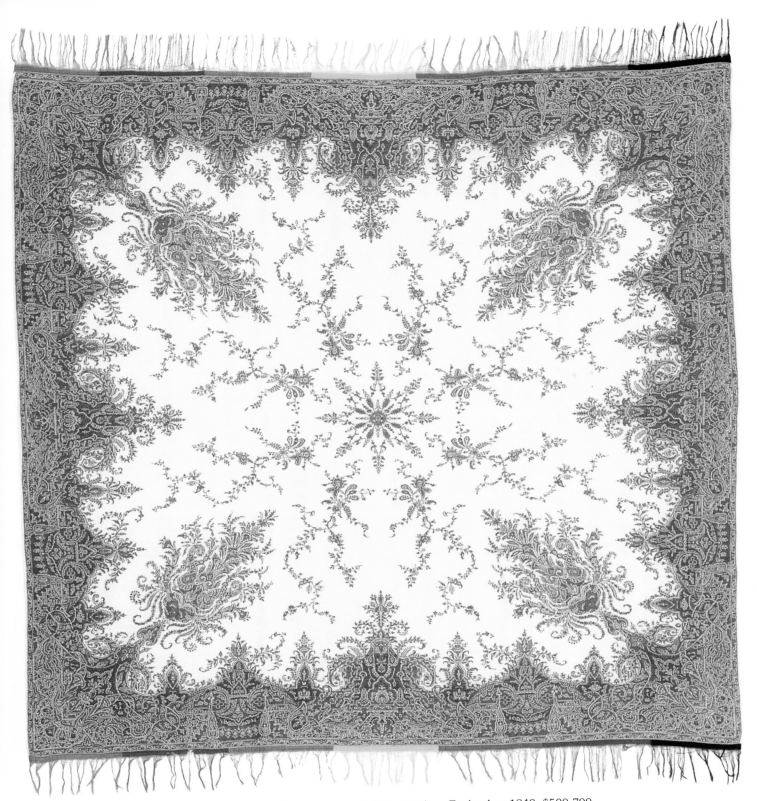

41. 67.5" x 69.5". Tight weave...wool. Vibrant colors. England, c. 1840. $500-700

163

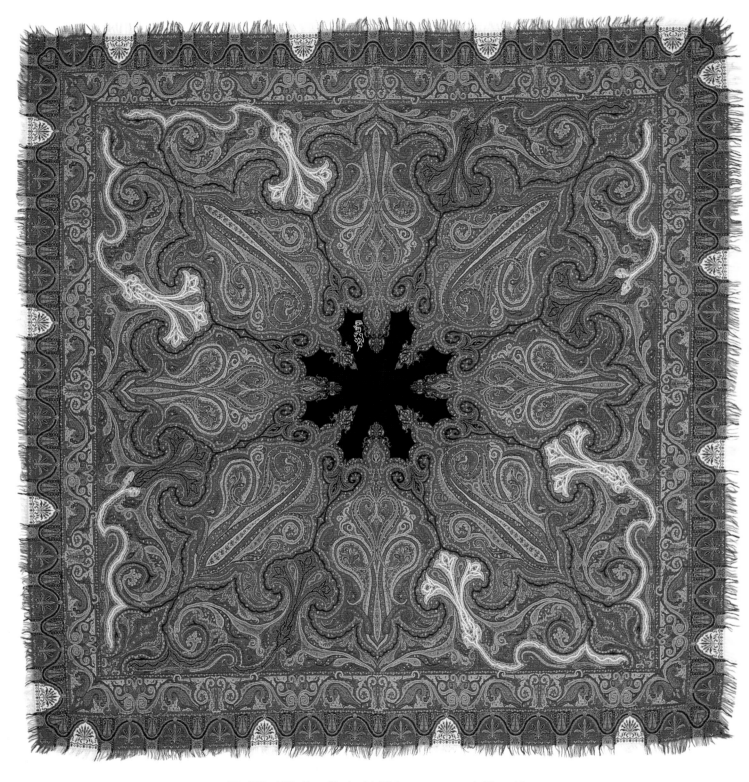

42. 72" x 72". Faux Kashmiri. Tight weave...wool. Signed in black center field. Very heavy shawl. India, c. 1860. $600-800

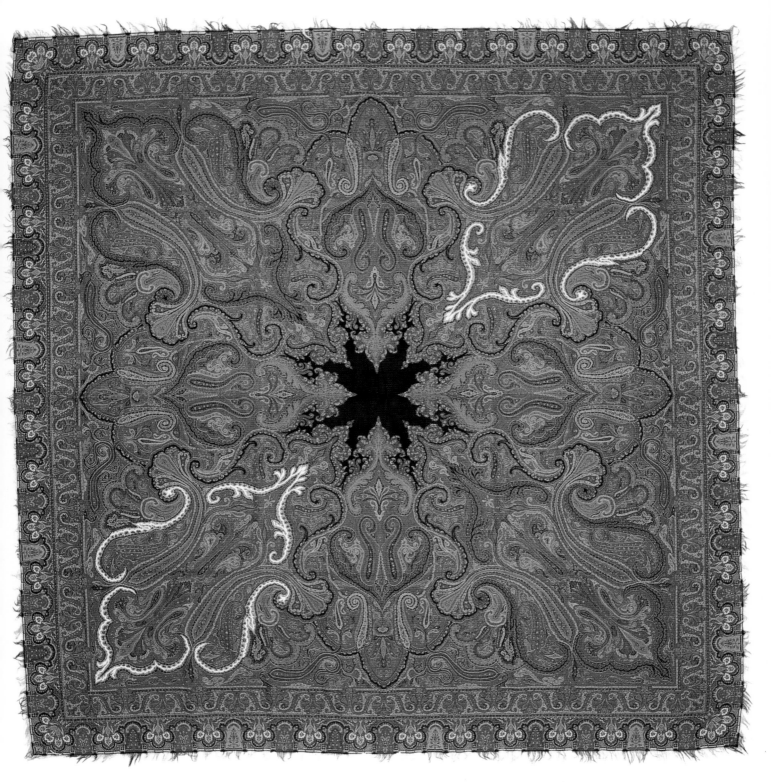

43. 71.5" x 70". Faux Kashmiri. Tight weave...wool. Attached gates and fringe on all four sides. White accents. India, c. 1860. $600-800

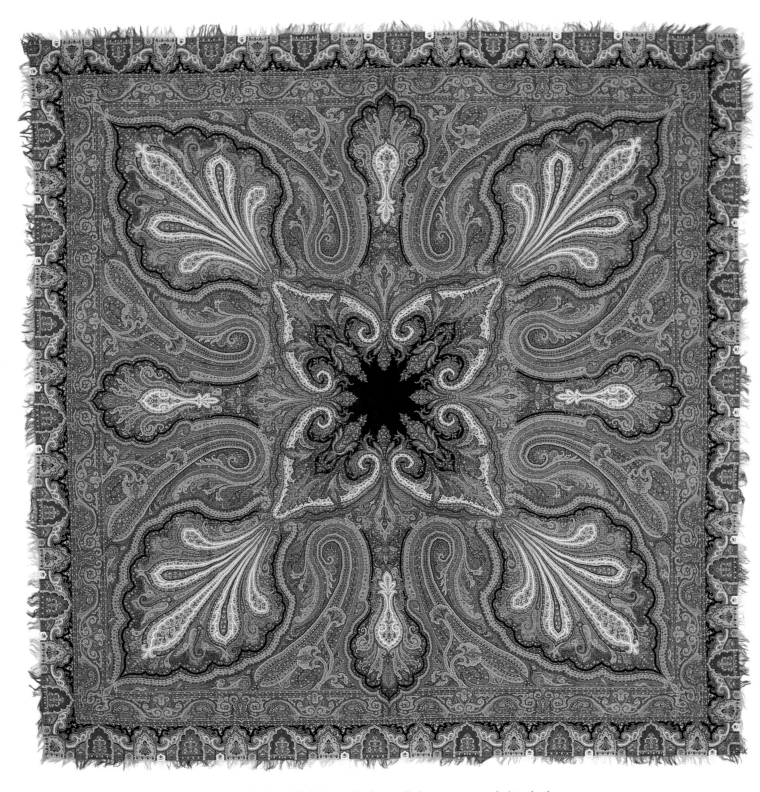

44. 71.5" x 69.5". Faux Kashmiri. Tight weave...wool. Attached
gates and fringe on all four sides. White accents. Very heavy shawl. India, c. 1860. $600-800

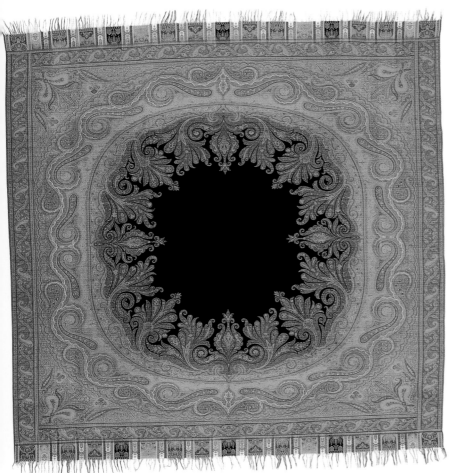

45. 72" x 74". Tight weave...wool/silk blend. Unusual circular pattern. India, c. 1860. $400-600

46. 57" x 60". Loose weave...cashmere wool. France, c. 1850. $400-600

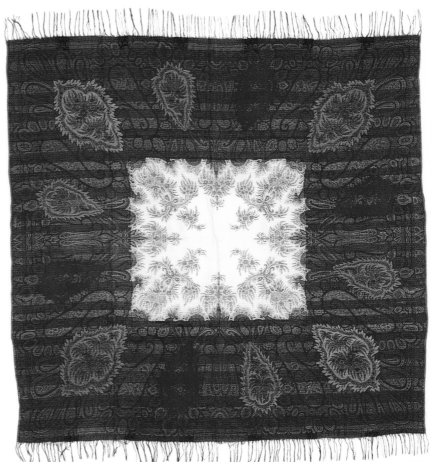

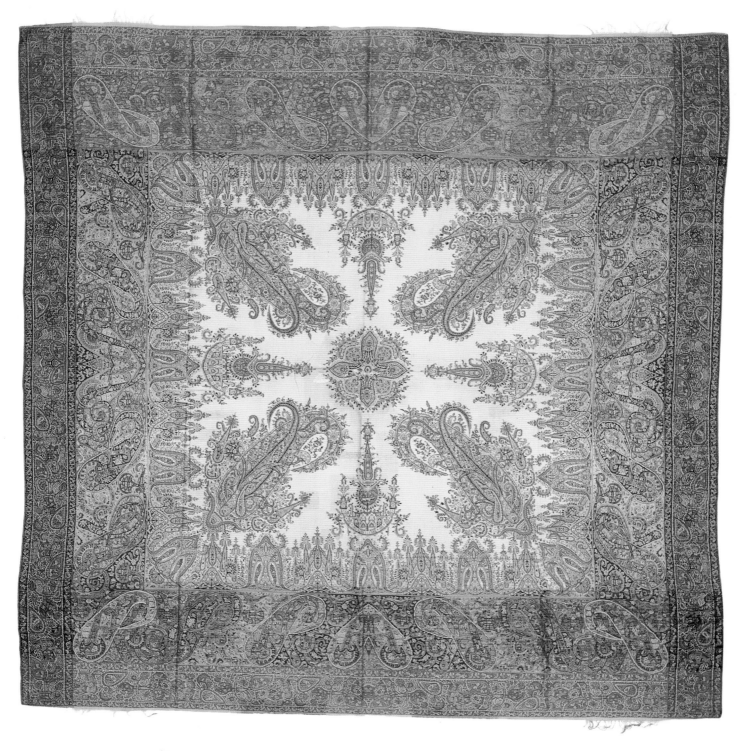

47. 74" x 80". Tight weave...wool/silk blend. Beige center field. Of note, this is the oldest shawl in my collection. The material is exceptionally fragile and very thin. England, c. 1830. $600-800

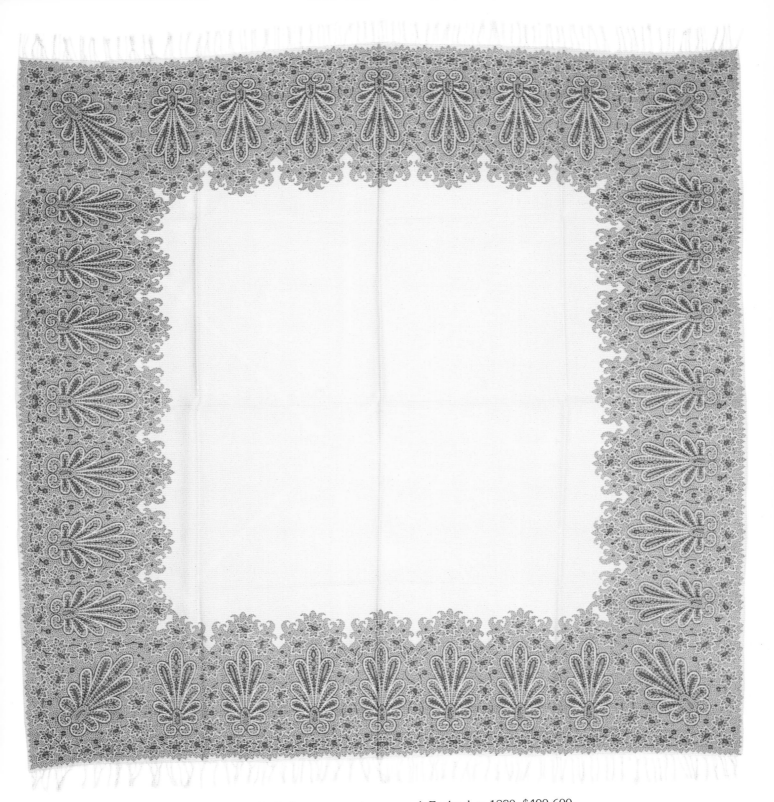

48. 61" x 63". Tight weave...cashmere wool. England, c. 1880. $400-600

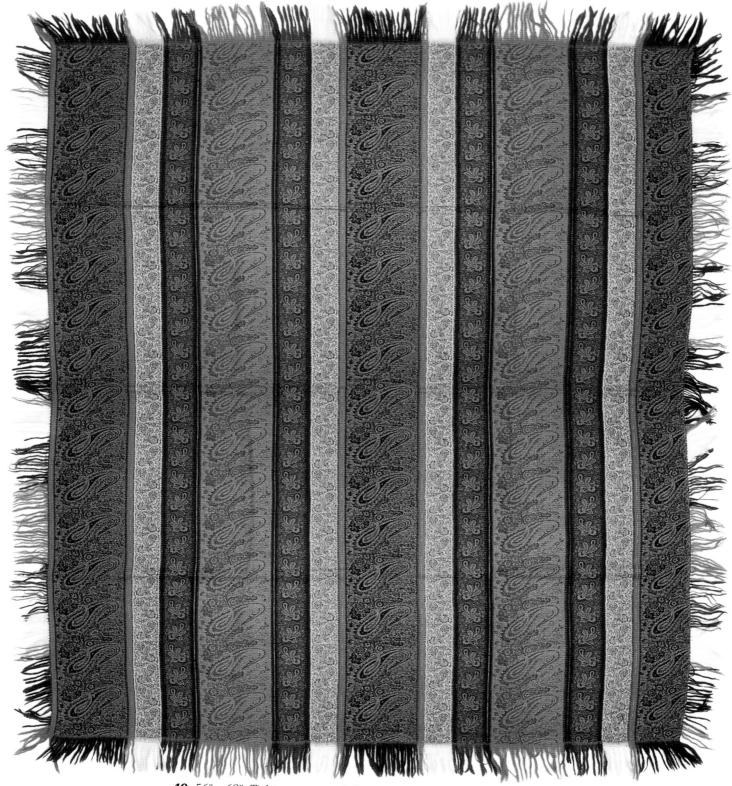

49. 56" x 62". Tight weave...wool. Roman stripe with attached individual hand knotted fringe on two sides giving the shawl fringe on all four sides. England, c. 1880. $400-600

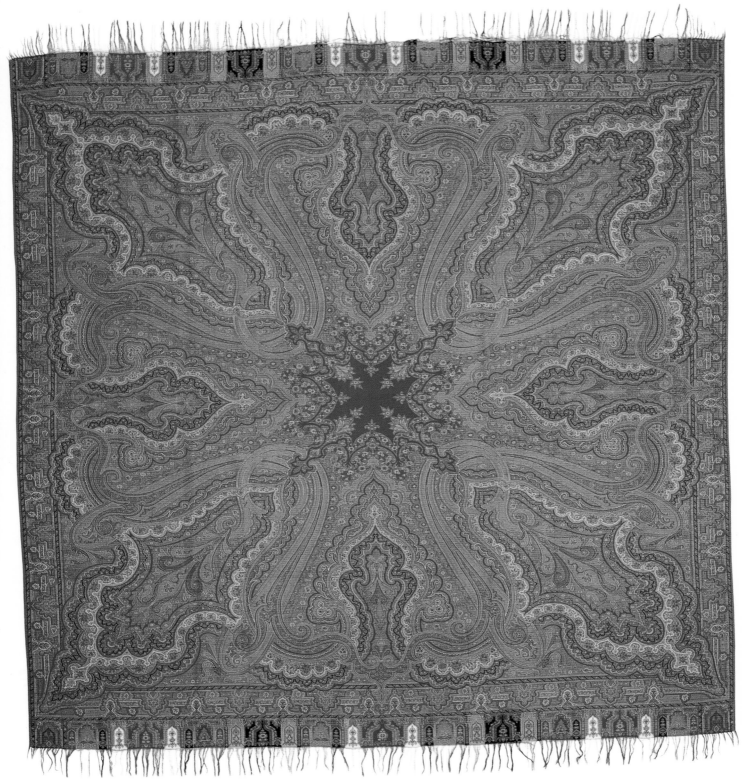

50. 70.5" x 70". Tight weave...wool. White accents. Scotland, c. 1870. $500-700

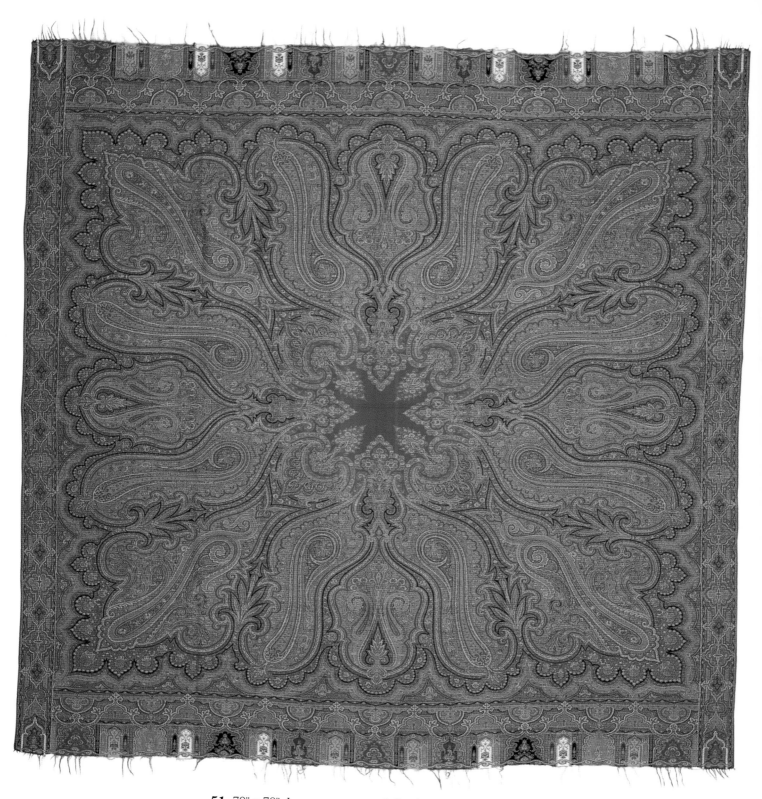

51. 70" x 70". Loose weave...wool. Scotland, c. 1870. $400-600

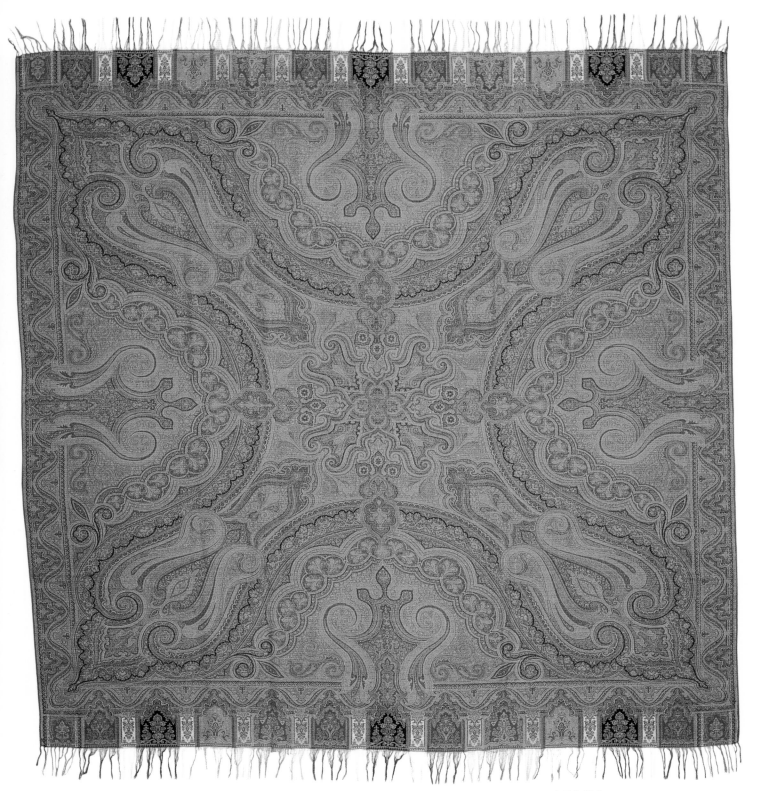

52. 74" x 75". Loose weave...wool. No center color field. Scotland, c. 1880. $400-600

173

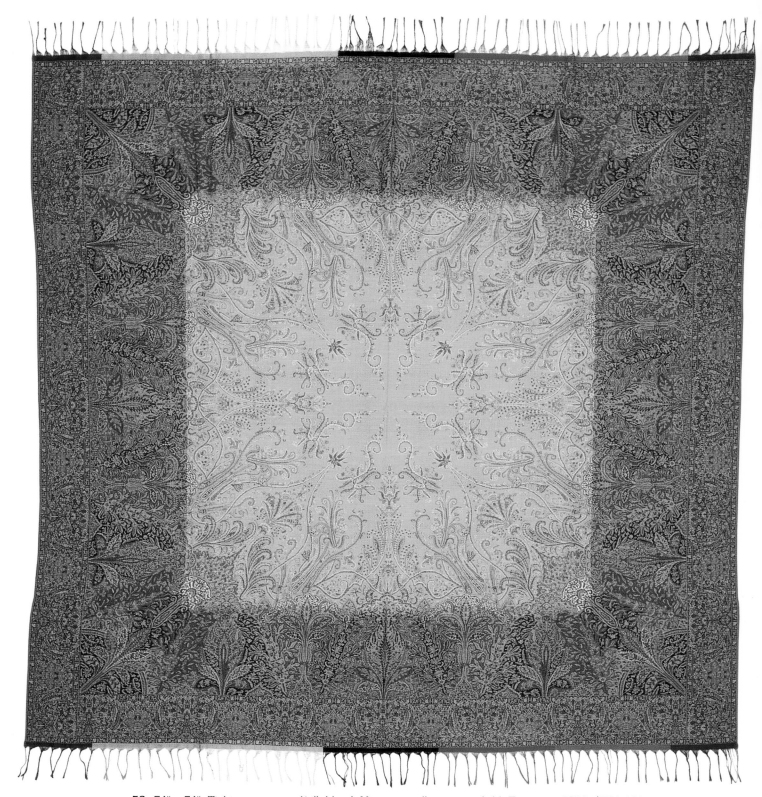

53. 74" x 74". Tight weave...wool/silk blend. Very rare yellow center field. France, c. 1850. $700-900

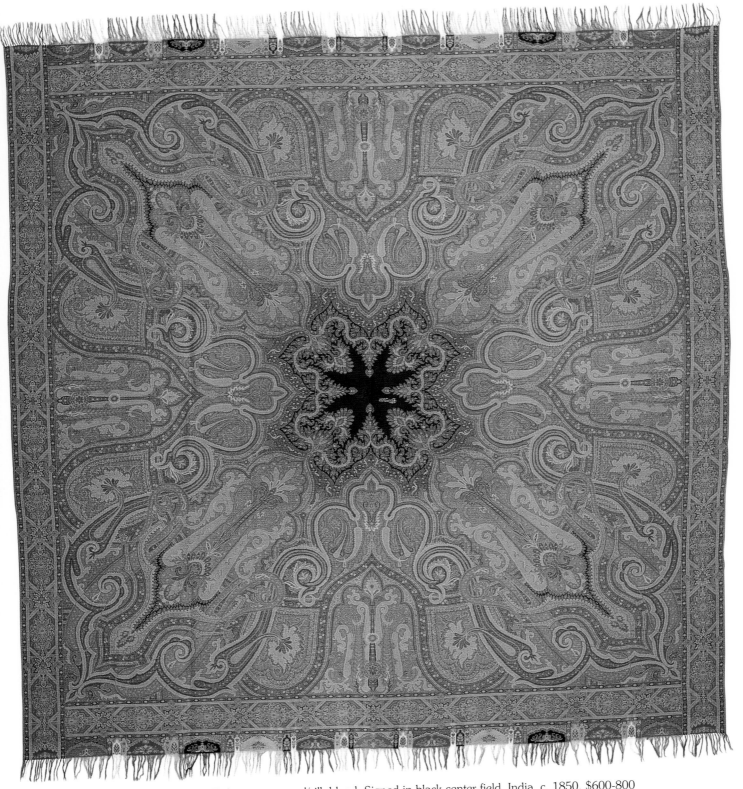

54. 73" x 72.5". Tight weave...wool/silk blend. Signed in black center field. India, c. 1850. $600-800

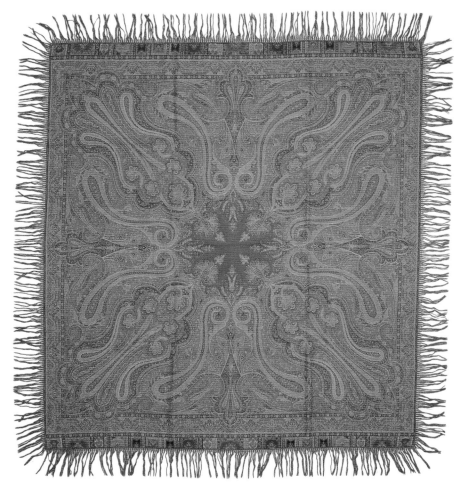

55. 60.5" x 70". Jacquard weave...wool/cotton reversible throw. Attached hand knotted 5" fringe on all four sides. This shawl is a copy of an older design. Italy, c. 1955. $400-600

56. 64" x 68". Loose weave...wool. Rare tri-panel design. England, c. 1850. $400-600

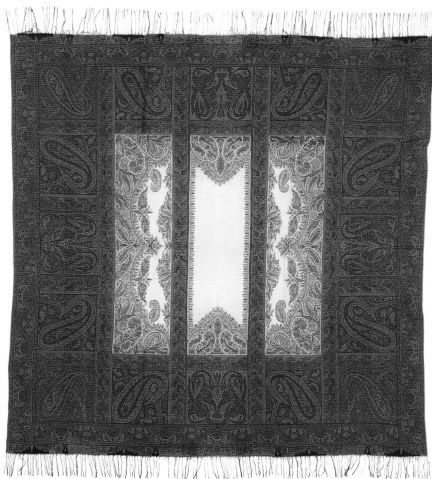

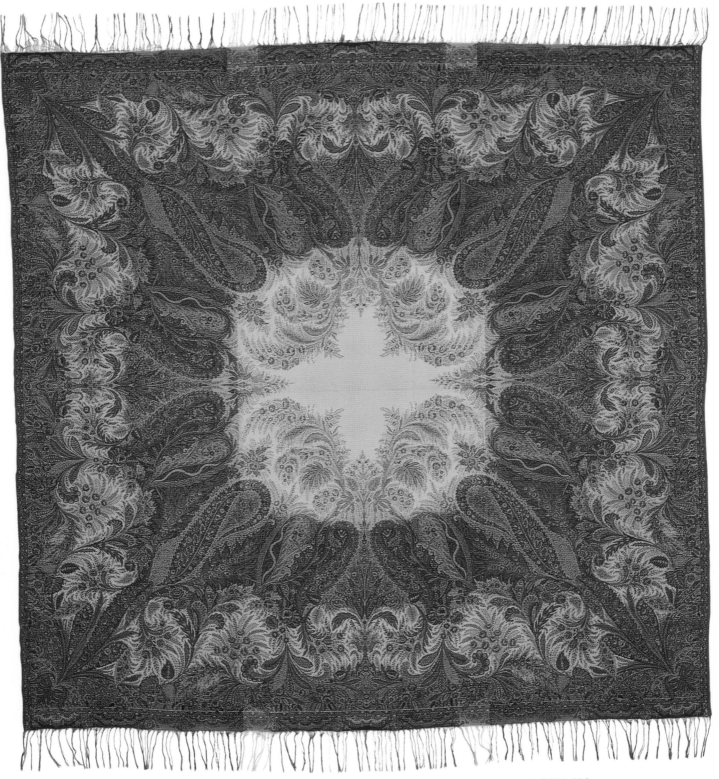

57. 64" x 68". Loose weave...wool. Rare yellow center field. France, c. 1850. $600-800

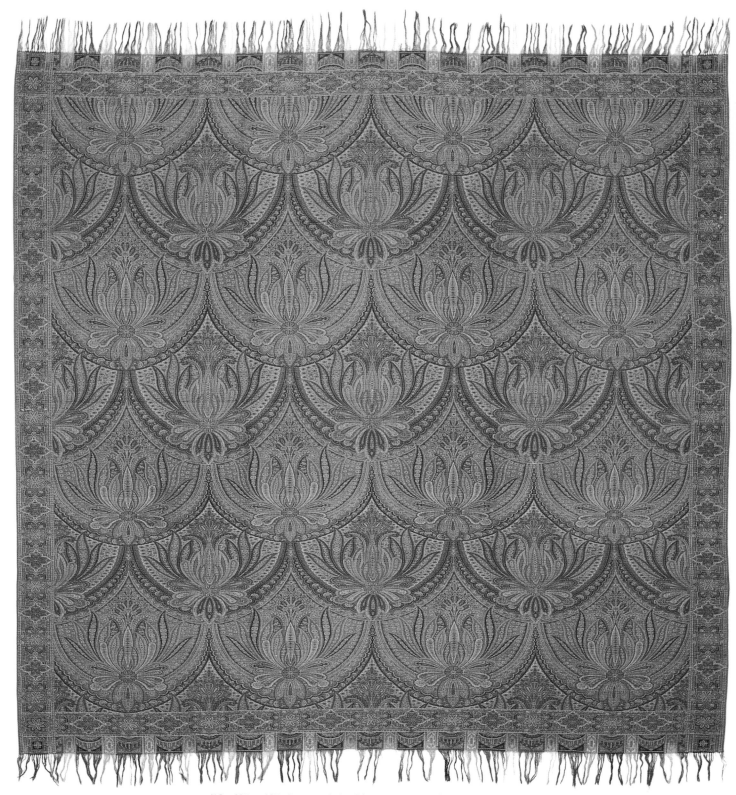

58. 68" x 69". Jacquard double weave...wool reversible shawl.
Colors are reversed on the opposite side. Scotland, c. 1860. $500-700

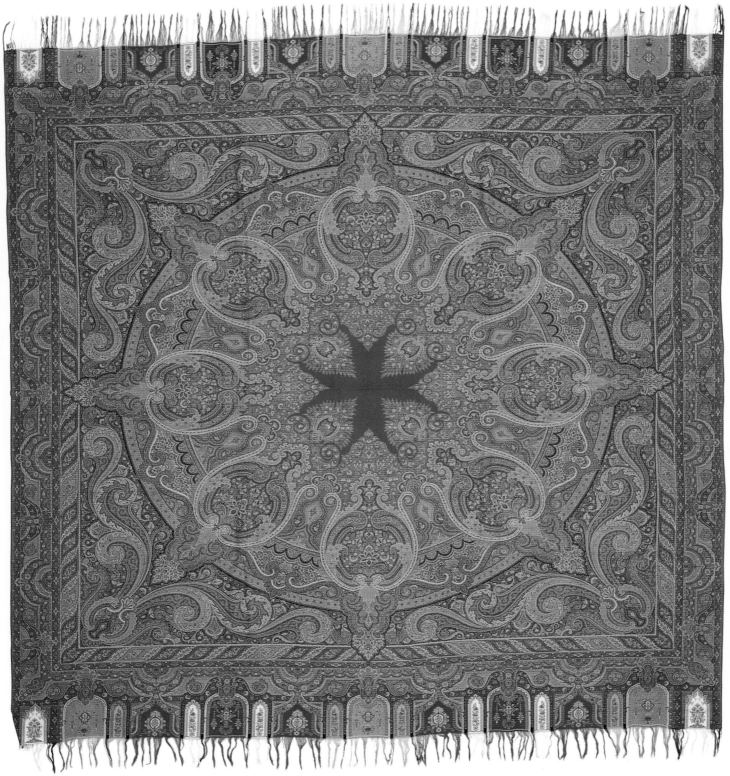

59. 71.5" x 72". Tight weave...wool. India, c. 1870. $600-800

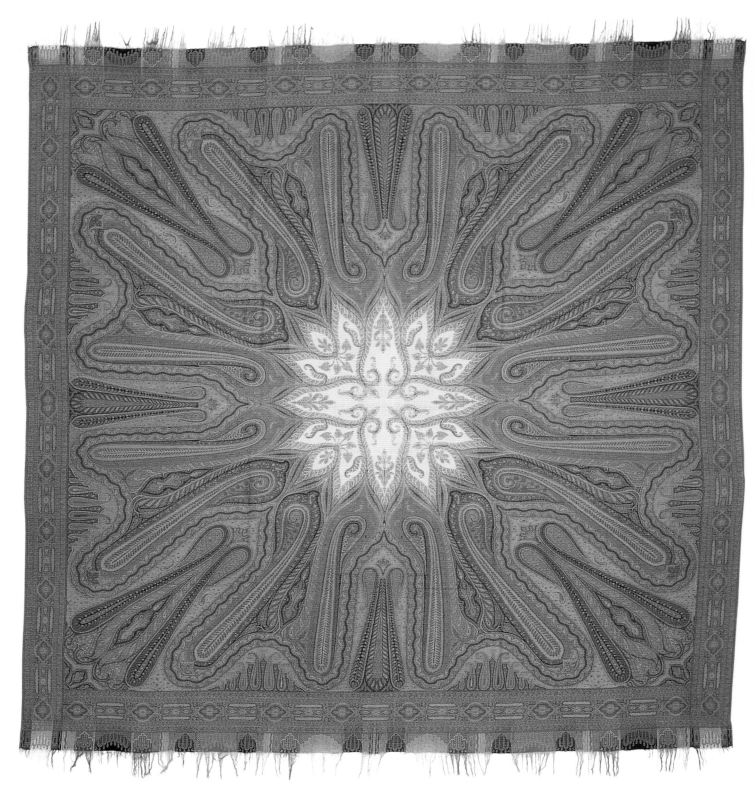

60. 72" x 72". Tight weave...wool/silk blend. France, c. 1850. 400-600

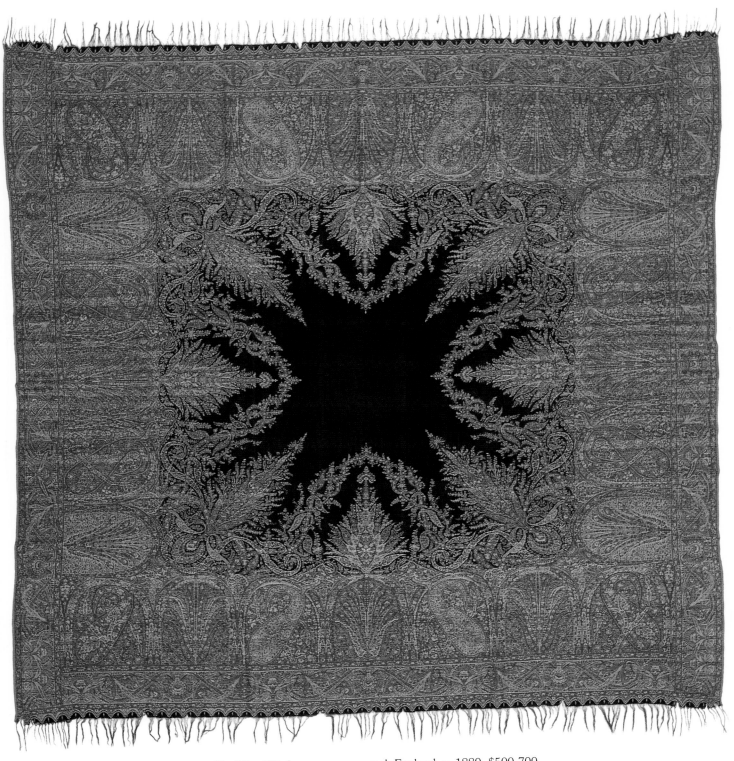

61. 68" x 70". Loose weave...wool. England, c. 1880. $500-700

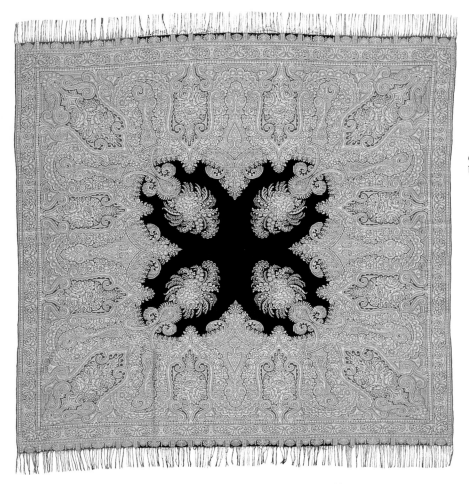

62. 63" x 65.5". Tight Jacquard weave...wool/silk blend. England, c. 1880. $500-700

63. 62" x 67". Loose weave...wool. France, c. 1850. $400-600

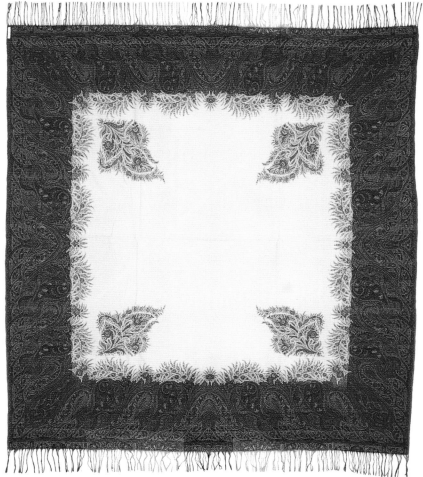

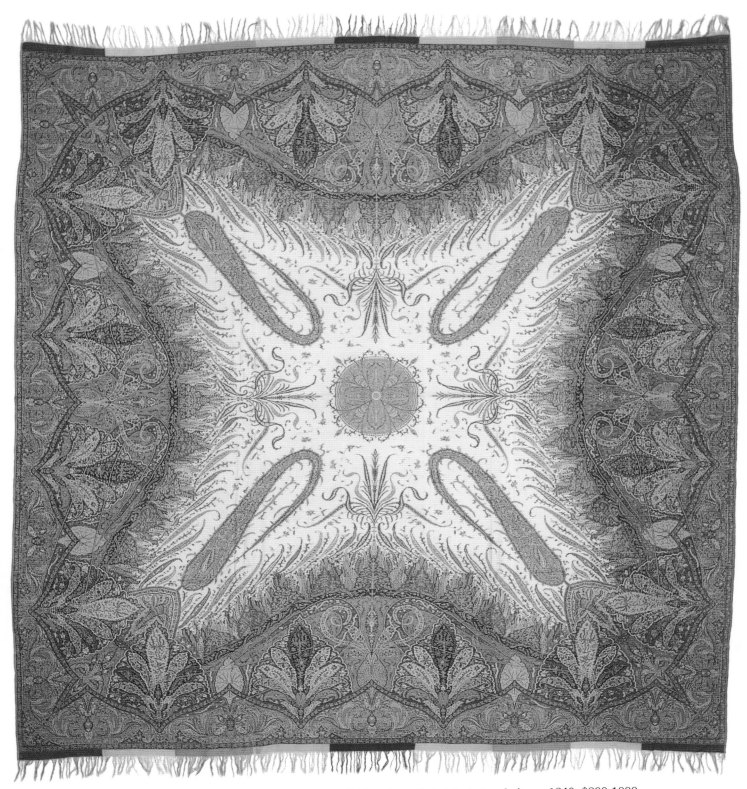

64. 70.5" x 71". Tight weave...wool/silk blend. Very dramatic boteh design. India, c. 1840. $800-1000

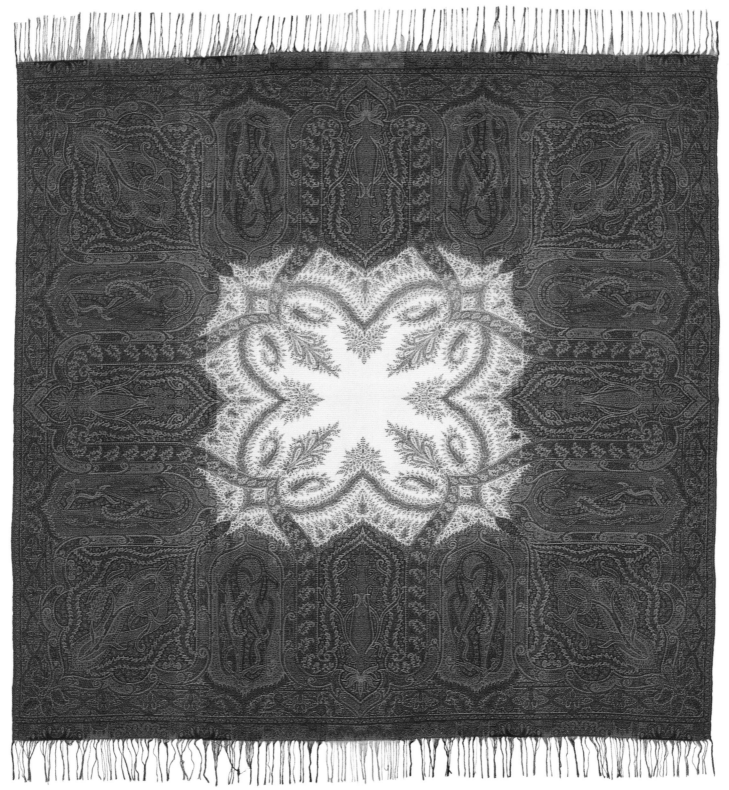

65. 67" x 69". Tight weave...wool. "Framed" white center field. France, c. 1850. $500-700

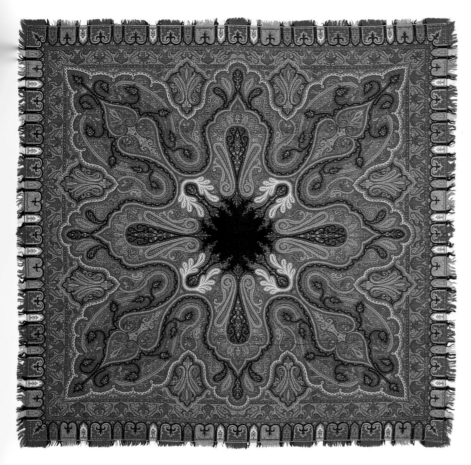

66. 71" x 71.5". Tight weave...wool. The wefts and warps are used to create the fringe on all four sides. White accents. Very heavy shawl. India, c. 1860. $500-700

67. 67.5" x 68". Loose weave...wool. Continuous run pattern. Ireland, c. 1880. $400-600

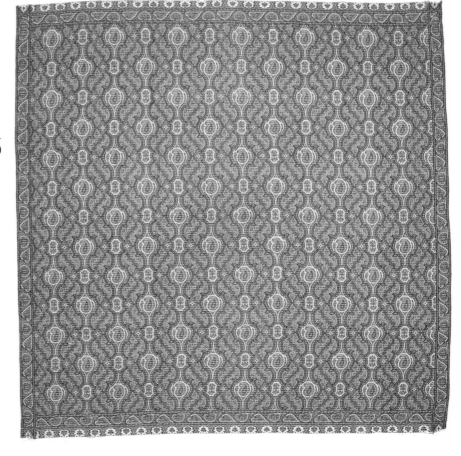

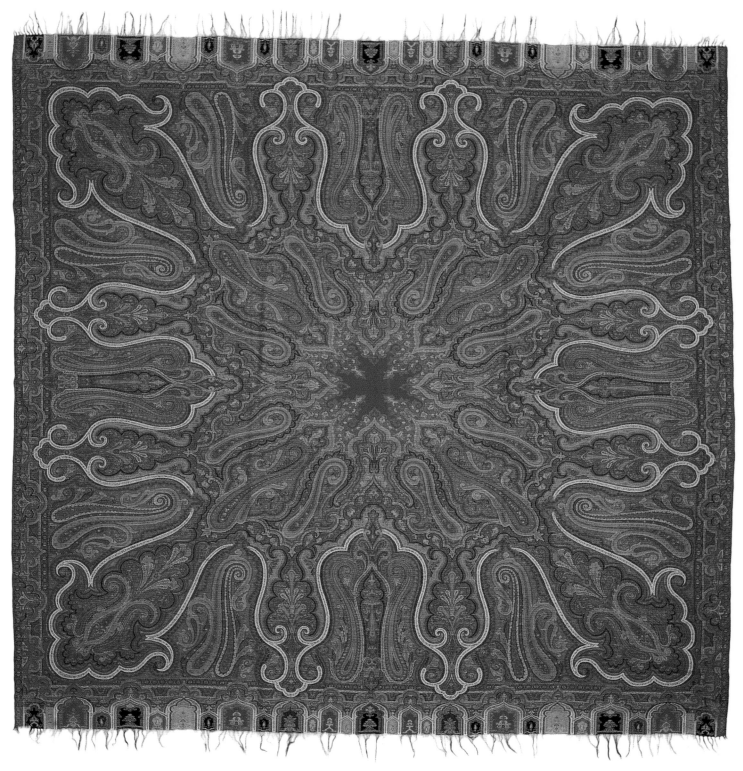

68. 70" x 72". Tight weave...wool. White accents. India, c. 1870. $400-600

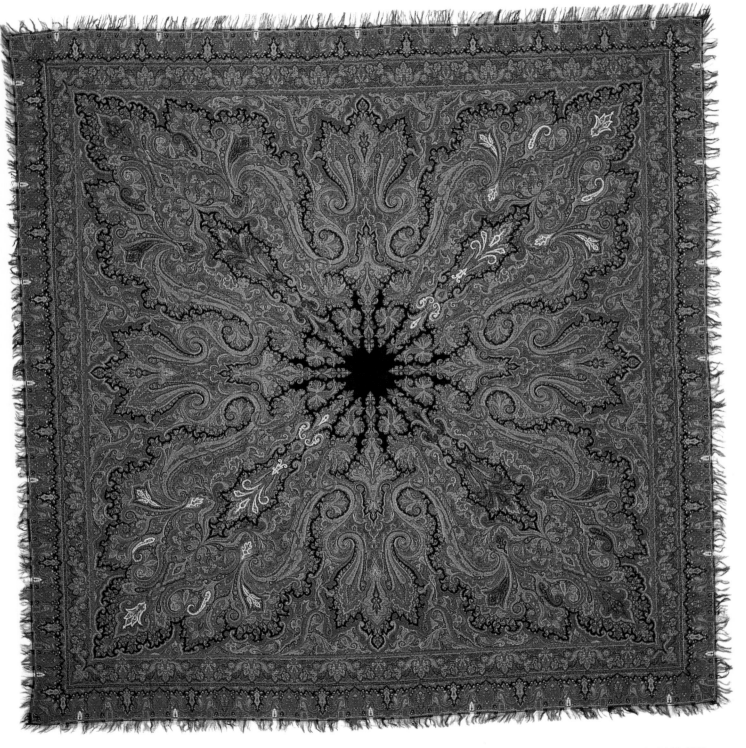

69. 70" x 72". Faux Kashmiri. Tight weave...wool. Attached 4.5" gates and fringe added to all four sides. India, c. 1860. $600-800

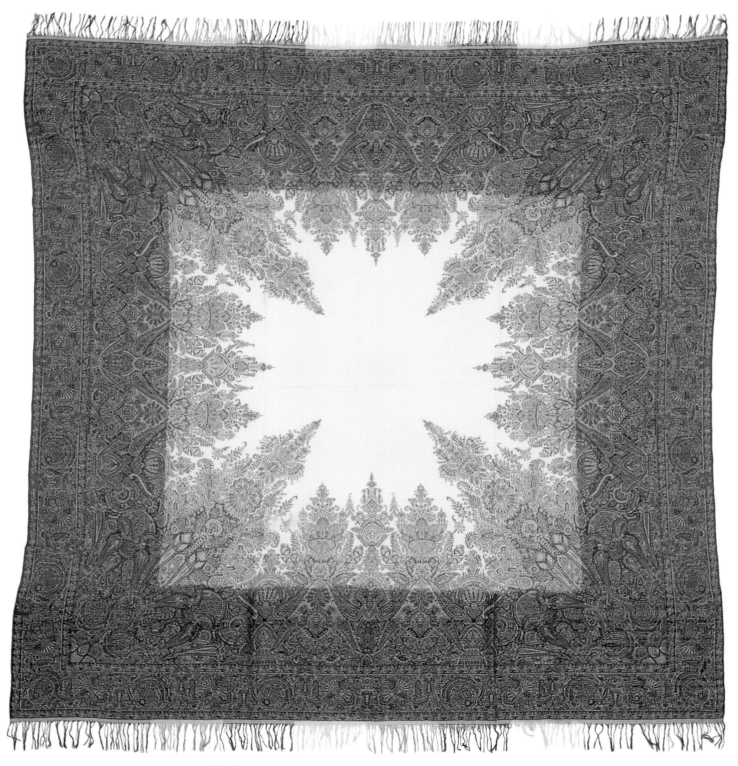

70. 65" x 65". Tight weave...wool. England, c. 1850. $500-700

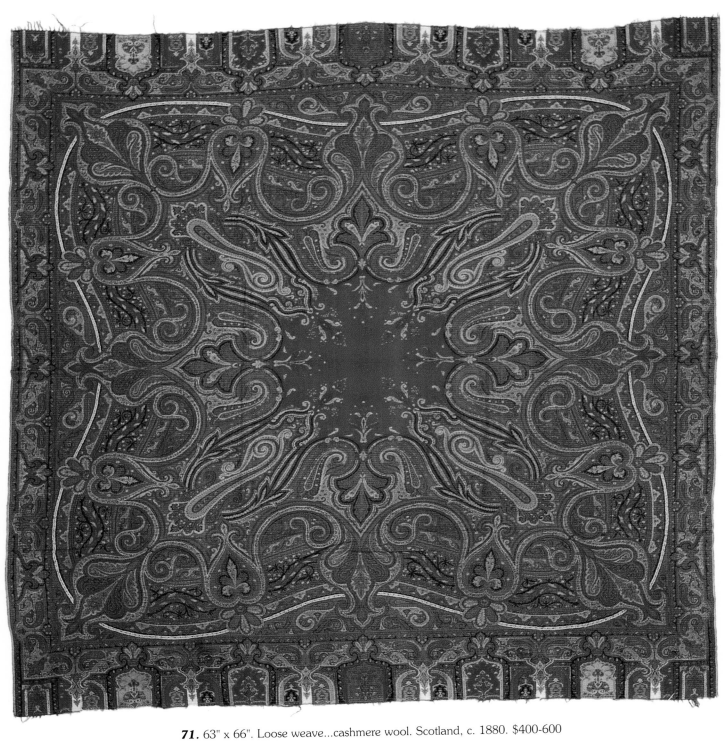

71. 63" x 66". Loose weave...cashmere wool. Scotland, c. 1880. $400-600

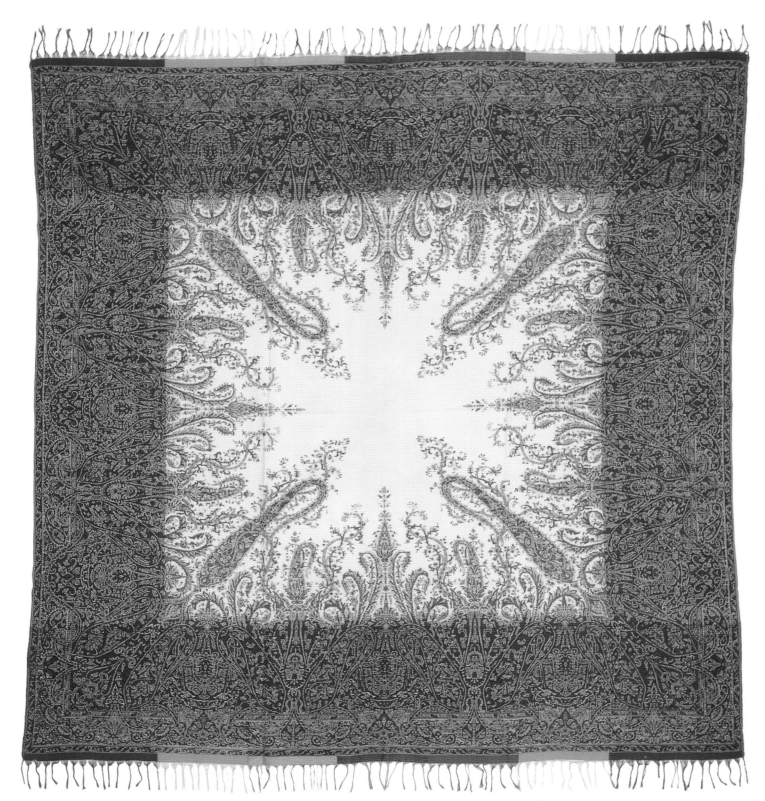

72. 67" x 68". Tight weave...wool. Vibrant colors. England, c. 1850. $500-700

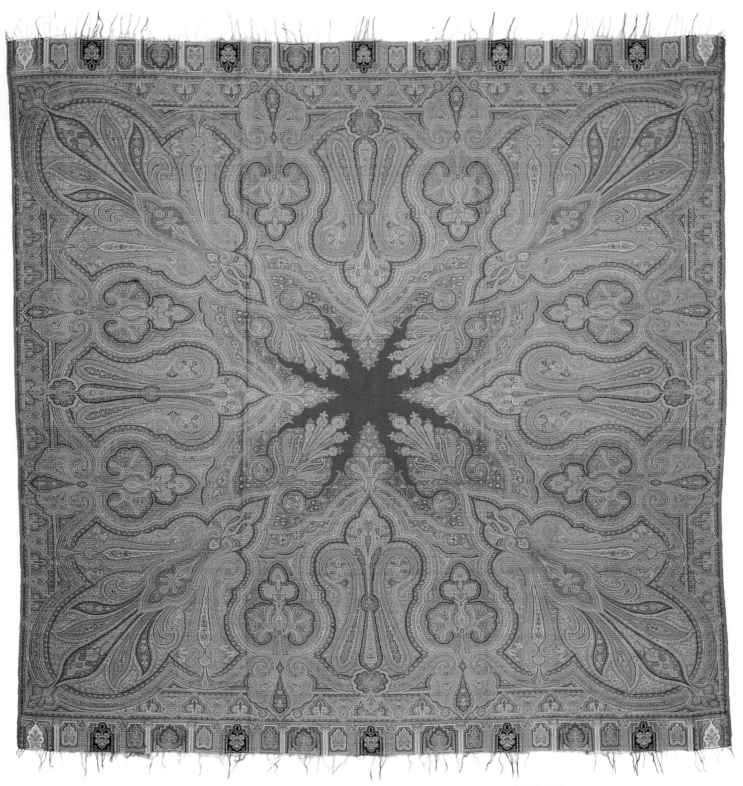

73. 69" x 70". Tight weave...wool/silk blend. Scotland, c. 1870. $500-700

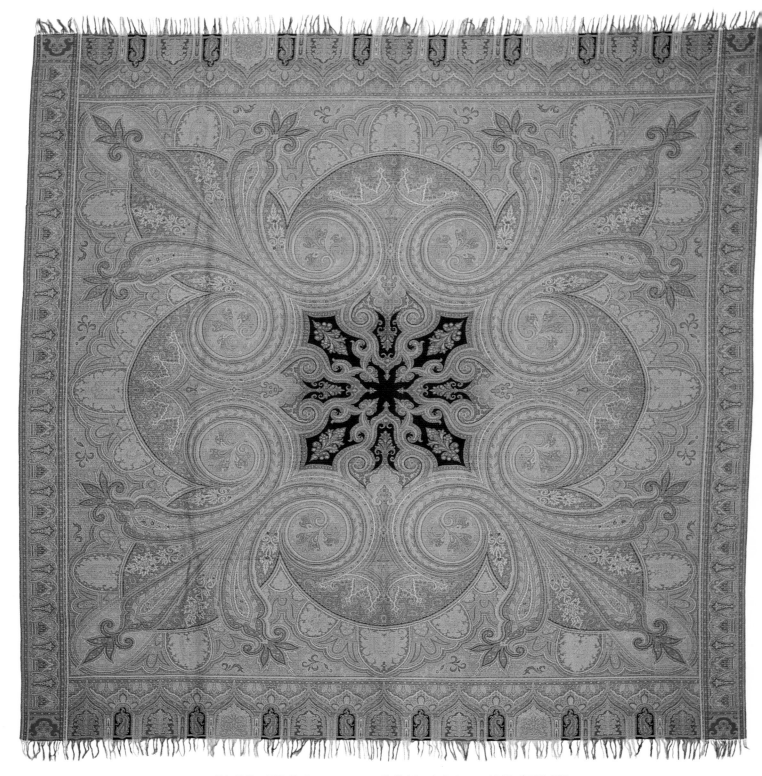

74. 74" x 78". Tight weave...wool/silk blend. India, c. 1880. $500-700

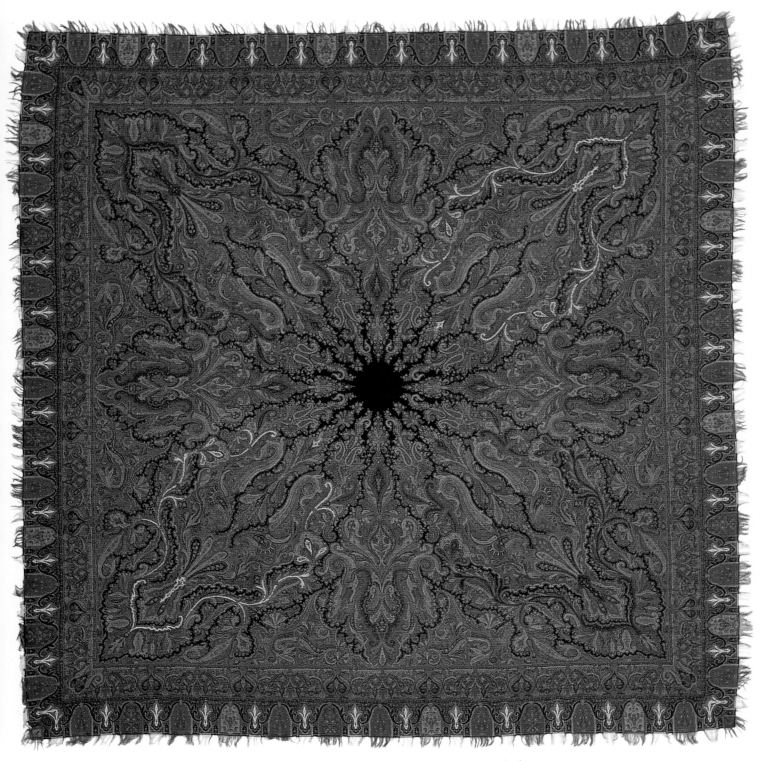

75. 70" x 71". Faux Kashmiri. Tight weave...wool. Attached gates and fringe on all four sides. White accents. India, c. 1870. $600-800

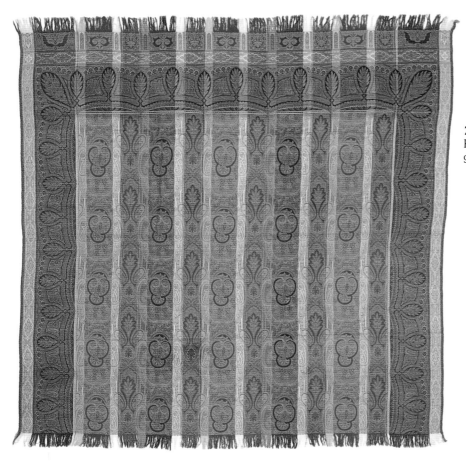

76. 63" x 64". Tight weave...wool/silk blend. Roman stripe. Silk embroidery on wool background. England, c. 1860. $500-700

77. 67" x 69.5". Jacquard weave...wool/silk blend. Reversible shawl. Colors reversed on opposite side. Scotland, c. 1890. $400-600

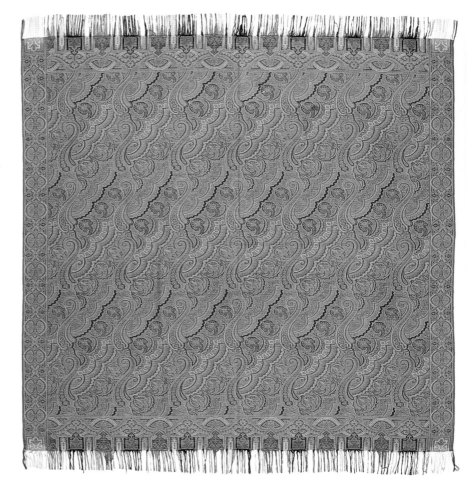

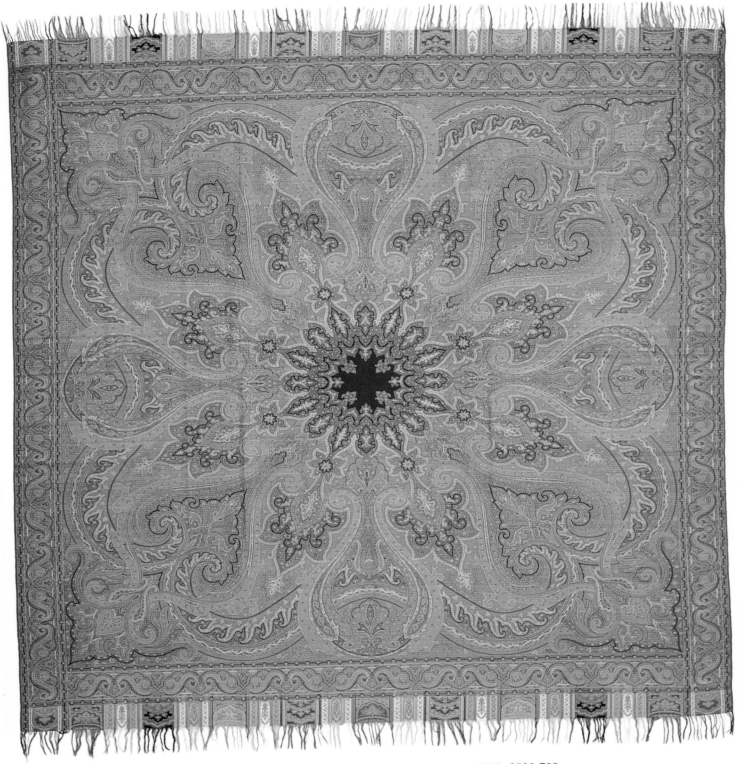

78. 69.5" x 70". Tight weave...wool/silk blend. India, c. 1860. $500-700

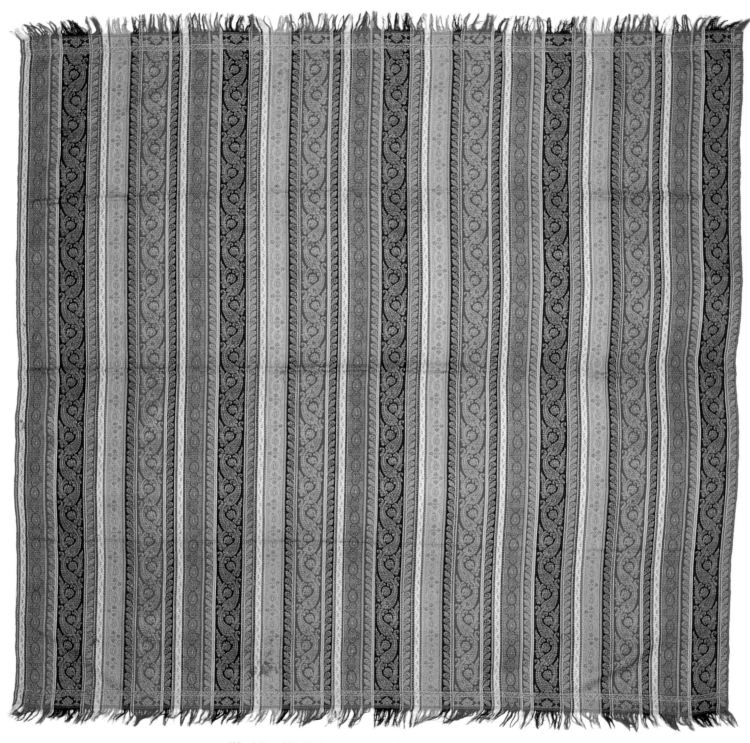

79. 64" x 67". Tight weave...wool/silk blend. Roman stripe.
Silk embroidery on wool background. England, c. 1870. $500-700

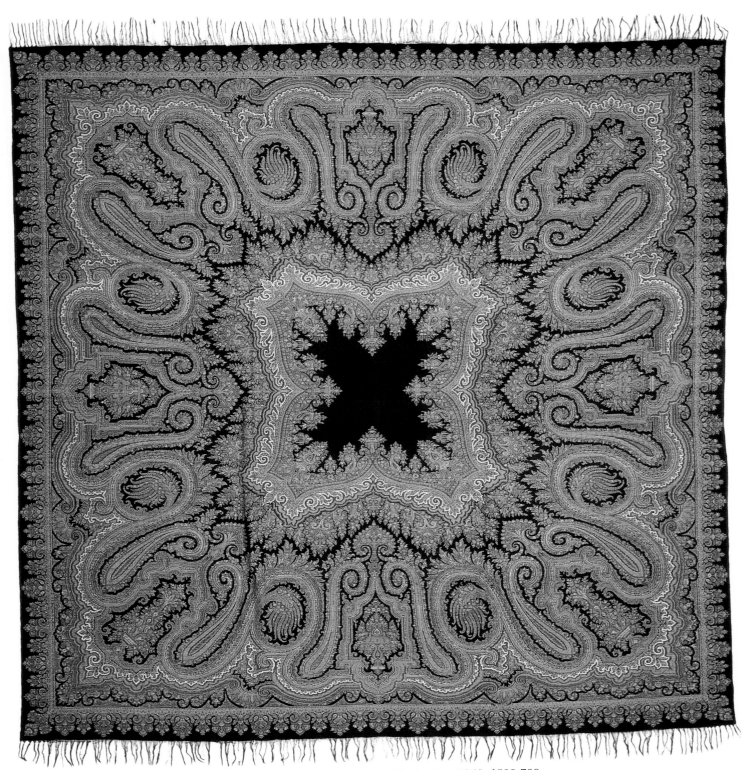

80. 72" x 72". Tight weave...wool. England, c. 1860. $500-700

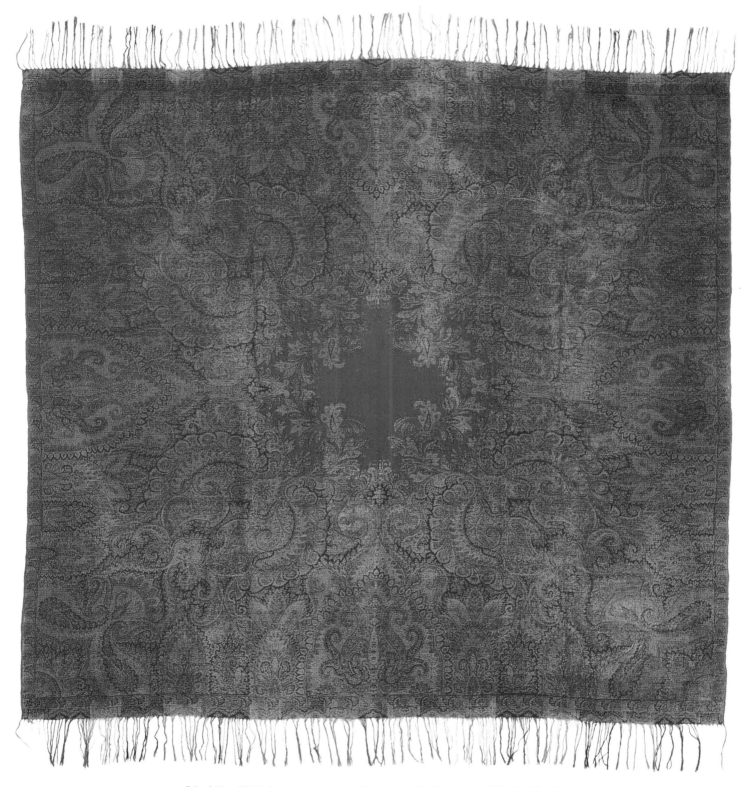

81. 64" x 67.5". Loose weave...cashmere wool. France, c. 1850. $400-600

198

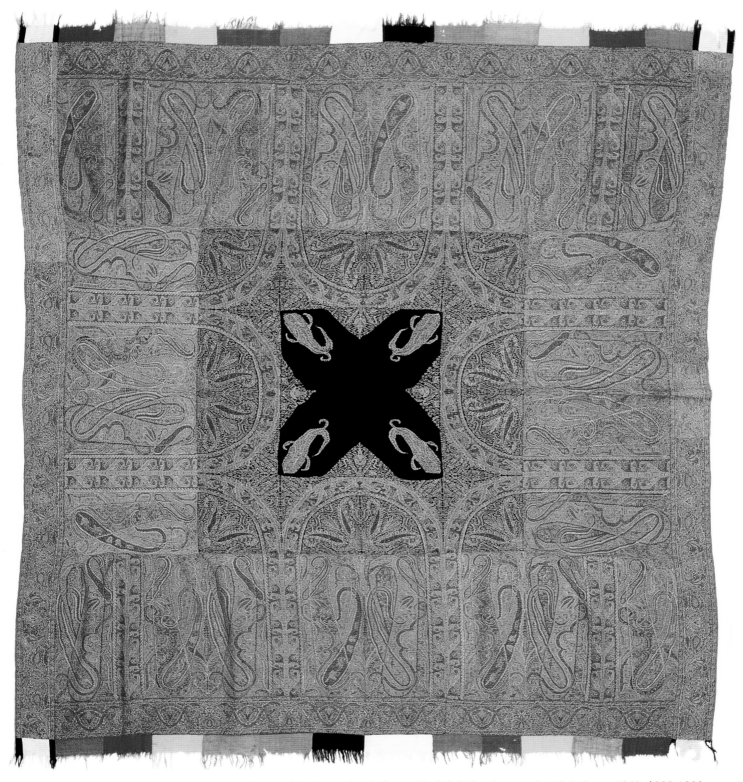

82. 70.5" x 74". Tight weave...wool. Hand pieced Kashmiri shawl. Center black field has been replaced. India, c. 1860. $800-1000

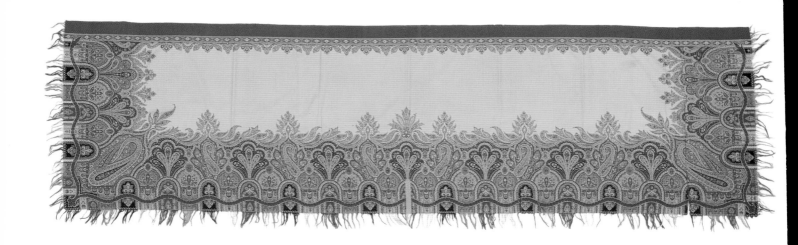

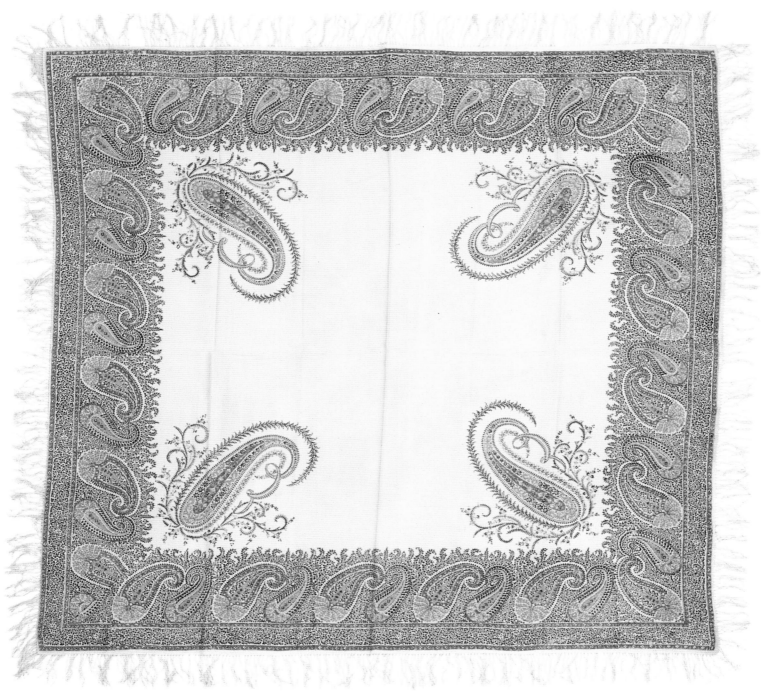

Opposite page:

83. 29.5" x 107". Tight weave...wool/silk blend. Shoulder mantle. Very rare color and vibrant. France, c. 1870. $1200-1500

84. 57" x 62". Tight weave. Rolled or block printed on cashmere wool. England, c. 1880. $300-500

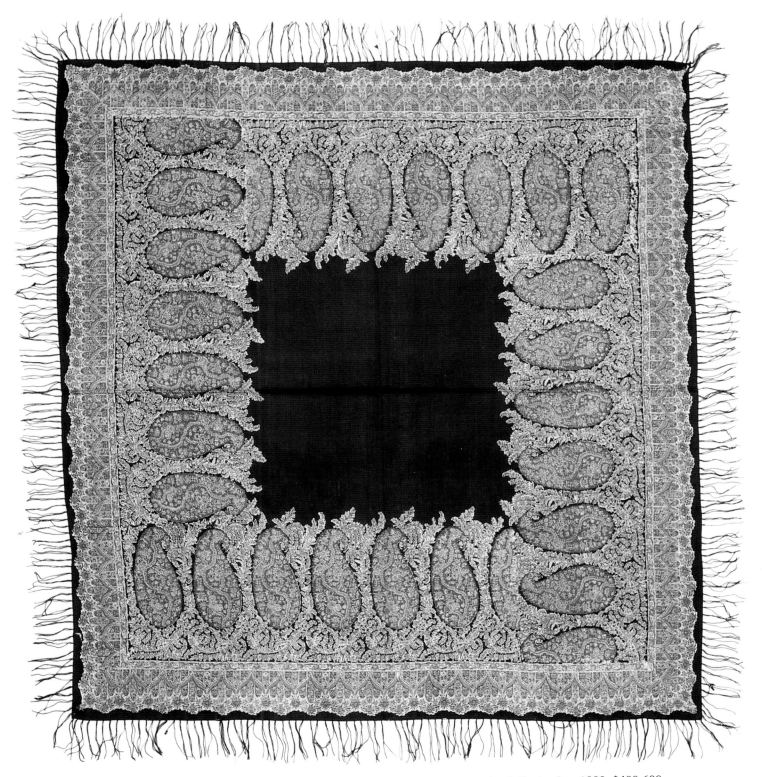

85. 61" x 63". Tight weave. Rolled or block printed on cashmere wool/silk blend. England, c. 1880. $400-600

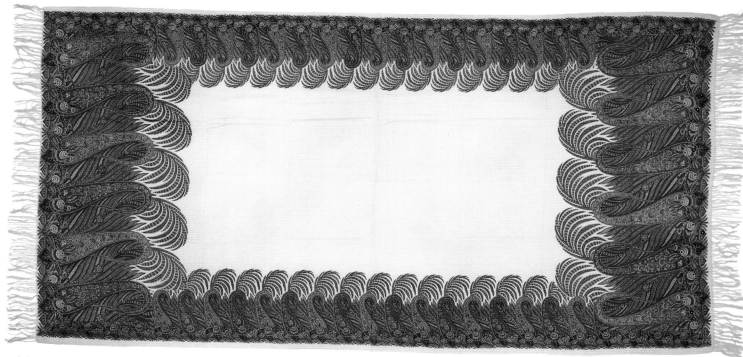

86. 65" x 128". Tight weave. Rolled or block printed on cashmere wool with individual 6" hand knotted fringe added to vertical ends. England, c. 1890. $600-800

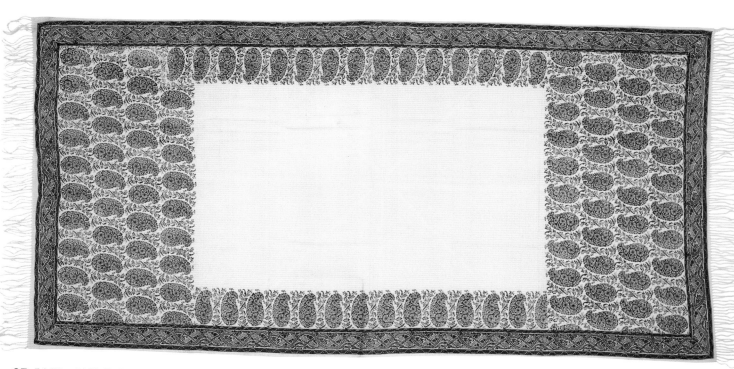

87. 54.5" x 115". Tight weave. Rolled or block printed on cashmere wool with individual 5.5" hand knotted fringe added to vertical ends. England, c. 1890. $600-800

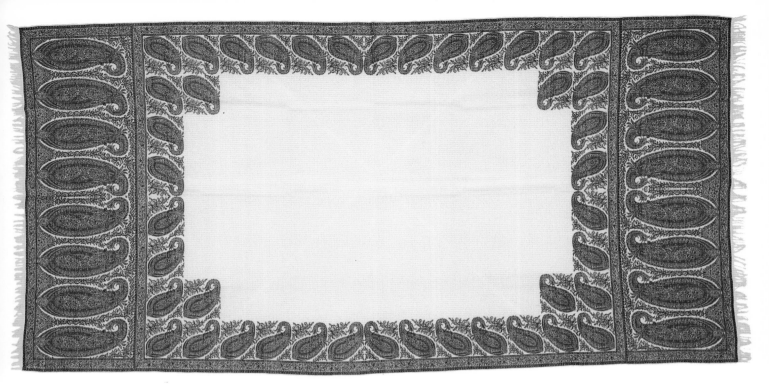

88. 50.5" x 101". Tight weave...cashmere wool. This is a woven Norwich design on very fine wool. England, c. 1870. $500-700

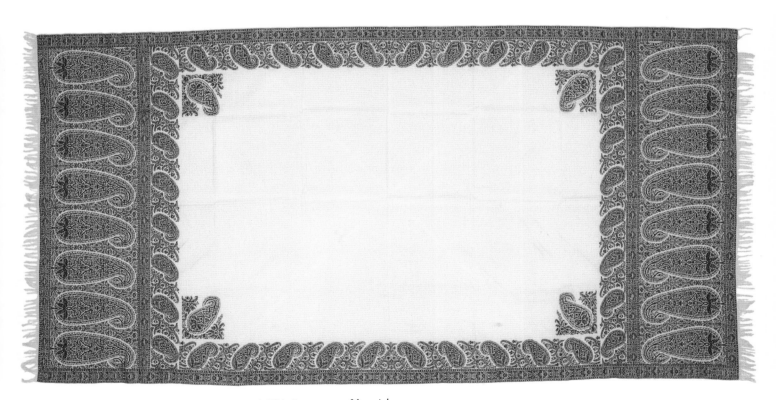

89. 53" x 104". Tight weave...cashmere wool. This is a woven Norwich design on very fine wool. England, c. 1870. $500-700

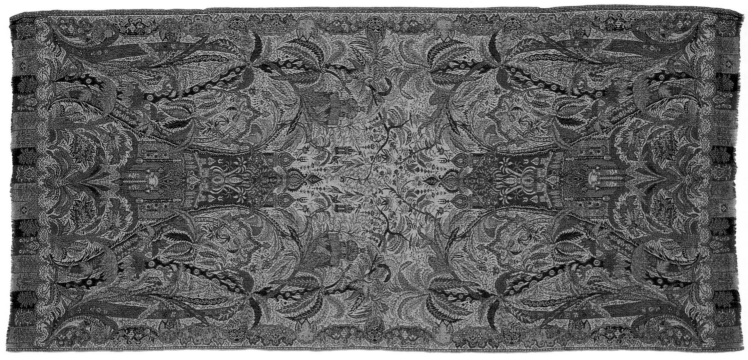

90. 40.5" x 82". Jacquard weave Pashmina wool. This shoulder mantle is a Mogul design. This is reversible shawl and very rare. India, c. 1890. $1000-1200

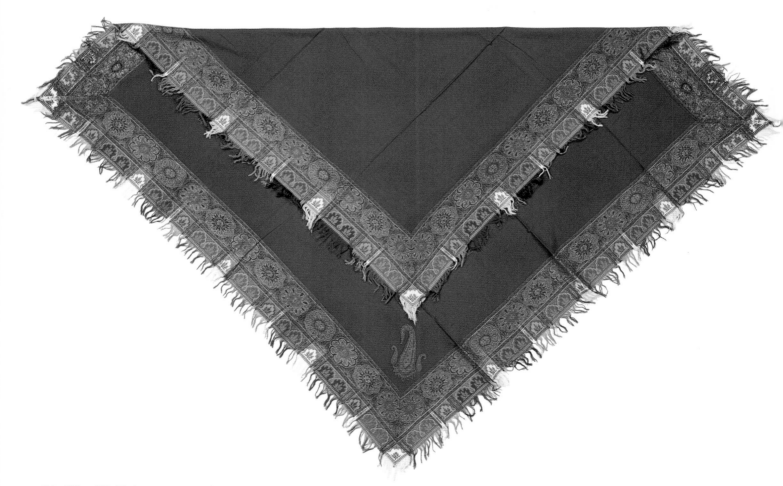

91. 62" x 62". Tight weave...wool. This is known as a "fold over" shawl, whereby the finished borders of all sides are displayed. This shawl has two sides of the border attached with the unfinished side facing up. The borders are hand pieced. France, c. 1860. $400-600

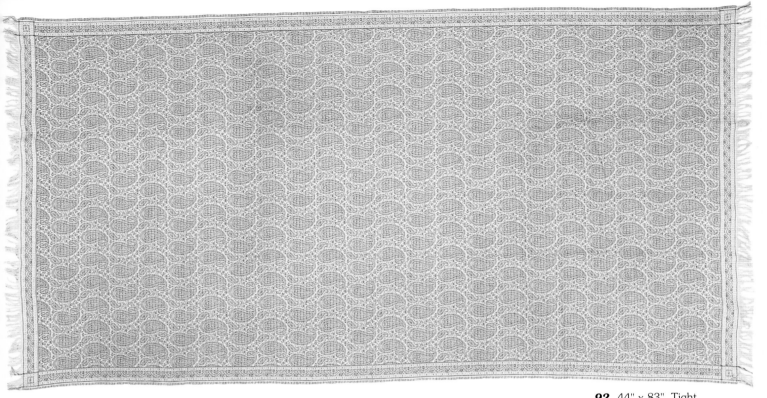

92. 44" x 83". Tight weave...wool. The design of this shawl is called a "continuous run." Ireland, c. 1890. $300-500

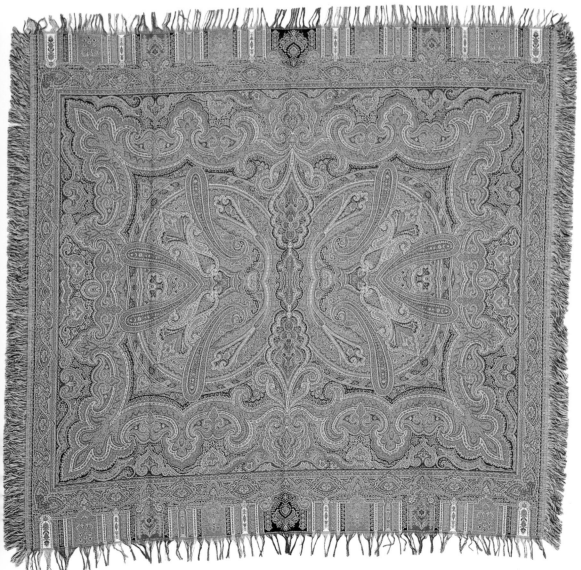

93. 55" x 56". Jacquard weave...wool. Fringe on all sides is formed by the wefts and warps. This is a newer shawl and is reversible. Holland, c. 1915. $200-400

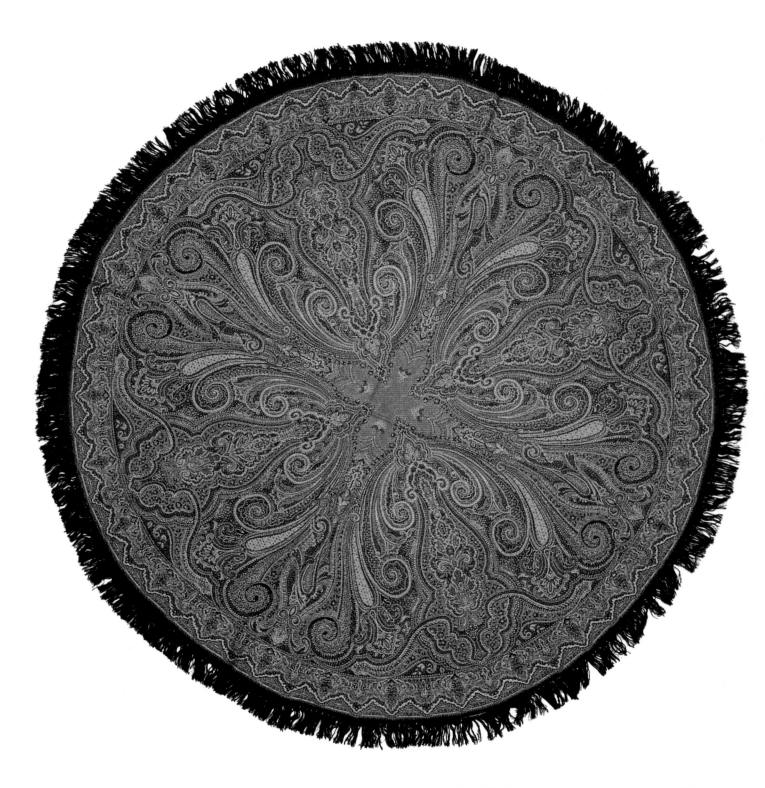

94. 62" diameter. Jacquard weave…wool. This circular shawl is newer and is reversible. On one side, the central color is red; on the opposite side it is blue. This type of shawl is rare. Holland, c. 1915. $200-400

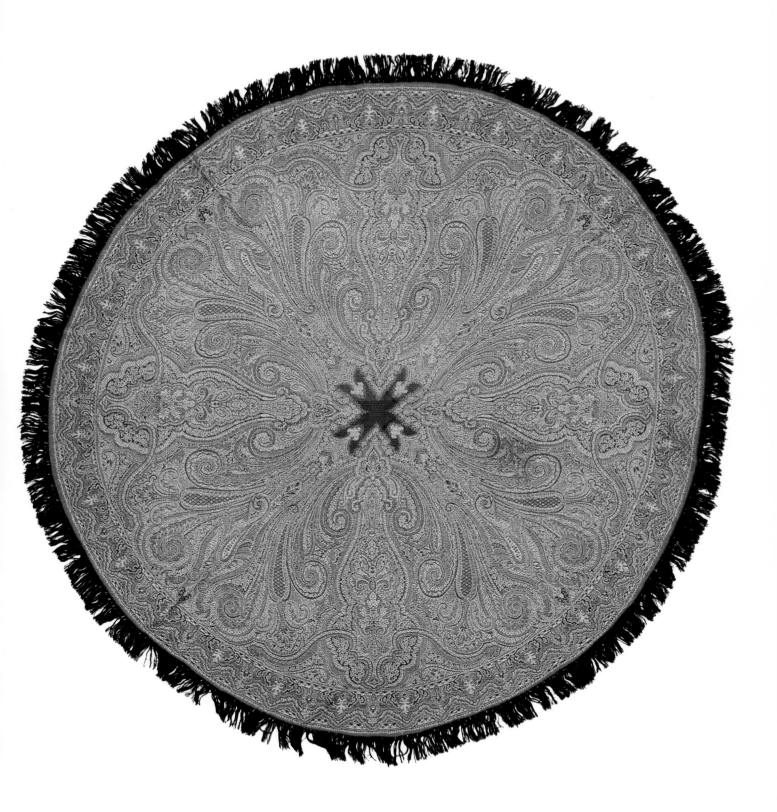

Bibliography

Ames, Frank. *The Kashmir Shawl and its Indo-French Influence*.
 Woodbridge, Suffolk England: The Antique Collectors' Club, 1997.

Levi-Strauss, Monique. *The Cashmere Shawl*. New York: Harry N.
 Abrams, Inc., 1988.

Lowe, Blanche Beal. "Paisley Shawls." *Spinning Wheel Antique
 Magazine*. March 1956, vol. X11, Number 3.

Prakash, K. *Paisleys and Other Textile Designs from India*. Mineola, New
 York: Dover Publications, Inc., 1994.

Reilly, Valerie. *Paisley Patterns, A Design Source Book*. New York, New
 York: Portland House, 1989.